Stargazer

ONE WEEK LOAN

SOUTHAMPTON INSTITUTE

Southampton Institute Library Services Ltd
MOUNTBATTEN LIBRARY
Tel: (023) 80 319249
Please return this book no later than the last date stamped.
Loans may usually be renewed - in person, by 'phone, or
via the web OPAC.

Stargazer

●●●●●●●●●●●●●●●●●●●●●●●●●●●●●●●●●●●●●●●

The Life, World and Films of Andy Warhol

Stephen Koch

Revised and updated

Marion Boyars
New York · London

This revised and updated third paperback edition first published in 1991
in the United States and Great Britain by
Marion Boyars Publishers
26 East 33rd Street, New York, N.Y. 10016
24 Lacy Road, London SW15 1NL

Distributed in the United States and Canada by
Rizzoli International Publications, New York

Distributed in Australia by Wild and Woolley Pty, Glebe, NSW

Distributed in New Zealand by Brick Row, Auckland

Original edition (subtitled Andy Warhol's World and his Films) was published in 1973 by
Praeger US and 1974 by Calder & Boyars UK. An expanded edition was published by
Marion Boyars Publishers, New York and London, in 1985.

Library of Congress Cataloging-in-Publication Data
Koch, Stephen.
 Stargazer: the life, world, and films of Andy Warhol/
Stephen Koch. — New enl. ed.
 Includes filmography and index.
 1. Warhol, Andy, 1928–. 2. Artists—United States—Biography.
I. Title.
NX512.W37K6 1991
791.43′0233′092—dc20 90–26983

British Library Cataloguing in Publication Data
Koch, Stephen 1942–
 Stargazer: the life, world and films of Andy Warhol.—3rd ed.
 1. United States. Cinema films. Warhol, Andy 1928–1987
 I. Title
 791.430973

ISBN 0–7145–2920–6
Printed and bound in Great Britain by
Billing and Sons Ltd, Worcester

Contents

Acknowledgments

●●●

It was a suggestion by Annette Michelson that first triggered this idea, and whatever intellectual strengths the book may possess have been sharpened and sophisticated by my friendship with her over the past few years. She remains my ideal reader.

Research would have been impossible without the facilities of the Anthology Film Archives, and the book is deeply indebted to the generous assistance and encouragement of P. Adams Sitney and Jonas Mekas, who gave me the benefit of their greater knowledge at every step of the way, and whose observations saved me from many errors of fact and emphasis.

I've been particularly fortunate to have the cooperation of Stephen Shore, that *enfant prodige* of photography, whose extraordinary photographs of the old Factory surpassed professionalism at an age when most photographers hardly know what that concept means. I'm likewise grateful to Babette Mangolte for her professional help in assembling what I think is the best collection of Warhol film stills anywhere.

Thanks are also due to John L. Hochmann, my editor, who bore with me through many vagaries, and to Gilda Kuhlman, who designed what you see.

Finally, thanks to the Factory—particularly to Vincent Fremont, for innumerable practical services along the way. Thanks to Paul Morrissey.

And of course, thanks to the pale master himself.

STEPHEN KOCH

AFTER THE END[*]

●●●

After the death of Andy Warhol on February 22, 1987, almost everyone in New York agreed that life would never be the same. Wherever one went, people sighed about eras ending, and with reason, I suppose. For over twenty years this cool, greatly gifted, wonderfully ingenious imp of the perverse had been at the center of those interlocking worlds of society and art which in 1987 were passing through dark times. Something did seem to be coming to a conclusion, and doing so in tragedy.

Warhol died in New York Hospital following otherwise uneventful—albeit emergency—surgery performed the day before to remove his gall bladder. The need for such an operation had been obvious to his doctors for years, but Warhol had used all his many powers of evasion to resist the recommendation, gripped by a phobic belief that he would never survive it. Hospitals had been for him a source of terror ever since 1968, when a member of his entourage, a woman named Valerie Solanas, had attempted to shoot him to death in his studio on Union Square. Warhol had been desperately wounded. Three bullets penetrated many vital organs; on the surgical table his heart actually stopped beating until the

*This additional chapter was written by the author for the paperback reissue of 1991.

surgeon's emergency heart massage revived him. In Warhol's sense of things, he *had* died and then been brought back, as if God had reconsidered and on second thought returned his life on loan. His life had been restored in a tentative amnesty, an act of grace, a revocable freebie. He would live the rest of his life feeling a precisely formulated sense of metaphysical specialness, and an accompanying metaphysical terror. He was breathing on borrowed time; his period of grace might be annulled at any moment.

As for hospitals, he was sure that if he ever returned to one, that would be *it*. His fear was so acute that Warhol could not bring himself even to pronounce the word "hospital:" he spoke instead of "the place", as in "they are trying to send me to the place." He made it a point never to pass a hospital: he would never under any circumstances visit a friend in a hospital; taxi drivers were often given elaborate instructions for avoiding even driving by "the place," and if for some reason he was forced to pass one he would avert his eyes. And he would never go back; he would die there; he just knew it.

But in February 1987, Warhol's gall bladder condition was close to critical. His doctors could no longer humor his evasions, and he could no longer sidestep his agony. He was told that without the prompt removal of his gall bladder he would probably die. Emergency surgery was scheduled for a Saturday, February 21.

A cholecystectomy is a serious but not unusual form of surgery, and Warhol's went very well. When he emerged from the recovery room that afternoon, he was awake and reasonably cheerful. He spoke to friends on the telephone; he watched some television; he joked with his nurses. Then he slept.

And then, before dawn, around 5:30 the next morning, his private duty nurse (who it appears either had left the room or fallen asleep) suddenly became aware that her patient was in severe crisis. Warhol's always pallid skin had turned blue; his breath faltered into inaudibility; he was unresponsive; he was possibly moribund. The room was abruptly crowded with shouting interns and nurses in full emergency, but nothing helped. Within half an hour it was clear that he was gone. The reprieve of 1968 had been rescinded.

But it was a time of dying. In August 1988, Jean-Michel Basquiat, a young artist whose rapid rise took place very much under Warhol's patronage, was found in his apartment lying in his own vomit, dead of a drug overdose. Three years after Warhol's death, Keith Haring, the graffiti artist who had been among the last young artists assisted into a grand New York high-style success in fashion and finance by Warhol, was dead at the age of 31 from complications accompanying AIDS. Twenty years before, little bespectacled Keith, a smallish ten year old,

gaped up at one of Warhol's *Marilyn Monroes* in the basement of the Hirschhorn Museum. The boy was in Washington on a trip with a church group from his home town in Pennsylvania. This was little Keith's first look at "art," his first image of what art was, of what being an artist might mean. The moment Haring was big enough, he moved to live in the New York where Warhol was master. Inspired by what he saw as Warhol's populism, Haring began by making his mark (literally making his mark) in the New York subways. Haring would descend into the stations in the dead of night, supplied with chalk and black background paper. He pasted the paper over advertising spaces on the platforms. When morning came the trudging workaday traffic would find, in the sundry outposts of underground Manhattan, graffiti drawings of the figure Haring called his "Radiant Baby," a cryptic white-on-black cartoon of a crawling infant from whom chalky startled beams of joy seemed to be breaking loose. Bright in their black and white, the unsellable pictures were pasted to the populist walls, and they advertised nothing but new birth.

Three years after Warhol's death, Keith Haring was gone too, dead at right around the same age that Warhol had become a famous man. "Warhol was the validation and most active support of what I do," Haring said when the master died, though his Radiant Baby had turned out to be an insignia for an age of farewells.

So in a sense, Warhol died twice, and in a parallel sense he always seemed to be ending some era or other. I would argue that this is very much part of who Warhol was. There was something subtly valetudinarian about his very presence, something in the immediacy and vanguard freshness of his work which continuously foreshadowed its own end, something in the implicit pathos of his estheticized immediacy that was, with shy ingenuousness, waving a kind of perpetual goodbye.

Immediacy is transience. This moment is forever just about to become that moment. One could hear Warhol's sense of the pathos of this truth even in his comments on his artistic "immortality." His view of the life of his work posthumously was the reverse of the classic aspiration. "I know my work won't last. A few years, at the most. I know that."

The sense of ending that broods over Warhol has been noted by many observers. Some see it as a last commentary on the exhaustion of options in the Western visual tradition, and as itself the final option within that tradition, the *terminus ad quem*. On its highest level, this argument has been advanced most impressively by Arthur Danto, and it is an important part of Danto's activity as an art critic and his revaluation of Hegelian esthetics.

My own view does not grant Warhol that pride of last place; I do not see him as the ghost of a defunct tradition. I see him as an artist among

artists, one who in his unique fashion renewed for our time the philosophic options on a certain aspect of the romantic tradition. And along with many observers I agree that the pivot of this romantic transition into a new immediacy was the remarkable and (in recent years) much over-rated work of Marcel Duchamp and his (somewhat under-rated) American fellow wiseguy of the high serious, John Cage.

I see Duchamp less as the post-modern Leonardo than as a kind of metaphysical wit. I also see Duchamp as an initiating opportunist in one of the most important and durable modernist myths: the myth of the end of art. The avant-garde in particular is addicted to this myth, since the exhaustion of the old is essential to its own prestige. It is an opening move, a means of leveling the field, a gambit, and we have been through it a thousand times since the Armory Show. The end of art just goes on and on.

For his own reasons Marcel Duchamp made himself into the grand comedian of this view. It is invariably a strategy rather than an authentic claim, and it is usually opportunistic: "art is over; therefore you must turn to me." At its best it is a more or less penetrating historicist wisecrack, the flash of a half-truth.

The more interesting result happens when, on rare occasion, the claim about art's ending really does produce worthy and renovated vision. Of course, the connoisseurs of the claim never *really* want to close up shop. (They might sometimes want the competition to close up shop, but that's different). They are invariably playing a game of loser wins, invariably seeking to recuperate the art they claim to renounce. And remarkably enough sometimes they really do.

Even Duchamp did. Marcel Duchamp's early renunciation of "art" was a defensive move against the dominance of a Parisian Cubism. Despite bravura performances like the *Nude Descending a Staircase*, Duchamp had come to realize that his own position with the movement would never be much higher than the third, or at best second, rank. Seeing that he was about to become a Cubist also-ran, Duchamp renounced an art he could neither master nor endure having failed to master, and proclaimed it a dead end.

In this process he found himself. He proceeded to produce some perverse but very interesting art, though admittedly his art is more interesting than actually powerful. He also produced some quite (not inexhaustibly) suggestive bric-a-brac. Finally, in both his talk and work Duchamp struck off a great many flinty bright ideas about art, shrewdly orchestrated visual and verbal witticisms about the End. Duchamp's real place is as a visual footnote to the tradition of Voltaire, although interminable repetition has made it difficult to remember that his acid *esprit* was once really genuinely fresh, filled with astringent charm and insight.

Simultaneously Duchamp took up residence in America, where his cold ego could find gratifications and standing that would have been impossible in the land where Picasso reigned as king. There various gifted Americans, especially after the war, became impressed by Duchamp's perversities as their own possible path out from under precisely the same French dominance against which he had rebelled forty years before. And these Americans were the ones who recovered Duchamp's self-protective renunciations for a renewed art.

These young Americans followed Duchamp's chilly lead down two parallel paths. The first begins in Duchamp's arch obscurantism, part of his work that culminated in the *Large Glass* in the Philadelphia Museum. That obscurantism led them to a hermetic style, to abstracted and cryptic surfaces in which the visual struggle, the "push-pull," was an unresolved struggle over the disclosure of meaning itself. The result at its best produced a sumptuous surface on which meaning was significantly *refused*. Duchamp Path Number One led to Jasper Johns.

The Second Path—a parallel one—moves from Duchamp's wise-guy wit, from the moustached Mona Lisa and from his bottle rack and urinal as sculpture, through the opposite of hermeticism. It passes through absolute legibility. Here the picture surface discloses its meaning *instantly*. But it is the afterglow of the instant that matters here. For Path Number Two leads to a special region where cynicism and naivety cannot be distinguished, where populism and romantic decadence merge. That is, it leads to Warhol. Depending on which path you prefer, Warhol is *possibly* Duchamps' greatest pupil. He is surely Duchamp's most influential pupil.

The afterglow of the instant: with his estheticized surfaces and the pathos of the moment, Warhol is very much a romantic. He is tied up in romanticism's standard concerns, and it is through Warhol's uniquely ingenious populist recovery of late romanticism that his work really speaks. In particular, Warhol's way of knotting up romanticism's familiar unity between beauty and mortality was no casual part of his artistic identity. Warhol was fully conscious of that unity, and conscious of it early on. For him, the authority of the immediate and the authority of the posthumous were linked. One needs look only at the disaster series or the grieving Jacqueline Kennedys. An anecdote: Isabelle Dufresne, the aristocratic Factory minion who was named "Ultra Violet" there, recalls the day Warhol suddenly embarked on that series of portraits of Marilyn Monroe which so impressed little Keith Haring. It was the day of Monroe's suicide. As soon as he heard, Warhol started working. But before he slipped into the workaholic absorption people came to know, he remarked to Ultra: "Timing is everything."

The sixties are usually seen as Warhol's prime decade. It was then that

the young commercial artist Andrew Warhola emerged as Andy
Warhol—as the social and artistic phenomenon, Andy Warhol. Surviv-
ing the murder attempt not only became part of Andy Warhol's myth
but also part of his private, half-magical, half-sage sense of his own
absolute destiny.

His shy boyishness, the central and least willed trait of his personal
style, was always marked by a look of passivity and unhealthiness which
in the sixties he made seem the very visage of dissociation, dehumaniza-
tion and what is called decadence. It is a central paradox of Warhol's
career that, at all its stages, a man so very shy, so frail, so manifestly
uncertain of himself, should also have been so spectacularly gifted for
fame. . . (*"I've always had a conflict because I'm shy and yet I like to
take up a lot of personal space. Mom always said 'don't be pushy, but let
everyone know you're around.' "*) During the sixties, his means for
keeping the balance of that paradox was "cool": a slick hypnotized
voyeuristic stare and the slightly smarmy worminess of the underworld.
It was a look that inspired a great deal of slightly sickened but fascinated
talk about inhumanity, being a machine, and what you find under rocks.
(*"During the sixties I think people forgot what emotions were supposed to
be. And I don't think they've ever remembered. I think once you see the
emotions from a certain angle, you can never think of them as real
again."*)

In the middle and late sixties, Valerie Solanas had been very much in
evidence around the Factory, one of the more pathetic and driven
members of Warhol's entourage. She was a bright woman, born in
Atlantic City, a graduate of the University of Maryland, who had done a
bit of graduate work at the University of Minnesota in 1959. Then in the
sixties she came to New York, where she got mixed up at the fringes of
the various radical political movements. As time went on, it became
increasingly clear that despite Valerie's almost too-quiet demeanor,
something was wrong. She grew more and more paranoid; she was
locked more and more in unreality, fixated on a set of lurid fantasies
about the evils of the male sex, and ways to exterminate these evils.
Valerie also fancied herself a writer, and a writer with a mission. She
would expose, she would destroy, all manner of evil with her art. To this
end, Valerie wrote a play. Its title was less obscene than absurd, *Up
Your Ass*, and it had a psychopathic subject matter: a mother joins her
lesbian lover in murdering her own child. Together they chop up the
corpse and bury its pieces in Prospect Park. Warhol appears to have
agreed to read this opus as a joke. The title was *so* funny. According to
some reports, Valerie was explicitly led on by Warhol's film assistant
(and later partner) Paul Morrissey. Others claim that Valerie was simply
ignored while her fantasies ballooned. In any case she became con-
vinced that Warhol was going to make her play into a film. Her

disordered paranoiac mind soared. She was going to be a star. She was going to sit beside Andy at the best table at Max's Kansas City. She was going to make it.

Solanas' film became her obsession; she pestered everyone about it until on the morning of June 5, 1968, before Warhol arrived for the day, his assistant Fred Hughes, a man whose freezing supercilious manner was calculated to intimidate braver souls than poor Valerie, at long last told her plain and simple to get out.

As Valerie left the Factory that June morning, stinging with her rejection, recognition at last clicked into place. They were not going to make a movie of her play at all. They never had *intended* to. They were laughing at her play. They were laughing at her. They always had been. They despised her play. They despised her.

Valerie proceeded home. There the first thing she did was change into a dress. In all the years Valerie had been hanging out at the Factory nobody had even once seen her in a dress, but for some reason Valerie wished to approach what she was about to do in the full vestige of her femininity. Then, very carefully, she put on make-up. Nobody could remember seeing her in make-up either. She then took a paper bag and put into it a Kotex and two loaded revolvers. And then she proceeded back to Union Square.

Valerie did not go into the building at first, but stood waiting outside quite a long time. At last Andy pulled up in a taxi. The celebrity got out and as it happened met on the sidewalk a relatively new assistant, Jed Johnson, who later became very close to him. Warhol and Johnson walked into the building, and when they reached the elevator Valerie slipped in behind them, in her familiar quiet way. They all rode up together, it seems without a word.

In the studio, Jed and Andy went about their business while Valerie stood around pointlessly for several minutes, being studiously ignored. This was typical. Sooner or later anyone who was not a star would stand around pointlessly at the Factory, being studiously ignored. Warhol took a phone call, chatting to one of his "superstars" about John Schlesinger's film *Midnight Cowboy*, a film about a male street hustler which everyone at the Factory viewed as a commercialization and therefore a validation of Warhol's films *Lonesome Cowboys* and *My Hustler*. At this point Solanas reached into her paper bag and extracted her .32.

She lifted it and began to fire directly at Warhol, gut-shooting him repeatedly. Warhol received the first and second bullets standing, then fell to the floor when hit by the third. It is plain Valerie believed she had killed him. She crossed the room looking for her next victim, and found a visitor, the art critic, Mario Amaya. She fired two shots at Amaya, and

hit him once. When the wounded Amaya managed to get into another room and barricade the door against her with the pressure of his bleeding body, Valerie turned on Fred Hughes, who stood immobile with fear behind a desk. She had by then fired five shots: one remained in the gun. She raised the revolver and aimed it at Hughes' chest. "I have to kill you," she said. The man who had so icily dismissed her a few hours ago now fell to his knees begging for his life, begging her to leave.

At this point Solanas paused, frozen in a moment of uncertainty, or perhaps thinking ahead to her escape. She turned and walked to the elevator doors, where she pressed the button. Then she walked back to Hughes, aimed the revolver directly at his forehead, and pulled the trigger on the sixth and last bullet. The pistol did not fire; the thing had jammed. Without her weapon, Valerie was omnipotent no longer. She was frantically digging for her second revolver in the brown paper bag when the doors of the empty elevator slid open at last. "There's the elevator, Valerie," Hughes shouted. "Just *take it*." Without the gun, Valerie's madness was dissolving into fear. She bolted through the doors as they closed.

As his sixties ended, Warhol had fallen to the floor violently bleeding but not killed. He was in excruciating pain, but conscious. He remembered looking up to find one of his most loyal assistants, Billy Linich, kneeling beside him and sobbing. Warhol mistook this sobbing for laughter, and that "laughter" in turn made him begin to laugh, which made his pain all the more anguishing. Blood was now soaking his clothes, and he begged, *"Don't laugh, Billy. Please, please don't make me laugh"*. When his breath began to falter, Hughes gave him mouth to mouth resuscitation, an action which Warhol, who had his own special sense of gratitude, never forgot; it helped Hughes retain his position managing Warhol's empire in later years when relations grew strained, as they occasionally did.

Warhol was taken by ambulance to Columbus Hospital, later Cabrini Hospital, on East 19th Street in Manhattan. He arrived semi-conscious. He was aware of the emergency room: he remembered hearing doctors muttering that there was no hope and remembered his own people shouting at the doctors that their patient was very famous and had lots of money. Then Warhol was swept into emergency surgery, where he lost consciousness. Both of his lungs, his liver, his esophagus, his stomach, spleen and that gallbladder had been punctured or grazed by the bullets. On the surgical table his heart stopped beating for some considerable time: at this point the surgeon opened his chest and revived him with heart massage.

He had been brought back from that death from which he saw himself reprieved. He spoke often about his Lazarus-like passage at

Columbus Hospital, this Coming Back, addressing the subject with his strangely unexpected little-boy eloquence. *"For days and days afterward I wasn't sure if I was back. I felt dead. I kept thinking 'this is what it's like to be dead.'"* Or: *"Being that close to death is like being that close to life, because they're both nothing."* Or: *"Before I was shot I always thought I was more half there than all there. I always suspected I was watching TV instead of living life. Right when I was being shot, and ever since, I knew I was watching television."* And: *"I wasn't afraid before, and having been dead once I shouldn't feel fear. But I am afraid. I don't understand why."*

After she left the Factory that day Valerie Solanas turned herself in to a traffic policeman in Times Square. She was committed to Elmhurst General Hospital in Queens but was shortly released, prior to going on trial. Before her trial began, she telephoned the Factory to demand money for her "losses," and threatened to come and "finish the job." She was later charged, presumably with attempted murder, declared mentally incompetent to stand trial, and sentenced instead to three years imprisonment for first degree assault, which time she served. *"Less than if you steal a car,"* as Warhol remarked. When she was released in the seventies, she saw herself as a woman with a mission of vengeance. Several such missions, in fact. For years, Valerie continued to dispatch letters and calls threatening to murder not only Warhol but a number of other people in the network of oppressors upon which her paranoia had seized. Warhol now had to live behind locked steel doors. His path to taxis and elevators had first to be checked by his assistants. Nobody now was permitted near him who had not passed through the elegant but unwelcoming surveillance of the minions in the outer offices. Meanwhile, Valerie sank deeper and deeper into psychosis. In time she became a kind of bag lady, drawn by her disease into muttering helplessness. She faded as a real threat, though Warhol remained afraid of her for the rest of his life. Valerie Solanas died about a year after Andy did, in 1988.

A year after the event Richard Avedon made a set of photographs showing Warhol's scars: portraits of a wound, as it were. Playing exhibitionist rather than voyeur, Warhol hoists his leather jacket and we see an eyeful of skin, a lurid cross-hatching of pits and incisions and chest-wide sutured slices. It all has a decidedly Frankenstein side. In the picture that shows his face, Warhol gapes at Avedon's camera in ghastly bewilderment. His expression is somewhere between that of a little boy showing us where it hurts, and one of the Undead startled in the midst of some hideous *toilette*.

With the murder attempt, a door was slammed in Warhol's world. A sector of society, a part of New York that once had been indispensable

to his ideas, was suddenly and permanently locked out. Simultaneously, a certain phase of his art, the making of what he would call his "Pop Statement," was complete. And with that change, there seemed to come an end to what had been original in Warhol's work.

Warhol the artist was a social creature, a sort of wordless, parvenu Proust. In his reactive way, he was one who played with the infinite gradations of social standing on what the New York of the 1960's used to call the scene, and which I would prefer to give the old-fashioned name of Bohemia.

The *vie Bohème* is a mode of living that modernism retained from the romantic movement. In America its capital is certainly New York, and its gradations are complex. For purposes of discussion let us neatly suggest that all Bohemia, like Gaul, is divided into three parts. Let us call those parts Upper Bohemia, Middle Bohemia, and Lower Bohemia. There might also be Outer Bohemia, but Outer Bohemia is too bleak to visit. That is where uninteresting dying drug addicts live with end-stage alcoholics, runaways, the insane, the most wretched of the homeless. Outer Bohemia is Desolation Row.

Upper Bohemia on the other hand is a place Warhol adored. It consists of that branch of Cafe or gossip society which is very monied, very fast, very famous. It is the land of Mick Jagger and Madonna, and it is the capital of vanity, dedicated to unabashed narcissism, celebrity, and self-love. It is filled with stars and stars' acolytes. The key to Upper Bohemia is fame and its *modus operandi* is the service of collective self-regard. In it live many (but by no means all) stars, almost all "leaders" of high fashion, and almost everybody whose name appears with any frequency in the gossip columns. Occasionally, but very occasionally, a genuine artist is actually able to stomach Upper Bohemian life. Proust and Cocteau could do it. Truman Capote could do it too, at least until his demons began to complete their conquest of his soul. Warhol survived Upper Bohemia's perils much better, and he created his magazine *Interview* in order to serve its dreams.

Middle Bohemia on the other hand Warhol visited rarely and reluctantly. In truth, he hated every brick. In Middle Bohemia, artists claim to be distanced from the mainline middle class not by style but by an *idea* of some sort, some actual *belief* concerning something other than themselves. Almost all artists and almost all intellectuals, certainly all left-wing intellectuals, live in Middle Bohemia. So do most literary people; so does much of the academy. The publishing industry, insofar as it is an intellectual and literary enclave, is mainly Middle Bohemian; so is much in the film industry: most screenwriters, directors, even some of the more self-aware stars. Middle Bohemia has a number of classic habitats: Greenwich Village, Soho, Schwabing, the Left Bank, the

south of France, East Hampton. Among painters, its venue is not the chic club but the classic painter's talk bar, and it can be recognized not by the vanity of fame but opinion. The sound of talk is how you know you are in Middle Bohemia.

Warhol detested it. For Warhol, that talk was what you heard in the hated Cedar Street Tavern among the Abstract Expressionist painters around de Kooning and Pollock, the "real men" who he was so sure despised him for being "a sissy," or "commercial," or liking "pretty" art. In a certain sense much of his entire social existence can be seen as a reaction against Middle Bohemian attitudes.

Talk, talk, talk. Part of Warhol's hatred was that he saw Middle Bohemia as literary and "verbal" in a way that he insisted he was not. He clung to the apparently sincere belief that he was "non-verbal" and a poor talker. Likewise, it was a closely held secret, not thought fit for his image, that he was a constant habitual reader of books; in fact, he was one of the best- read visual artists of his generation. The business about being a poor talker was another of his most essential defenses. If he really believed it, it was a curious misjudgment. In fact, the Andy Warhol I remember could be a perfectly enthralling talker, who like many gifted talkers was also an indefatigable gossip and (as everyone knows) a very considerable phrase-maker. In fact, he joins Pablo Picasso as the best artist-aphorist of this century.

Picasso meanwhile is the era's last-word example of the Middle Bohemian as absolute success as a painter. Picasso's allergy to Upper Bohemia was as intense as Warhol's hatred of Middle Bohemia. The Spaniard studiously avoided even seeming to play ball with Cafe Society, still less with high society. (Picasso's brief stint there, led by his second wife Olga, was a hated failure). Picasso saw the life of his work recording a struggle in consciousness; he saw himself as a card-carrying charter member of what Lionel Trilling called the Adversary Culture. He saw himself at perpetual war with the middle class from which he came; he was absorbed in the vocabulary of "revolution." Warhol did his best to look "apolitical," although in practical fact, like that love of books he so carefully concealed, he was a practicing Roman Catholic a bit to the right of center. Picasso saw his whole strength born in his capacity for refusal, the virile force of his fierce middle Bohemian *no*. As for our Andy, he saw things in a very different way: *"all is pretty."*

So Warhol detested Middle Bohemia. Lower Bohemia, on the other hand, was the place where Warhol found his art. Lower Bohemia is the land of the more or less inspired outcast. Drug addicts. Transvestites. Alcoholics on the downward decline. The interesting insane. Hustlers. Flamboyant hopeless geniuses beyond the pale.

It is an intensely romantic place. It looks for meaning not in ideas but ecstasy, driven not by Upper Bohemia's vast system of vanity and chic

or Middle Bohemia's talky narcissism of ideas. Lower Bohemia runs on hopeful dreams and a narcissism of doom. It specializes in the rhetoric of the wild lost soul. It is filled with interesting people who see themselves as excluded from everything desirable except their own forbidden ecstasies. The resident of Upper Bohemia finds his excitement seeing himself as in the Happy Few. The resident of Middle Bohemia, as in the Right. The lower Bohemian sees himself as in Hell.

Warhol was absolutely mesmerized by life in Lower Bohemia, and he filled the Factory with its most striking denizens. That is where Ondine came from: *"the most interesting person I met during the sixties."* It is also how Valerie got in. Warhol probably did more for Lower Bohemia's cultural standing than any figure since Baudelaire, who likewise loved Lower Bohemia and who is one of the inventors of its romance. This is the world of Warhol's films, above all of his strongest film, *The Chelsea Girls*. Indeed, the Chelsea Hotel on 23rd Street in Manhattan for many years served as the Plaza, the Connaught of Lower Bohemia.

Orchestrating a new link between Lower and Upper Bohemia was the heart of Warhol's social enterprise in the sixties. In the old Factory, Lower Bohemia is what Upper Bohemia came to look at. What Warhol rigorously excluded from everything he touched and did, publicly at least, were the "intellectuals" in the middle. In the early days, it was quite common to hear intellectuals denouncing Warhol as mindless, decadent, dehumanized, the enemy of art. In these complaints one could sometimes hear protest against the insult to them obscurely felt in Andy's presence. It was correctly felt: the snub was Warhol's vengeance, born in his passivity, for the humiliations of the Cedar Street tavern. And it was central to Warhol's entire strategy as an artist in the world.

Which brings us to the question of his art in the world. It seems to me that *as an artist*, Andy Warhol was a remarkably talented and ingenious man who in his entire public lifetime had one and only one true idea. But in his hands that idea became a tremendously interesting one. It was (so far as I know) original to Warhol. Certainly it was one to which he was particularly well suited. It is *essentially* one idea, *essentially* singular, though Warhol played with it in many ways and in a number of media, including film. It assumed a hundred different faces.

This concept consists of one deeply absorbing insight into something that I shall call here visual power. Though many do, I do not see it as based in the so-called esthetics of the banal found object. There is nothing banal about the *Disaster Series* or the *Race Riots*, or Warhol's portraits in series. What counts instead is the images' *power*, what a given image is capable of exerting over the mind.

So far as I can determine, this concept fell into place in Warhol's mind somewhere around the time he turned thirty and the country entered that decade of convulsion that began with the inauguration of John Kennedy: the convulsion that brought among others Edie Sedg- wick to his door. Until that time Warhol had been a commercial artist in Manhattan; he was somebody whose task it was to make things look interesting, make them look pretty. By 1960 Warhol had spent eleven years at it; he had gotten to be very good at it. A big success. But then "The Statement" clicked into place, and the way it clicked had the quality of self-discovery, a life-long search realized. It transformed him and his entire life; it made him a gallery artist and a very famous one at that. The Statement left its mark on the mind of the culture like the afterburn of a flash. Now that immediacy is past and the works have become part of that thing called history which Warhol so resisted and despised. That is why it is worth recalling once again just how startling and suggestive those works once were and how powerful they remain: *The Gold Marilyn* (1962); the *Disaster Series* of 1963 and 1964 (works such as *Five Deaths Eleven Times in Orange*, or *Suicide, Purple Jumping Man* or *Saturday Disaster*); his "portraits" of the electric chair; *The Triple Elvis* (1963); and, among the films, *Kiss* (1963) and *Sleep* (1963) and *The Chelsea Girls* (1967).

Once seen, these works are not forgotten. They stop us on the spot; we recognize them instantly; they seize us as we sink into them. It is true that their primary impact is one of a perfectly astonishing visual immediacy. Of course time has worked its changes on that momentary immediacy. When the work first appeared it was distanced only by Warhol's estheticism. We were not used to looking at Marilyn Monroe's face in all its frank frontal immediacy made at once more striking and more remote by Warhol's transformations of color: the changes he could ring on that single face. But with the passage of time, and above all with Warhol's death, the interplay between distance and immediacy is complicated by the look of history. In the great Warhol retrospective at the Museum of Modern Art in 1989, I myself was surprised to discover how authoritatively his work stood up, how well it had survived its author. Not only did the work look good, it looked good in a rather new way. How to describe it? Well, it looked "real," it looked like "real art." What seemed strongest about it was its sumptuous visual presence, while the formal ingeniousness that had seemed at first so interesting had rather faded. It had picked up the patina of historical standing.

Ordinarily when we look at a given image there is a certain passage of time required for primary comprehension. There are five, or maybe fifteen seconds (thirty would be a long time) during which the mind is simply identifying what it is seeing. In Warhol's case time required for recognition is reduced to something instantaneous. We get it, always,

right away. I am speaking of that absolute legibility on Duchamp's second path. These are some of the most famous faces in the world, Marilyn and Mao; these are the universal commonplaces of brand names or things universally known: the mushroom cloud, the electric chair. The images are often horrific, as for example the execution chamber in Sing Sing or the torn body dangling from the wrecked car in *Saturday Disaster*. Whether awful or inane, every image invariably asserts an intense graphic frontality which would hit us smack in the eyes were it not modified by Warhol's counter move against its power, his voyeur's transformation. That frontal, overmastering, universally famil- iar content is distanced and subdued by Warhol's estheticizing—I almost said prettifying—stare. "*All is pretty*," blinks the bland master. Taking in the raw immediacy of his primary image, Warhol used all the techniques of immediacy and distance he acquired as a commercial artist to subdue the picture's unvarnished arrogant strength and establish it in an unnameable esthetic distance. (It happens to be a *colored* distance). *This* distance is uniquely Warhol's own.

The game here is power. The back and forth of Warhol's work is always a subtly eroticized interplay of active and passive terms, a subdued encounter with *energy*. The endistanced immediacy, the sub- dued potency of the work is precisely that of the man who could say, "*My conflict is that I'm shy and yet I like to take up a lot of personal space.*" And, "*Once you see the emotions from a certain angle you can never think of them as real again.*" Angle? it must be said that this angle is very much the same one that makes the almost unbearably repellent *Saturday Disaster* what it is: an exceedingly beautiful but almost unbearably repellent picture.

Before his death a leading question among his detractors was whether Warhol's work was art at all. The question deserves response, all the more because Warhol's reputation is hedged round by a discussion of art's end. Yet one turns to it with a heavy heart.

It seems to me Warhol's work is plainly art and moreover art of, if not the very first rank, at least a very high order. It is powerful and it keeps its power. It speaks. It is interesting to look at and it is interesting to think about. It is linked to the principal questions that trouble and drive art in the twentieth century. Deep in its paradoxical distances the "frivolous" art Andy Warhol produced during this period trafficked in themes of major dimension: what it means to see feelingly, what it means to fear what you want to see; the wit and the visual power of fame, beauty, death, and terror. It is a little difficult to see what more might be required for the accolade.

And what about the mind of the man who suggests all these philosophic reflections? Warhol's mind was neither naive nor unedu- cated, but it *was* thoroughly intuitive and passive. In fact, his was the

most powerful essentially passive mind I have ever encountered. *"I do not seek,"* Picasso is reported to have said, *"I find."* Warhol was found by the idea that became the dominating concept of his art. Before it took him over he was a talented wistful successful commercial artist in Manhattan. Once it had passed through him, he became Andy Warhol, professional celebrity. In between, Warhol the perfect vehicle for a certain idea, which passed through his life like a cold storm. It was as though the Statement had found *him*. In this fey, talented, ambitious, neurotic poor-boy, it came upon exactly who and what it needed to get said. It found power locked in shy passivity; it found a hand uncannily talented; it found an exceptionally sensitive intelligence that thought nothing and responded to everything; and it found a capacity for absolutely unstopping hard work. The idea became Andy, except that ideas do not have autonomous life. It was, and it was not, all Andy.

Before that event, Warhol had been living in New York with his mother, successful enough to own a shabby but genuine town house on upper Lexington Avenue, designing shoes and doing commercial art. He was a classic Manhattan type: gay, slipping around the edges of fashion, publishing and gallery life. A freelancer forever on the freelancer's round of art directors. At night he slipped around the New York night world, notably the San Remo Bar where he met those members of its underworld, those leading lights of lower Bohemia who would become an essential part of his idea of who he was and from whose company Valerie Solanas would emerge with her gun. As for the Statement, it was bigger than Warhol. It seized upon him and shook from him seven or eight years of art: it possessed him. And once it had passed through him it tossed him aside, a famous man. Through it he could continue to imitate himself, but after it was articulated he never again found a new departure of comparable interest. *"I would like to make more art movies"* he once said to me. *"But I don't have any ideas. Do you have any ideas?"*

I told him I was terribly sorry but that when I tried to concoct a new Andy Warhol movie, I didn't have any ideas either.

"Oh," he said.

Warhol began to attract an entourage at an early stage of his fame, right after his first New York show at the Stable Gallery in the fall of 1962. In the winter of 1963, he acquired a huge loft space on East 47th Street and named it "The Factory." It was also around this time that Warhol became an amphetamine addict, starting with a quarter pill each day of Obetrol, which he took as a "diet pill" after some magazine picture had made him look fat. The regimen of a quarter pill a day was short. The Lower Bohemian drug of choice at that moment was amphetamine and

the Factory was soon filling with its more interesting addicts, while the Obetrol gave Warhol himself what he needed to drive deeper into his already compulsive habits of work. And with all those wonderful extra hours he could play a little, too. *"I slept only two hours a night from 1965 to 1967."*

He had an impressive eye for people, a sense of their secret star quality, and with the coming of fame and amphetamine his dissociated voyeuristic vision began to include people. People became the images whose power compelled him; people were beginning to absorb his stare.

The terrible story of Edie Sedgwick is of course the *locus classicus* of this fusion. It has been wonderfully told in Jean Stein and George Plimpton's book *Edie*, and it leaves one hating the man. An upper class girl, who therefore has access to Upper Bohemia, is led by Warhol, by her self contempt and by her drug addition into a wild immersion in everything Lower Bohemian. Edie became the spectacular emblem of their meeting. And she became the icon of self destruction that went with it.

In his partly ghostwritten book *Popism* Warhol actually addressed the question of his guilt. *"Now and then someone would accuse me of being evil—of letting people destroy themselves while I watched just so I could film them and tape them. But I don't think of myself as evil—just realistic. I learned when I was little that whenever I got aggressive and tried to tell someone what to do nothing happened—I just couldn't carry it off. I learned that you actually have more power when you shut up because at least that way people will maybe start to doubt themselves."*

There seems something sincere in this statement. Unimpressively sincere, but sincere. As the bodies fell around him, the man who had discovered the "angle" from which the emotions are not real, did what he always did: *watch*. His defense is the classic defense of the passive: *there was nothing I could do*. It fails to answer the obvious counterclaim: *you could at least have tried*.

Except that Warhol never, under any circumstance, tried.

The death of Edie Sedgwick is an event parallel to Valerie Solanas' attempt to murder him. It is its inverted twin. He is of course far from entirely responsible. One of the most compelling aspects of the Edie Sedgwick story is how many collaborators there are in just one ruined life. What fascinates is Warhol's exemplary availability for the role, the unsettling integrity with which he showed how its moral dilemmas are fused with his style. He claimed to have felt for Edie Sedgwick something *"probably very close to love."* This "love" was the lock of the voyeur on the exhibitionist. He claimed to have been "sad" when the bleak, blasted, last end came for Edie. It was a mighty mild sadness.

The prod to action is desire, and the way to maintain passivity is to conquer desire. Desire is what tempts us into the rough and tumble of

being human. *"As soon as you stop wanting something, you get it. I've found that to be absolutely axiomatic."* There is an unsettling wisdom, the wisdom of half-truth, in this remark. The young Warhol turned his shyness and fear into a kind of will. The other side of his cool, all that passive not wanting is, of course life, appetite, danger, love. That is what we see transformed in the pictures: hope, excitement, love, loss, terror, all denied. It would be interesting to know the moment when it dawned on the scared talented mama's boy from McKeesport that his incapacities and his fears might be the very mirror of art. I bet it all happened very quickly. It must have been an exciting moment, even for somebody who had learned not to care.

Stargazer first appeared in 1974 and now enters this third edition, the first since Warhol's death. It speaks of a Warhol still alive. It begins with the fated little phrase, "These days. . ." *These days?* These days have become those days. I have left in place all my original eager references to "now," to the way things "are." I have left in place my confident present tense even though its immediacy is now past. Eliminating that once fresh and now dated tone would have meant re-writing everything, and being a bit false to it too. Let it stand there in the distance to which time has consigned it. Warhol was this century's great artist of immediacy and distance; the cool master of its pathos, its ingenuity, its cruelty. So be it. As time bears both Warhol's presence and *Stargazer* into the past, that perpetually renewed distance will serve as another occasion to recall what he was: the reversed mirror of wanting, the stilled surface of power.

The End of the Other World

●●

"I think we're a vacuum here at the Factory. It's great."—*Andy Warhol*

These days, people speak wistfully about the "old" Factory, where Andy Warhol created his myth and his world. Like the Great 1960's Scene, of which it was the art world's center, the "old" Factory is gone. From 1960 to 1968, the silver-covered other world of Warhol's loft on East Forty-seventh Street functioned as the place where interlocking subcultures of the late 1950's—artistic, sexual, sometimes even criminal —were able at last to surface into the bright glamour of the 1960's afflu-ent chic. The "old" Factory has been replaced by a "new" one—large, sleek business quarters in an office building on Union Square West, a very different region of the mind, indeed. All those fantastic parties, all those beautiful people, all those drug trips that were so much "some-thing else": Gone. The sense of being at dead center of the *Zeitgeist,* the head-filling intuition that one could hardly make a wrong move—it all seems to have come down with the silver paper, been thrown out with the five-foot plastic candy bars.

Access was easy during *la Belle Epoch,* all you needed to do was get into the freight elevator (the Factory had once been a real factory) and

3

groan with it to the fourth floor. The silver room was crowded with a-heads, street geniuses, poor little rich girls, the very chic, the desperately unknown, hustlers and call boys, prostitutes, museum curators, art dealers, rich collectors, the best artists of the time, and the worst hangers-on. Within those silver-covered walls, all the dreadful things outsiders imagined were really done with the air of kids squirting each other with garden hoses. The people "in" thought the place had everything: intensity without demands, class without snobbery, glamour without trying. Not to mention a lot of sex, a lot of art, a lot of amphetamines, a lot of fame. And a door that was always open.

The elegant "new" Factory is reached by means of a passenger elevator that, when its door opens on the sixth floor, confronts one with another, bolted, steel-covered door inscribed with this sign:

KNOCK AND ANNOUNCE YOURSELF

Inside, sunlight pours in on polished hardwood floors, and near the high windows are two desks with sheer slate tops, floating rectangles that give the impression of being at once ephemeral and immovable. Nearer the door is a desk of hammered brass, a small triumph of Art Deco (Warhol is an ardent devotee), perfectly placed, an ideal collector's item. Though one of the Factory's numerous white telephones is on the desk, you hardly dare sit down to place a call. There are no smudges on the brass; the glass top is flawless. As for the atmosphere of freedom in this new place, there is no such atmosphere. Light a cigarette and you'll fret about the ashes. Sleek, even lovely, young men in their middle twenties move quietly from desk to desk, phone to phone, trying to maintain a look of bored languor while, in fact, they cope with the pressures of a small but promising American enterprise, Andy Warhol Films, Incorporated. Like the new Factory, most of these people are "new." Most never saw the legendary old place. Most have never seen Warhol's early films. They have a job to do; they do it. There are no paintings on the walls.

Beyond the reception room is a long screening room where some flavor of the old Factory still lingers, just a touch. The furniture is at least a little battered; a beat-up vinyl-covered couch serves as the first row before the screen. To one side is a small editing room; occasionally the lush silence is broken by the squeals of Jane Forth or Jackie Curtis as their celluloid images spin through the Steenbeck beneath the editor's patient, methodical hand. It's the only sign of any freak inhabiting the place. A little farther back is a cubicle painted not silver but white: it is Warhol's office when he is there. But Warhol is not there very often.

The old Factory was about decadence, about the wasted pallor on Warhol's boyish face, about his silence, his affectless gaze, the chic freakishness of his entourage, about all the things he was able to endow with the magic of his fame and transform into the image, par excellence, of a subterranean world of beautiful people and geniuses and poseurs, the obsessed and the bored, come at last into their glamorous own. To the people who gathered around him, Warhol *was* fame; he shed fame's redeeming light on them, and they basked in it, refugees from an invisible secret world that had been growing and steadily defining itself through the late 1950's. One senses that, in those days, a thrilling complicity united the artistic and sexual and drug subcultures, that some kind of shared refusal threw together mute *seriosos* like the composer LaMonte Young with hardened, quick-witted, druggy street performers with names like Rotten Rita, Narsissy, and Ondine, people living on drugs and their wits, doing their numbers in bars and apartments and lofts, of the existence of which the straight world had only the merest dreadful intimations. Men for whom the flamboyant pose and a tongue like lightning were the only life found themselves in a department of limbo adjacent to middle-class artists. On the one hand, there were the money and established conspicuousness of Pop; on the other, that *really* underground subculture, the transvestites. Pale, softspoken young men with jobs sorting mail in the post office, who came out at night transformed by Marilyn Monroe wigs and make-up caked on their faces, their thin bodies twisting in outlandish thrift-shop gowns and sequined stockings, shrieking and vamping in one of their havens, passing the drugs that would keep them awake during the next grim day when they showed up at work in Klein's dacron sport jackets and stringy worn-out ties. But at night they found themselves in "heaven," some invisible bar on the Lower East Side, where a beefy mafioso stood guard at the door, his teeth mauling a cigar.

Warhol certainly wasn't the first artist to enter and use this world; the cryptic, obsessional film-maker and aesthete Jack Smith, for example, transformed it into a cinematic swirl of rococo flesh in *Flaming Creatures* with a camera as sinuous and violent as Warhol's was withdrawn and still. Throughout the late 1950's, the links between the subcultures had been articulating themselves, and film-makers like Smith had established a popular association between underground art and the sexually misbegotten. Yet the *avant-garde* was larger than that: Warhol was the one man who, in his silent way, moved through all its realms, the one man obsessed with those festering underworlds who

had also managed to become rich, famous, established. He turned and admitted the outcasts to his world, made them part of his establishment. They became the image of this master of image. Within the silvery walls of the Factory, they became visible, and one of the central cultural images of the decade.

Because the image worked. With its hierarchies, its stars and leaders and followers, with the aggressive, enthralling secret knowledge outcasts share with one another and the sense of an awful isolation somehow redeemed within those walls, the Factory inverted the traditional subculture's role: While the little world mocked and mimicked the big one, the big world looked on, fascinated, making the Factory shine under the spotlight of its attention. The audience out there became part of the scene; everybody in the Factory knew he was being watched, and a glowing, theatrical self-awareness was built into the place's very life, endowing its most casual actions with a sense of moment. You couldn't make a wrong move; every impulse signified. That was Warhol's gift—he made everybody in his world watched. And what is being watched has a meaning, even if it's only the meaning of being watched.

At the height of the "Scene," the Factory's society was a firmament, a revolving social universe of concentric circles. At dead center was the pale sun Warhol himself, immediately flanked by the two men who made the Factory work. The most conspicuous of the two was Warhol's "assistant" Gerard Malanga, the hyped, endlessly talkative golden boy of the art world, with his superb arching Italian face, combination superstar and errand boy, the omnipresent voice and body of the master, transporting just a touch of Warhol into every night, the depthlessly narcissistic center of every scene. For six years, Malanga must have attended five parties a night, either in company with the art world's super star, or as his magical representative. Then there was Billy Linich (who restyled himself Billy Name), another hyped, torrentially verbal young man, who, after a life on the streets, actually designed the Factory, put up the silver paper, and brought in the big couch, the only person ever really to live full time in what seemed almost his domain. At the next remove in this little universe (the orbit of Venus, I suppose) were women bathing in the light of ultrahip, feminine mainstays like Baby Jane Holzer in 1964, Edie Sedgwick in 1965 and 1966, Tiger Morse in 1967, Susan Hoffman (Viva) in 1968, women who, thanks to chic, or money, or beauty, or luck, got as close to the sun as any woman could before drifting into an outer darkness that could be very black, indeed. (Edie Sedgwick died of a barbiturate overdose in late 1971.) And, around each of these heavenly bodies, friends, lov-

ers, connections revolved in tiny epicycles, often with very unstable orbits. In the next circle were superstars, collectors, models, beautiful people, hangers-on, who, if not *"very* close" with "Andy," were still definitely part of the entourage, privileged to make their entrances in tow with him at all those right places at the right time. Just beyond that sphere came an invisible but all-important Van Allen belt of the solar system: the media—with their flashbulbs and TV lights and tape recorders. Whoever came within this sublime circle of media technology could hope for fame; admission was not easy. But outside it were Warhol's intellectual and practical allies: Jonas Mekas, Henry Geldzahler, Ivan Karp, Leo Castelli—dealers, theorists, "important" admirers. Then, in the outer circles were found the people who had only managed to get in the door: the curious, the bewildered, the a-heads looking for a drop, the homosexuals who wanted to see the capital of homosexual glamour, the kids on the lam, the intellectuals trying to figure out what it all means. Not quite in outer darkness, but just about. Stars flickered and fell; egos and careers trembled. "No one could get too much power, be a star for too long," recalls one who was there. "Everyone had a limited time span." When Warhol arrived, usually in the late afternoon, one's whole house of cards might fall if the master didn't smile his "oh, hi" as he drifted by.

Warhol is one of the masters of passive power. During the 1960's, he made himself into one of his own objects: tawdry and brilliant, unmistakable, instantly grasped, but with a resonance that kept flickering at the edges of attention, his image seeming to build meanings that then fell away like static in fantasy that seems to come and go at once. Or, to change the figure, meaning seemed to attach to him the way it does to a single pale light bulb burning at night in a deserted courtyard. This unreadable, obscure sense of meaning in his passive mutism gave him both his fame and, in the entourage, enormous power. Endlessly proclaiming its independence, endlessly rejecting any ordered center of focus, the youth culture was, in fact, by and large made up of very dependent people. And, for that reason, the people in it faced a dilemma that Warhol's passivity resolved. In his presence, security could shine on the happy few—"oh *Andy*, of *course* I know *Andy*"—the fleshly love thud of recognition, status, a place to be and belong, were available without the slightest apparent demand being placed on anyone. The paradox provided Warhol with enormous power. Shyly and sweetly—in the language of a five-year-old—he could make and break at will, arbitrate all. As with the monarch, proximity to the Presence was everything. And, if that redeeming Presence could be given, it could also be taken away.

I myself think he turned the trick by replacing the dimension of
Personhood in himself with an exaggerated dimension of Presence.
In his life and in his art, "Presence" is Warhol's prime theme; he ac-
quired his own spooked undismissable version of it by successfully
giving the impression that, for all his delicate charm, he wasn't really
a person in the ordinary sense of the word, certainly not a person like
the rest of us, who reveals his desires and satisfactions and distastes
with every move, for whom the incarnation in the world, the body and
face and hands, is animated with whatever sustains one's life and
makes it a life. Warhol seemed not to have a personality in this sense:
Instead, he had a persona; his actions revealed not so much who he
was, but *what* he was. He was Andy Warhol, that phenomenon, Andy
Warhol. The movements of desire, the impulses that connect, that ar-
ticulate the personality—that *are* the personality—seemed in this man
to be entirely lacking. He was somehow a being without needs. One
gazed at him in amazement—for almost ten years, a half of society
gazed at him—bewildered, perhaps repelled, but secretly enthralled at
his liberation. "I still care about people," he said, "but it would be so
much easier not to care. . . . It's too hard to care. . . . I don't want
to get involved in other people's lives. . . . I don't want to get too
close. . . . And I don't really believe in love."

That pretty much laid it on the line. At the center of the Factory
was a wonderful, all-resolving, innocent wickedness that didn't really
believe in love. A dire, lousy liberation, but a liberation; what's more,
the awful undertow somehow got lost in the sparkling presence. One
looked and suspected: True enough, there's something awful about it,
but *look* at him. Maybe he *has* beaten the game; maybe it really
doesn't hurt any more. At moments, Warhol seemed not a problem,
but the solution to a problem.

His much-flouted images of the perversions were somehow bound
up in that solution. I'm thinking not of homosexuality, but all the other
craziness. For years, Warhol and Malanga went everywhere in sado-
masochistic drag; black leather jackets and high boots were central to
the image. Later in the 1960's, all Malanga's narcissism was at last able
to twist itself out in a tour with the Warhol rock band, the Velvet Un-
derground (its very name lifted from s-m patois), writhing through his
famous whip dance, dressed from top to toe in black leather, a huge
bullwhip in his hand as the light show flared in the darkness. A vicious,
theatrical horniness seemed to triumph over lovelessness.

It seems the two phenomena of s-m and chic are so often joined
that one can almost speak of the link as traditional, traceable through
the history of style for at least a hundred years. It's got something to
do with the nasty, snobbish, exploitative sexual games supposedly

played by the bored, decadent leisure class, something to do with the vicious inverted elitism of Satanism, something to do with the theatrically alienating, dissociating, *object-forming* look in the sadist's ferocious style and presence. It combines preciosity and brutality, just as, psychologically, s-m so often combines cruelty with sentimentality. S-m is theatrical sex par excellence, simultaneously superficial and intense, which is ideally suited to chic. Whatever the precise nature of the link (I leave the matter to whoever writes the magnum opus on the etiology of chic, which might be an interesting book), the 1960's certainly went in for it in a big way, from Warhol to the Rolling Stones.

I suspect that the Factory's theatrical sex somehow struck, in society, that nerve of fear that fascinated and awakened a shocked response that felt like a presentiment of things to come. As with garden-variety homosexual dread, the thrill of revulsion feels like impending change, not merely in one's life but in the life of man, no less: "They're everywhere, taking over." The Factory played its Satanism with style, and was admired for something that seemed dire and real. Which makes it strange to talk to these dreadful Satanists now; Ronald Tavel, the scenarist, his hair tied in an Indian headband, speaking quietly, with an elegantly considered academic manner. Ondine, most brilliant and vituperative of the superstars, his irrepressibly flammable temperament modified by a peculiarly impressive ethic of honesty and intensity. Malanga, boyish, almost shy. Or Warhol himself, with his childlike charm, amazingly attuned and warm. One wonders—maybe it was *all* illusion. Maybe what this society saw in the Factory was nothing but itself, smeared as in the curved mirror that greets you now, stepping out the elevator to get to the new place on Union Square.

❄ ❄ ❄

A snapshot. It is 1966. The elevator moans to the fourth floor; the silver door is pushed open. In the middle of the silvery haven, Edie Sedgwick sits on a huge quilted red couch, her face warm but sharp, her eyes alive. She smokes a cigarette, sips a Pepsi. People in groups talk or romp, and the whole place is hollowly resonating with Maria Callas in *Traviata*. Two goofy-looking girls in one corner are taunting a beefy-looking young man in blue denim. A hustler who doesn't yet quite know where he is, his foursquare face bewildered. Around the turn of the L-shaped space, Warhol sits on an old trunk, watching one of his own films. Chewing his gum, he stares at the nearly unchanging image, one hand lightly lifted toward his chin, his fingers trailing on his skin. He seems utterly self-contained, at peace; "a Buddhist who has achieved the desired transcendent state," as Tavel has described Warhol watching his own films. Back in the main space, Linich greets the

newcomers and plunks one under a key light before a permanently installed Bolex. A reel of film is run through; a film portrait has been made. Nothing is happening. It is Linich's incessant task to record it. Then caterers arrive. The elevator unloads a rock band, which begins to set up. There is to be a party.

A party. During the mid-1960's, it became fashionable for the more hip art galleries to throw a new and more extravagant bash for every opening: The entertainment tabs at Castelli and Pace Galleries must have resembled receipts for paintings. (Certain restaurants were also social anterooms to the "Scene," principally Max's Kansas City on lower Park Avenue. It's reported that the monthly bill there for the Warhol entourage was regularly over $3,000.) They just don't make parties like that any more. A huge loft space would be thronged with many hundreds of people; the pop records at a deafening decibel level alternated with a live band amplified to speaker-ripping intensity. In the "environment" thus "totalized," very conspicuously beautiful people preened as one had never before thought it possible to preen, part of the vast heaving throng, flesh dense as an orgy or the subway at rush hour. What was being celebrated? Why, the party, of course. The parties at the Factory (*crème de la crème*) grew progressively grander: Baby Jane Holzer and Ethel Scull, poor lightweights, had to give way to the *real* movie stars—*at last!* the stars!—mingling with the street freaks and Warhol superstars. Jonas Mekas remembers Judy Garland and Josef von Sternberg engulfed with Tennessee Williams in the palpitating crowd that had eyes for none but the home-grown glamour—Ingrid Superstar, Mario Montez, Ondine—faces that Garland could not quite place. Montgomery Clift was leaning against one of the silver walls as the Beautiful People swept by, unnoticing.

Absurdly enough, those unreproduceable parties of the 1960's, irresistible and grotesque, stick in my mind as the image of what the decade was all about. Certain events are good because a lot happens: The right people are brought together and the atmosphere becomes dense with interchange. But, outside the inevitable sexual action, nothing ever happened at the bashes I'm thinking of. Those jangling, throbbing lofts were nothing but theaters for their own ebullience; like Warhol himself, they were the merest Images of themselves. They witnessed themselves in the blackness, dancing out their existence beneath strobe lights that make you inhabit the space anew, transport you into a flashing new medium of existence itself where every twist of the hand, every turn of the thigh, every toss of the head seem somehow touched by the magical, diffracted grace of a new, perfected otherness.

* * *

The least theatrical of all the central figures was Billy Linich, the man who actually ran the strobes and invented the light shows, who took the hundreds of thousands of photographs (literally) of visitors to the paradise of narcissism, who made them sit for their film portraits before the Bolex. As Warhol was passive and conspicuous, Linich was active and inconspicuous. As Warhol was silent, Linich was torrential with the a-head's volubility. As Warhol was at the center, Linich was behind the scene. Within that endlessly ingenious Chinese box of narcissism that he had designed in the Factory, its walls silver mirrors, Linich tinkered, perfervid with amphetamine intensity, making it work, transporting it into the self-reflecting otherness that gave it its strange antienergy. Jones Mekas remembers him "forever" there, two cameras slung around his neck, "snapping and snapping."

Linich was and is a mystic, a variety common among very druggy people in the 1960's, except that his mysticism was of longer standing and more seriously pursued. Inevitably Oriental (he is still part owner of a bookstore specializing in things called Orientalia), his mysticism by the time he left the Factory was primarily concerned with the works of Alice Bailey, who claims to be the spiritual amanuensis of a Tibetan sage who dictated to her books on Theosophy and Elena Blavatsky.

There is something striking in that. For at times it seemed that the denizens of the Factory imagined that they had been touched by the presence of a purely secular, yet powerful transforming grace. It was Robert Collacello, now an editor of Warhol's *Inter/View* magazine, who first pointed out to me the overweening proportion of former Catholics at the Factory, people who, by virtue of their homosexuality, or at least their sexuality plain and simple, are obsessed by what he calls a "taste for decadence." Almost every major protagonist was a refugee from that Catholic Childhood we've heard so much about: Warhol himself (still a practicing Catholic), Linich, Ondine, Malanga, Brigid Polk, Viva, Paul Morrissey. The list could go on for a long time.

It puts a new light on the place's libertarian style, the theatrically decadent sex, the silver-covered walls, the helium-filled silver pillows floating, the angelic voice of Callas soaring on and on forever while the inhabitants sailed on amphetamine. The Factory begins to seem the Great Good Place for children of an ideology dominated by *petit bourgeois* sexual repression, a hypocritical *contemptus mundi*, and a preoccupation with the miracles of grace. The Factory was a region of resolution for those dilemmas, another world.

For Warhol was a central protagonist in a social drama that tried to make the 1960's look like another Age of Innocence. A childlike, gum-chewing naïveté inflects his visions of electric chairs and the ripped

bloody bodies dangling from car wrecks; it merges with the porno-
graphic lusting in so many of his films to touch them with an almost
sweet aesthetic anodyne. Like that of the classic *décadent*, his aesthetics
is the narcotic to a sense of damnation; unlike that of the *decadent*, his
aesthetics is that not of a rarified connoisseur but displays the chintzy
joys of American naïveté. The hope of heaven is mere prettiness, but
prettiness becomes something else when approached at this level. In the
1960's' narcissistic worship of youth, in its supposed liberation of en-
ergy, in those disastrously simple resolutions of ethical dilemmas that
only innocence—call it ignorance—can propose, Warhol discovered his
ethical world. Possessing the smoky mirror of a Catholic sense of dam-
nation, he reflected these values in ways that sometimes touched the
profound, where innocence and viciousness, energy and ennervation,
life forces and their opposites become indistinguishable.

 These are not simple matters: The hinge of redemption is death.
And so is Warhol's central theme finally death. He is an artist whose
glamour is rooted in despair, meditating on the flesh, the murderous
passage of time, the obliteration of the self, the unworkability of ordi-
nary living. As against them, he proposes the momentary glow of a
presence, an image—anyone's, if only they can leap out of the fade-out
of inexistence into the presence of the star. Tavel reports his amaze-
ment at Warhol's personal library: It contains virtually every book on
the stars ever written. Show biz and metaphysics merge, but, as in the
cult of James Dean or Marilyn Monroe, that obsession is underwritten
by a romantic, necrophilic myth that partly explains Warhol's interest
in film. For, in film, just as Cocteau said, there is an imagined redemp-
tion of mortality; in it, time is *saved*, the revelatory tropisms of the
flesh and face and person are redeemed and "imm..ortalized." By the
time Warhol produced *The Chelsea Girls*, this aspect of his artistic
Identikit had fully matured. Significantly, it was the mystically inclined
Linich who developed the work's time-confounding split-screen struc-
ture. But, above all, that film records the never-to-be-duplicated per-
fection of Warhol's ironic sense of cinematic *presence*.

 One of the people who invented that presence, Ondine, speaks of it
now: "Your brain seems to be apparent when you're on camera. It
seems as if—when you look at yourself on the screen—it seems as if your
brain is working. Like, to me, I can tell what people are thinking by
what they look like on the screen. *Not exactly what they're thinking,
but what their next moves are going to be, what they're going to do.*"

 If this is a description of cinematic presence, it is also a description
of something close to a state of grace, that illumination by which the
way is revealed. Perhaps the entire style of the Factory, and a central
element in the Warhol films, is that the preoccupations with beauty,

glamour, lust, chic, presence itself are all corny but absorbing modern models for the redemption of being chosen in a loveless world, for the light touch of absolute rightness. Ondine adds, "I know what you mean by the way the performances on the screen come in and out of focus. Sometimes it's there and other times you feel the lack of it. It's like all of a sudden there's a great presence that's missing, and then it's there again. The thing is that when you're involved, you don't know, you're carrying on and that's that."

At the decade's height—late 1965 and early 1966—the same sense of a magical presence hovered over the Factory itself. "At that point in my life," Ondine says of it, "in everybody's life, that was the culmination of the 1960's. What a year. Oh, it was splendid. Everything was gold, everything. Every color was gold. It was just fabulous, it was complete freedom. Any time I went to the Factory it was the right time. Any time I went home, it was right. Everybody was together, it was the end of an era. That was the end of the amphetamine scene, it was the last time amphetamine really was good. And we used it. We really played it."

❈ ❈ ❈

The 1960's created the Factory and the 1960's killed it dead. Like the turntable sparkling with tiny mirrors in the center of the silvery room, forever turning at an unchanging rate, Warhol stood at the center of his time, passive and mute, the mirror of the decade, his little world its microcosm. Utterly absorbed and utterly disinterested, he had an almost Satanic power to make its casual hysteria cohere, signify, become visible. He was central to that world, but he stood apart from it just a bit. Between his bizarre, isolated integrity and the throng, there was a kind of space. It was the space of the mirror. Warhol's responsibilities were the mirror's responsibilities, his replies the mirror's replies. A man had transformed himself into a phenomenon; one looked into him and saw—a scene. As the word suggests, the scene was theater, but theater lived for real, though just enough itself so that the dangers of living seemed to go away. There seemed to be everywhere the grace of art and fame and sex and money: A shabby world seemed redeemed, and, in Warhol's mirror, image and object somehow got interchanged, both vanishing into the sparkling light.

But, as the 1960's began to fall apart, the sparkle began to glare. For one thing, despite youth, drugs, art, beauty, chic, all of it, the precious Aquarian Age of Innocence turned out to be another self-flattering lie. Perhaps, if people had looked carefully enough in the mirror, they would have seen that. Most had to discover it all on their own. Just on the other side of the bubbling infantilism, the all-flattered disorientation, the self-admiring carelessness, there turned out to be

terror and rage and despair. The media found their touchstones for this turn in youth-cultural events in Altamont and the Manson murders. But how many hundred thousand Aquarians discovered it in small rooms with peeling paint rather than beneath the TV lights? Was Warhol's deathly pallor once interesting? It is less so on the shipwrecked faces now wandering the streets of the Flower Children. One hears less these days about mind-blowing in a New York where it is difficult to walk ten blocks without seeing somebody (usually black) who is insane, literally raving with anguish. Folk heroes who once basked in frighteningly unanimous attention stumble from the limelight, their theories seedy to the point of embarrassment, of contempt. The politics it was once so fashionable to ignore has been doing its work anyway, and can no longer be ignored: The drug scene has lost its glamour to say the least. And the biggest shock of all: The recession demonstrates that innocence 1960's style is expensive: The saints need cash.

Faced with the dire threat of maturity, the 1960's tried to transform their time into a single all-giving, all-perfect Moment. The scarcely inconsiderable forces of art, drugs, beauty, glamour, talk, youthful energy, style, mysticism—all were enlisted in the effort, and for a while it seemed almost to work. Warhol, it seems to me, understood the nature of that effort with an intuitive profundity second to none. But, in spite of everything, time took the hand. Even in the Factory.

It was the special destiny of the place to make the underground visible. When that process was over, the show was over. Warhol himself had no place to turn except back to the sustained practice of his art, or into commercial film-making. He chose the latter course, turning over the entire enterprise to another assistant, Paul Morrissey, who now runs the "new" Factory from top to bottom, to the end of exactly that—commercial film-making and nothing else. After Warhol was shot in 1968, the move toward this commercialism (incipient since just after *The Chelsea Girls*) went into high gear, and the old scene was finished. There was an incongruity in the new spirit; the old people in the Factory had had an entirely different relation to their art and to society. Heads began to fall: Warhol had exploited people of great energy and brilliance who were otherwise beyond the pale: Ondine, Ronald Tavel, Brigid Polk, Mary Woronov, Ingrid Superstar, Billy Linich himself. Under Morrissey, they defected or were eliminated one by one. "Warhol had been told," Ondine says, "that commercialism means you can't bother with the freaks any more. You have tintypes. Whatever sound somebody did originally, well—you can duplicate it." Tavel is bewildered: "I don't know what it is, because it looks to me inauthentic." Admittance to the "new" Factory began to be difficult: The gaze of the "new" people could make a stranger writhe. The entourage

was replaced with reliable, presentable employees. At last, the impossible happened: Malanga was fired. Only Linich remained, the only person actually living there, just as he had done before on Forty-seventh Street.

He held on for three years, holed up in the small storeroom in back of the new place. "He couldn't come out with those mediocrities," Ondine recalls. "When they moved to the new place, the only part of the Factory that was the *old* Factory was Billy Linich's back room. The old world was really up there. He had tapes, it was painted black and silver, he had his whole number going on. Outside was this . . . this . . . ," Ondine searches for the word, "this *Juilliard*."

Linich's isolation grew more and more complete. "He read continuously—Alice Bailey. . . . He read her books in the back room in black light, so the page jumps. He was taken to the hospital at one point with retinal colic. His eyes turned something all yellow, and all the while he was getting scabs on his face and his fingernails were growing." Ondine pauses. "There was some kind of fire going on in Billy's brain. And Warhol's lack of interest in Billy triggered it off to such an extent that Billy couldn't come out of the back room. . . . I wouldn't say he was exactly crazy, but he was in touch with something so spiritual that most people would be frightened by it."

In time, even Linich's commitment broke. A note was found in the back room: "I am all right. Goodbye." It was the definitive end of the Warhol Scene. The man who had designed the Factory, and its last, most loyal defender, had left. Linich now lives in Los Angeles, but his connection to the Factory entirely severed, one gathers much to Warhol's regret. "He was so loyal to that man," Ondine concludes. "Three years he waited in the back room for somebody. And nobody was there. Andy Warhol was no longer there. He had gone somewhere else."

* * *

Warhol is a major artist whose social role and art are inseparable. He is also an extremely conscious artist, at least at a nonverbal, very self-reflective level. For almost ten years, his intuitions diffracted the phenomena of his time into an aestheticism that transformed him into one of the exemplary modern antiheroes. But, mute as they were, those diffractions, those reflections had something that now seems almost admonitory, a warning. At the core of the passivity, the chic, the affectlessness, at the center of the phenomenally interesting thing he did with the incapacity to love or connect or believe, there was something crucial and dangerous: a very profound doubt about the value of life itself. It was *that* that set him apart; from *that* the mirror of his pres-

ence acquired its hypnotic allure. At a certain point, that doubt be-
comes a despair profound enough to become precisely what is meant
by decadence. It seems to me that Warhol's entire career can be un-
derstood as an attempt to redeem that despair without belying it; that
was perhaps the message in the deepest regions of the mirror. If this
is true, and if Warhol knew it at the height of his Scene, I am sure
he knew it only intuitively. I'm equally sure he never allowed that
knowledge to mature beyond the point where it threatened this astonish-
ingly passive man's astonishing capacity to act. As always, he kept si-
lent. It took a while—it took Time—for the people who rushed in to see
themselves reflected in his pale light to discover the precise message.
For Warhol himself, it took the elevator doors opening one day; he
looked up to see one of the minor members of his entourage standing
before him with a trembling face and crazy eyes. He said "oh, no" just
once, and then Valerie started to fire.

* * *

I can't feel anything against her. When you hurt another person, you
never know how much it pains. Since I was shot, everything is such
a dream to me. I don't know what anything is about. Like I don't
know whether I'm alive or whether I died. I wasn't afraid before.
And having been dead once, I shouldn't feel fear. But I am afraid. I
don't understand why.

* * *

The Great Good Place of the 1960's is gone. The remembered image
—it is a false image, of course, but then the image was always false—
is like a huge indoor festival of energy and innocence, of sex, bright
bodies under thirty preening over real or imagined strengths as if they
really were in the state of grace. The Scene I remember from seven
years ago was an absorbed, disturbed, cheering audience to itself, and
nobody could tell the dancer from the dance. But the cheering is over.
A theatricalism has been betrayed, and it has died. The silver hall is
empty.

The Tycoon of Passivity

●●●

In the late summer of 1963, Andy Warhol made a film called *Kiss*. It is silent. There are no credits or titles. Without announcement, the screen lights into a highly contrasted black-and-white close-up: A man and woman are—surprise!—kissing. The lips of both are full, sensuous, crawling on each other, melding in intense sexuality. Their tongues slide and probe; the woman keeps her eyes open, gazing almost frenetically at the man's closed eyes as the kiss continues. It continues for a *very* long time. Sitting out in the audience, we watch and wait. We are perhaps aroused, but also a bit perplexed. The time of this film is not our own; it implacably withholds itself from us. The lovers on the screen are elsewhere, images absorbed in the grinding of mouth against mouth. Deprived of their tactility, we look on and wait, isolated in our own, voyeuristic audience time. And suddenly the intense black and white of the image seems to flicker and whiten, then falters and is obliterated in a "white-out" before the kiss itself ends. A ragged piece of film end seems to flash by, as though the short film roll in Warhol's camera had simply run out. We see only whiteness for a mo-

17

ment, and then, with spectral insistence, the screen darkens again with the image of a new, long kiss.

While making *Kiss*, Warhol had been slowly constructing another film which he gave what was to become his characteristic monosyllabic title: *Sleep*. It, too, begins without credits, the image simply appears. Directly across the screen, like a kind of horizon, is a breathing line, brilliantly, unnaturally lit, its fleshly curve almost transformed by the highlighted intensity. Recognition takes a moment: It is the rhythmically moving abdomen of a man asleep. We stare at the screen: Nothing changes, nothing moves—nothing except that abstracted human line, breathing in the unchanging rhythm of sleeping life. Once again, the light-blasted image begins to disintegrate as the emulsion itself begins to flicker upward toward whiteness. The roll ends, the image is destroyed. There is pure whiteness on the screen for a moment, followed by a new image: The man sleeping on his back, shot horizontally from below the knee. He breathes.

The clock ticks. In each of these two films, the camera voyeuristically stares at images of people for whom—in sleep, in eroticism—the experience of time has been radically, metabolically, made other, rendered private, changed. In his first two films, with a precision undoubtedly derived from his involvement in the arts of postwar American painting and sculpture, Warhol was able to define on the screen the terms of a moving and even profound perceptual abstraction and give it life. There was no fumbling, no hesitation. That filmed kiss, the image of a man asleep, mute and steady with an almost geometrically defined artistic self-assurance, create a context that in retrospect seems to define all that was most interesting in what Warhol was to do as a film-maker, as he progressively abandoned painting in favor of movies throughout the 1960's, turning out with an offhand and almost profligate productivity well over seventy films.

Over seventy films. When he began making movies, neither Warhol nor any of his multitudinous assistants knew anything at all about cinematography. But, oddly enough, his complete technical ignorance only became obvious and burdensome a couple of years after he had begun, when he was trying to expand his methods and resources, after he was using sound and incorporating narrative elements that drastically expanded both the literal and metaphoric space with which the camera had to deal. For example, there has never been a competent audio man—never the ghost or smallest shade of one—on any Warhol set, and, for that matter, Paul Morrissey has only recently taken the relatively simple steps required for real audibility. In certain films, such deficiencies may not matter; in others, they are maddening and fatal. But, in his first, silent phase, Warhol was able—how very typi-

cally—to make strengths of his weaknesses. The films began to be slammed out of the Factory at an astonishing rate. One after another, they appeared to take their place on the scene of those sceny days: *Kiss, Sleep, Eat* (a portrait of Robert Indiana), *Henry Geldzahler, Empire* (eight hours of the Empire State Building and the majestic passage of day and night); an immense, lost, composite work variously called ****, *Four Stars*, or *The Twenty-four Hour Movie* (it is, in fact, twenty-five hours long), and, above all, the most successful and important of the early Warhol films, the best known and most often seen: *The Chelsea Girls*.

These days, sitting on a torn vinyl couch with punchy springs in the otherwise elegant offices of Andy Warhol Films, Inc., Warhol refers to these early works (the trace of a small smile playing around his lips) as his "art movies." Warhol does not make "art movies" any more—though he sometimes hints he would like to. *The Chelsea Girls* was the only film among them to come anywhere near commercial viability. There is a world of cinematic history and politics behind that mild, almost provincial little phrase Warhol uses—"art movies." Speaking very roughly, Warhol's early films belong in the stream of nonnarrative, "poetic" *avant-garde* cinema, a very vital branch of modernism linked historically to Duchamp, Cocteau, and Bunuel, and that transplant of modernist thinking to the American sensibility that has been most conspicuous here in painting. But parallel to the rise of post-war abstraction in painting was the emergence of the American film *avant-garde*. Warhol inherited both aspects of this parallel development. More particularly, within the artistic ambience in which he emerged during the 1960's—painting (and especially Warhol's painting) had embarked on a set of concerns in which film as a medium seemed constantly on the verge of declaring itself. And so he turned to film, and it was declared.

The American *avant-garde* cinema has never had important practical or artistic links to the commercial feature film as it is practiced in Hollywood—Warhol's beloved Hollywood. As the *avant-garde* developed, a kind of ideological (and more than merely ideological) hostility to the "commercial" cinema grew up within the movement and became very intense. A continental divide came to separate the supposed commercial mainstream and the *avant-garde*. Given the vast disparities in money and influence between the two camps, the quarrel may look like one between a mouse and an elephant. But in terms of working film-makers and their aesthetics, the distinction was and is real and important. And we know about mice and elephants.

Under the influence of his collaborator, Paul Morrissey, Warhol has bridged the great divide between the *avant-garde* and the commercial cinema in the simplest possible way. He has moved from one to the

other. In 1968, as Warhol lay in New York Hospital recovering from
Valerie Solanis's attempt to murder him, Morrissey conceived, shot,
and edited his own film, *Flesh*, which then appeared with Warhol
credited as the "producer." It was the first commercially viable film
since *The Chelsea Girls* to appear under the magic name. And it estab-
lished what was to become the direction of the Warhol-Morrissey col-
laboration: the style of *Trash, Women in Revolt, Heat, Amour*. It is a
"collaboration" more and more marked, even dominated, by Morrissey.
He should be considered *the* director of *Flesh, Trash*, and the rest of
the recent films. The "art films" Warhol began his career making as
part of the impecunious but vital Independent movement presided
over by Jonas Mekas have given way to a series of commercial sex
farces, what Warhol shyly calls his "comedies." Valerie Solanis was not
able to kill Warhol. But she did activate, or silence, something in War-
hol's private sensibility that brought the days of commitment to high
modernism to an end.

Those "art" films used to be heard about and not seen. Warhol's gen-
ius for publicity saw to it that everybody would be talking about them,
but that talk, in turn, ensured that the audience would stay away in
droves. Spending the evening in a basement somewhere watching six
hours of some guy asleep? Dear God! A celebrity is a person more fa-
mous for who he is than what he has done. He is a "name." In that
sense, Warhol is the 1960's' ultimate artistic celebrity. Within the small,
hectic world of the visual arts and independent film, he was and is
King of the Cats, the most famous artist living in the English-speaking
world. This is not accident: From the beginning, Warhol craved fame
with a thirsty, calculated desperation, as if it were the very metaphor
for life itself. And, in a sense, his career is about being a celebrity. He
has comprehended that all-desired American condition with something
like genius and found in its corruption the dignity of a certain very
modern spiritual condition that he has made his own. Looking at that
phenomenon—what else can it be called, it is the Warhol phenomenon
—from the outside, one sees first, last, and always that face with the
silvered hair, the dark glasses, the almost shocking pallor. He is the
phantom of the media.

It's only when looking at his work, and especially the films, that
the electronic phantasm dissolves and disappears. Behind those dark
glasses, there is a certain Warholvian stare—a gaze—that in turn is a
function of a consciousness that looks at the world in a very particular
way. I think that gaze is a major metaphor for art and life in our time.
Like Cocteau, an artist from another time and world whom he in some
ways resembles, Warhol carries a single set of artistic obsessions, a sin-
gular mode of vision, from one medium to another, subduing each me-

dium to his own ends. I'd argue that that singular mode of vision is a metaphor for an aspect of the modern condition, instructively drawn out to the extreme limits of its terms: Vitality and passivity; power and powerlessness; the fullness of being and the etiolation of withdrawal; fame and insignificance, and, most important of all, presence. Star presence. At what must be great cost—perhaps nearly the cost of his life—Warhol has made himself and his work into something entirely singular. He is one of the exemplary modern antiheroes. He has given himself a central role in the metadrama of alienated American consciousness. And it is a role based on a relation to the world best refracted through that equally modern instrument, the movie camera, its medium.

But let's speak first about the phenomenon, the man, this tycoon of passivity.

<center>✦ ✦ ✦</center>

"I never wanted to be a painter. I wanted to be a tap dancer."

A party is in progress, and lots of sleek-looking people stand artfully around. Glasses clink; there's the genteel rumble of talk, people are circulating a little faster than they ought. The faces seem vaguely famous; the memory squints, unsuccessfully trying to bring into focus who or what they are. But it doesn't work, they aren't famous enough. This is an art-world party, and the art world is a subculture where fame (I don't mean merit) is a somewhat superior brand of chic. But suddenly—the moment seems timed by a master of the inevitable-but-unexpected entrance—a man arrives with an entourage. Like an automatic transmission silently shifting upward, the whole room responds to that *really* famous silvered hair, the dark glasses, the leather jacket. Around him orbit, say, a couple of rather battered guys dressed in next week's superclothes, and two or three ostentatiously depraved girls with hair that looks like it was yanked out of a Brillo box. Without letting anybody notice, everybody takes a quick glance at what is now the center of the room. The rumble of voices remains unchanged, but the environment of the party has been made to cohere. Glasses clink. A scene has been made.

Warhol is a sweet, silent, pathologically mild-mannered man with intuitive genius for stepping into the mainstream of philosophy, art, aesthetic history, and the sociology of both the media and the image in our time and simply standing there, as if he were in a chic living room at their exact point of convergence. Most writers agree that his gift is not fundamentally plastic but theatrical; that he has a cool, uncanny knack for locating objects and himself within the environments

proper to them, simultaneously defining that environment and "cre-
ating" the object's status within it. Fewer writers remark that this gift
is an odd variety of good taste. ("People are so fantastic," he once
said. "You can't take a bad picture.") Or that this good taste is closer
to the art of the interior decorator or scene designer than it is to Ce-
zanne. But almost nobody notices that Warhol's art has a remarkable
relevance to certain traditions about art and the artist that have domi-
nated important aspects of Western cultural life at least since Baude-
laire, or that Warhol's style speaks to and through those traditions with
an ultranaïve and often staggering economy of means.

The first big Warholvian *coup de théâtre* imitated Marcel Duchamp
by inducing people to look at Coke bottles, Campbell's Soup cans, and
Brillo boxes through that special aesthetic modality of perception re-
served for looking at things that are functionless. Look at, say, a tele-
phone, psychically effacing its function. It will become something new.
Ever since Duchamp's Dadaist jokes over the urinal and the bottle
rack, we've known that scrutiny can aestheticize any object in this
way: All that's required is a simple shift of gears in consciousness.

The Duchampian game in which objects are aestheticized merely
by turning to them with a certain glint in your eye, does have continu-
ing value, though not as the comical antiart polemic so often ascribed
to it. Nothing is deader than a dead joke, and the chic giggles over
Duchamp's bottle rack died out half a century ago. But, like its com-
panion movement, Surrealism, the Duchampian dimensions of Dada
left behind something more important: new possibilities of metaphor.
If you look at any object through the aestheticizing Duchampian
prism, you are likely to be made peculiarly aware of the process of
looking, itself, conscious not merely of the object, but also the feel, the
nature, the very matrix and interplay of your perceptions. The object
will thus refer you again to yourself and your own personal capacity
to transform objects and their environments.

It is possible to understand this rather specialized aesthetic experi-
ence as a metaphor, in consciousness, for the perception of things at
large, in which the unlike things compared and fused are the self and
the world. This is a process that found its great bard in Wallace Ste-
vens, and it has enormous importance not only for Stevens's poetry but
for significant sectors of many of the other important arts, including
film. It is a major modernist procedure for creating metaphors, and an
antiromantic one, because it locates the world of art's richness not in
Baudelaire's "Elsewhere" but in the here and now. At least almost.

Warhol goes further. He wants to be transformed into an object
himself, quite explicitly wants to remove himself from the dangerous,
anxiety-ridden world of human action and interaction, to wrap himself

in the serene fullness of the functionless aesthetic sphere. Desiring the glamorous peace of existing only in the eye of the beholder, he tries to become a celebrity, a star, making no bones at all about his preference for objecthood over being human. "Machines have less problems," he once told an interviewer. "I'd like to be a machine, wouldn't you?" Another time: "The reason I'm painting this way is I want to be a machine, I think it would be terrific if everybody was alike." Another time: "I love Los Angeles. . . . I love Hollywood. . . . Everybody's plastic—but I love plastic. I want to be plastic." And again: "I still care about people but it would be easier not to care. . . . I don't want to get too close. . . . I don't like to touch things. . . . That's why my work is so distant from myself."

Warhol's self-transformation into an object—into that plastic machine that became the 1960's' exemplary celebrity, is possible only because of his extreme fame. Being famous is one of the things his career is all about—fame and passivity are the two things that dominate everything he does. "In the future," he once remarked in an almost spectacularly brilliant aphorism, "everybody will be world famous for at least fifteen minutes." Just as the bottle rack became art by being placed in the context of art (a context created above all by the media) Warhol *is* Pop Art. And just as the bottle rack has no intrinsic interest, the famous man has done little to deserve his fame except *become* famous and then rest passive within it. This is by no means an easy trick to turn, but nonetheless the prize is won not by action but by a kind of framed inaction. In fact, Warhol's career is part of—is the culmination of—that continuing critique of the man of action that has played its dual role in the history of art and masculinity since Baudelaire. Warhol always succeeds because he never tries. As with the tycoon, failure is not in his vocabulary. He is the tycoon of passivity, the last dandy.

Baudelaire wrote: "The character of the dandy's beauty consists above all in the cold appearance which comes from the unshakable resolution not to be moved; one might say the latent fire which makes itself felt, and which might, but does not wish to, shine forth."

The remark suggests what might be called a style of latency, an art of the immanent underlying those soup cans and those meek, blank stares from behind the dark glasses. Transforming himself into the object celebrity, Warhol has made a commitment to the Baudelairean "resolution not to be moved"—an effort to ensconce himself in the aesthetic realm's transparent placenta, removed from the violence and the emotions of the world's time and space. So Warhol turns out to be a romantic after all. But the world's violence and emotions are also inescapably located within the aestheticized human object himself, just as they are immanent within the eye of the beholder, who half

sees, half imagines them swarming there just beneath the quiet sur-
face. ("We have cops coming up here all the time," he says. "They
think we are doing awful things and we aren't.") The pale, cold light
Baudelaire saw repressed within the dandy is the fire of life itself—
whose latency, in this context, brings the category of art into being.

And so, as a supercelebrity, Warhol lives out the metaphoric dis-
tinction between life and art in the eyes of the Beautiful People, his
beholders. Famous for being famous, he is pure image. This, too, is
part of the ontological drama I mentioned. Ever since Pirandello, at
least, a metaphor for questions of being and authenticity of identity
has been working its way through modern consciousness in the form
of the idea of the theater and in images of theatricalism. Turning this
theatrical metaphor into the life of the celebrity, the star, Warhol be-
comes its last and most modern embodiment. Nobody turns to the the-
ater for his dream box any more, but millions dream of celebrity, ce-
lebrity for anything. The scramble for it is like a fight for a life raft
among a throng drowning in the sea of inexistence. But Warhol doesn't
fight. He floats.

He speaks in the language of a little boy, and sometimes (contrary
to the mute persona of the image) speaks quite a lot, quietly explain-
ing what he thinks is "really nice," or what would be "fun," or what he
"likes"—sometimes (as if he'd suddenly heard himself) pausing a mo-
ment with a tiny, almost secret smile, as if what he'd just said had left
him just slightly amused in some very private region of his mind. Never
healthy, the shooting has left him permanently ill: The pallor is ex-
treme, and his unnaturally thin hands rest in his lap as he talks, like
those of a well-trained child. He perpetually chews gum, copiously of-
fering sticks to everyone around him, and his eyes are very active, but
slow moving. At the Factory, the employees are, of course, always
around him with their busy languor, but he seems to feel a childlike
obliviousness to them all. He does not go to them. They come to him.
Decisions are made instantly and whimsically. I have never seen him
pause to think. It's just: "Oh yeah. That's nice. Do that." or "Oh . . .
oh . . . uh . . . no, I don't want to do that. . . . I never do that." He
no longer travels with his entourage, and his world has been reduced
and transformed by the murder attempt and the death of the 1960's,
but even now celebrated visitors are likely to drop by, there is around
him still the space of the celebrated. He is never without the light of
his fame.

Until now, Warhol's work has glittered in reflections from the aura
of his world, that ambience of freaks and glamour and money that de-
fined the realm of his celebrity. Once it began to move, Warhol's fame
began to sustain itself like a great fortune. Its glamour attracted atten-

tion. Which gave it more glamour. Which attracted attention. At the center of that world, gazed at forever by his beloved media, Warhol managed to use his fundamental passivity to transform himself into something rather like one of his own objects: Absolutely noticeable, yet apparently absolutely meaningless. He created a kind of space around himself, the way an object creates a space around itself, and, within that space, his every action seemed in some obscure way to *signify*.

But Warhol's world is going fast; it is unlikely to long outlive the 1960's that created it. In a few more years, his films and art works will have to survive unassisted by *Vogue* and the dazzle of the youth culture. They will be left with nothing but their artistic strength and integrity to defend them. Which means that many won't make it. But a few are strong enough, are sufficiently autonomous to operate outside that magical space Warhol generates around himself like a force field around a negative pole. It seems likely that *Kiss*, for example, with its mute, remote eroticism, will still be worth looking at. And the signed or initialed soup cans will not.

The winnowing process has already begun. The 1960's are gone: The world that generated these films is gone. Stepping now into the storage room of the Factory to dig through the heaped, careless piles of old film cans is to encounter the chic of the 1960's as if it were the relic of a lost age, forgotten beneath a layer of dust. Properly enough, I suppose. Warhol was the artist of the 1960's whose career was most visibly built on the rhetoric of immediacy that shot through the critical discourse of that decade. Chewing his gum, he threw away his works like the wrappers. They rose into the shining light of a whole culture's attention like new billboards beside a superhighway, changing ads every two weeks. Warhol discovered how to maintain his romanticism without the fantasy of timelessness. I pull a dusty, dented can from the shelves and pry it open. Absurdly, the work of five years ago seems antique.

But let me not speak posthumously. The Warhol phenomenon lingers with us still, though in its modified, 1970's version. At the center of it stands the enigma of Warhol's own charming and maddening personality. He is filled with dodges and evasions; what Henry Geldzahler, an old friend, calls "baffles," which Warhol seems to need at his disposal in both his work and his personal relations, the complex baffling system of his self-protection. "The one way to talk to Andy," Geldzahler points out (with the authority of one who has tried *every* way), "is on the telephone. Then he's got the baffle of that device and with that security he'll talk." In the meanwhile, Warhol is fearful and shy to a point that is scarcely credible, and accompanying the shyness is an

obsession with catastrophe. He is likely to take a taxi two blocks ("oh
. . . because there are all these muggings and things"). At a dinner
in the high-rise apartment of a mutual friend, he once stepped onto
the balcony with me, gazed for a moment at the spectacular view of
Manhattan below, and concluded: "Think about everybody down
there getting held up." When I recently inquired if he were still in-
terested in living in Hollywood, he replied with a worried wrinkle,
"Oh . . . oh . . . uh, not now. Before I did, but not since the earth-
quake." People tell me he is afraid of the dark.

Alongside this timid imagination of disaster are Warhol's evasions.
It is simply impossible to get the man to commit himself on anything.
Any effort to do so quickly becomes an embarrassing experience; to ex-
ert the slightest pressure of any kind promptly gives one the creepy
feeling of committing an inexcusable act of aggression, crashing
through the delicate spun-glass structures of those dodges he has
created around himself. Yet these evasions are the source of his wit,
which is small, sly, and quiet; Warhol's idea of humor is invariably
some variety of the fib. Hoping to probe the well-kept secret of any
painting he might have been doing in the spring of 1972 (there had
been rumors that he had been making unexhibited portraits at fabu-
lous fees), I recently asked him what he'd been doing in the hiatus fol-
lowing the completion of *Amour*. I was a fool to expect a straight
answer. "Oh . . . oh . . . oh . . ." (I thought the stammer would
continue for ten minutes), "oh . . . well, I've been promoting the
Playboy Club." After having the pleasure of my credulous, boisterous
response, he looked like a little boy caught at something sweetly scary,
and quickly reassured me: "Oh, no . . . no, I was just kidding." Kid-
ding, indeed. It is perfectly possible that Warhol has lately been pro-
moting the Playboy Club.

It is a mentality that carries him very often into more real regions of
dishonesty, which the people around him have come to expect, and
which they treat as they would the boring ploys of a spoiled child.
When one inquires about this or that unfulfilled promise, the answer
is always the same. "Well, Andy always says yes to everything, but he
doesn't really mean it." Whereupon further discussion is referred to
Paul Morrissey.

But these self-protective evasions are also installed within Warhol's
physical presence, which radiates the message of a highly protected
space around his body, defended by the force field of an intense pas-
sive energy. Behind that force field there is a profound, very fearful
removal from contact, which allows him his charm. And the visitor
quickly divines that it is a space that must not be crossed or jeopard-
ized. An old Warhol associate remembers once being at the Factory to

discuss a pressing financial matter. But Warhol was recalcitrant, endlessly evasive, and kept edging away from his interlocutor. At last, in some irritation, the man said sharply, "*Look* at me when I talk to you," and briefly touched Warhol's shoulder to retrieve his attention. The response was electric: Warhol spun in terror and cowered. "The flunkies started coming out of the *walls* in horror. Horror of horrors—Andy had been *touched*." The meeting was instantly ended; some very extreme violation had occurred.

It is at first extraordinary to find such pathological timidity in one so famous, there at the core of his entirely public and publicized existence. But withdrawal is central to Warhol's persona; his relation above all to fame is determined by it. One senses immediately that fame is for him the resolution of a conundrum of existence and inexistence, that, under the conditions of so profound a pathological withdrawal, fame alone presents the terms under which life is worth living, or can even be understood as a life. In his search for that precious condition, Warhol was never visibly hysterical or driven or pushy; his cool is, of course, the most conspicuous thing about him. Yet one also senses a certain desperation that underwrites it. "I am in danger, Sir," Emily Dickinson, who would not have fame, wrote to her mentor. Warhol is also in danger: His withdrawal, his fame, his transformation of himself from a man into a phenomenon is the means of surviving an experience of the self that trembles, a terrorized sense of being.

A dinner party: Guests gather around the table to take their seats. Warhol has arrived late and, miraculously enough, arrived alone. As he takes his place, he plunks a small black cassette tape recorder beside his plate and switches it on. Dinner proceeds. Comment on the little black box running at his side is obviously not *de rigueur*, and the obliging guests keep their questions to themselves, so that the dinner-table conversation is exactly like dinner-table conversation and little else: Warhol is charming and attentive, at times boyishly enthusiastic, especially when talking about his friends. When the conversation touches on politics, he is likely to be noncommittal or rather conservative, though never argumentatively so. Yet some of his remarks are pretty strong. "Do you know how long they keep somebody in jail if he murders somebody? Seven years, that's all, and then they're out again." The remark chills the table, Warhol gently touches his abdomen, and the judicial liberals present fall into a confused, abashed silence.

Warhol turns out not to be the near-catatonic he allows himself to seem in the media. Behind the "baffle" of his tape recorder, his responses are warm and quick and direct. Human contact and its pleasures ignite; the moment arrives when many people might, say, reach

out and touch your shoulder as they laugh at a joke, might perhaps say something special and observed, something really about you. It is exactly at this point that Warhol turns and pulls out his Star Polaroid. It's a sweet, friendly gesture, but after the fifth or sixth picture, it becomes obvious that Warhol is using his Polaroid as another baffle for his impulses of contact, that the clicking of the shutter is retrieving the distance his feelings have threatened. In the deep, shiny recesses of film, something is being structured and subdued. The flashbulb fires, and, after sixty seconds, the pinch of Warhol's human response is peeled loose, waved dry in the air, glanced at with an exclamation, and set aside.

The mild master of the instantaneous and reproducible is not collecting mementoes. He is giving form to the present. From a strictly psychological point of view, some dilemma over human contact is being resolved by that Polaroid and the cassette on the table. But all Warhol's art searches for a structured immediacy, just as he does at the dinner table. Time out of mind, Warhol has been understood as an artist of displacement: From the beginning, most people have understood that the Campbell's Soup cans staring out from the silk-screened canvas get their spark by brushing together the wires of two different kinds of visual response; the way we look at the paraphernalia of daily life and the way we look at a painting on a wall. He has been called an "antiartist." I think not. He is an aesthete, a true heir of the grand tradition of aestheticism, and he is (or was until he stopped creating art in 1968) in search of a modality of perception that will reduce (or elevate, if you prefer) the interacting world of pain and aggression and fear to the functionless sphere of the beautiful, that will transpose existence itself into the lush velvet of a kind of *décor*. But the aesthetic object needs to be seen at a distance; for Warhol, at least, it must inhabit the imagined terrain of an "Elsewhere." That distance is supplied by Warhol's own withdrawal. He is at an absolute removal from the world in a cool "Elsewhere" behind those shaded eyes of his, looking out with a stare.

And, in the far reaches of his own mind, he lives out an obsession with withdrawal's opposite: Immediacy. And Warhol has managed to discover a certain kind of immediacy in his removal from things. Not the immediacy of contact, of course; one must be present for that, besides which, immediacy of contact requires a hierarchical response, requires judgment: Nobody is equally open with the druggist and the love of their life. Warhol's immediacy is one found in distance. We might call it the immediacy of the unobstructed view. It is a view that only distance makes possible, and the creation of a withdrawal that successfully obliterates the difference between the druggist and the

love of our life, because it is a distance at which there is no longer any possibility whatever of human contact. This is the distance of the voyeur, the space of the watchman.

Because it is the creation of a pathological remoteness, that immediacy can hardly help but be surrounded by depression and by despair. Yet, in Warhol's case, it is a silenced despair, a workable depression. It is as if a deal had been made with these ancient Enemies, a deal that gave them everything they wanted (in other words, everything) and acknowledged them as the total victors over the self. In return, the victim is allowed a little bit of space in which to move. This is the region of Warhol's art, grotesquely constricted, of course, but filled with the mystery in which his intelligence flourishes, the strange sensuous logic of nonrelationship. There Warhol discovers his perverse pleasures and establishes his hierarchies—for, whatever he or his critics may claim, Warhol, like everyone else, prefers looking at some things more than other things. There is a sexual hierarchy, for example. But, more importantly, there is his preoccupation with human presence itself, which, in his withdrawal, he meditates over with wistful brilliance. Exploring the mystery of distance installed in his own remoteness from things and people, Warhol is obsessed with what is for him the impenetrable mystery of human presence, the human face and body.

He is obsessed with portraiture. There are faces everywhere in his art, caught not only by the eternal Instamatic and Polaroid, but in the silk-screens, in the films (which are, to a degree unknown to any other modern director, portrait films), there are the faces of the Warhol superstars, there are the faces of the Warhol women. At Warhol's distance, the face acquires a particular allure, it begins to assume the mysterious presence of the star, that *filmic presence*. Even outside the films, the stars are everywhere in his work; beneath the aestheticizing purples and greens and golds of the silk-screens are Marilyn, Elizabeth Taylor, Jackie Kennedy, Elvis Presley, Troy Donahue, Marlon Brando, Warren Beatty, and, of course, Warhol himself. Beneath his hand, the photographs are transformed and located in that aestheticized distance of immediacy that is Warhol's own condition in life, that region of bribed and bought-off despair where "all is pretty," their faces vivid with star presence and provided with the lush decor of this ultramodern aesthete's radically romantic way of looking at the world.

Here, I think, is the center of Warhol's power as an artist: The obsession of this profoundly withdrawn man—this profoundly withdrawn *star*—with human presence, which he invariably renders as a cool, velvety, immediate *absence*. That is his paradox, why he is the phantom of the media, why he is the tycoon of passivity, why the gaze of his vision as an artist operates the way it does. Presence: It is, of course, elu-

sive, particularly because grasping it means a close examination of our own perceptions as we look. Discussing it, criticism must at the outset abandon the strictly critical fiction of the self-contained aesthetic object. We must talk instead about the structure and psychology of perception, about the most elusive qualities flickering through our own sense of our own awareness. In those heady and refined regions of apperception, one rediscovers the electric logic of immediacy. Consciousness as theater becomes the arena.

Warhol *is* a way of looking at the world, and all his work in whatever medium manifests that way. It is a style that renders the presence of the real absent, a prettification that is also a metaphysical transformation that both creates and springs from an alternate consciousness, an alternate world, an alternate sexuality, an alternate art, and an alternate film. Of course, Warhol is part of a tradition in all this. But he has accomplished his task with such conspicuous completeness and integrity (of a kind); he has defined his alternate world with such extraordinary coherence of sensibility that it is difficult to think of precedents or peers. Just like a good little boy, he did it by the book, and he began his career by believing the book when it told him that it was in Art that his elsewhere could be found. But, like a bad little boy, he overdid it, and made that academicism permeate his entire existence. As a result, this modernist had to entirely change the textbook romantic's relation to time. For example: Strong emotion recollected in tranquility had to become strong reality aestheticized in immediacy. The aesthetic ideas that the art world had made fashionable in the name of Duchamp (just beginning to rise to his final zenith of influence when Warhol's career as a fine artist took off) showed him the way. It was Duchamp who showed him how all those precious—precious in every sense—endistanced regions of the elsewhere could be retained while the rest of the romantic ideology was unceremoniously discarded. (It would be interesting to see an essay on the preciosity of Duchamp; I suspect it might be normative.) From the wedding of the shy, fey young romantic and the cool Duchampian ideology, the New Realist was born. I once mentioned to Warhol that I was writing a novel, and he looked at me doubtfully, with his peculiar worried look. "But you need an awful lot of people for that, don't you?" I answered that I didn't really need a very large crowd. "Oh . . . oh . . . uh, you mean you just make people *up?*" A nervous incredulity spread over his face. I was speaking of a literally unimaginable artistic process. Warhol's is a world of immediacy, one in which it is never necessary to remember because it is never necessary to invent.

Finally, Warhol's interest in recording reality—whether in *The Chelsea Girls* or with the cassette at the dinner table—is, in fact, a means of

subverting reality, replacing the immediacy of contact with the immediacy of his paradoxical absences. It is only in the subtle nether regions of alienating and alienated perception that such a transaction can be performed. Duchamp had founded the standard mode of alienation when he pointed out that all one needed to do to transform an object into something new was to place it in a context that effaced its function; the objects removed from their context of utility could be made to glow like a phenomenologist's dream, could be given the privileged allure of an object drifting, like something from *2001*, in a special void of mental space.

Standard critical procedure defends this tactic of delimited perception as a means of heightening those perceptions. Perhaps so. I am thinking of other consequences. I am thinking particularly of the action of our gaze. As it darts from point to point in ordinary life, the reflexes of the eye pinpoint the spaces of movement and action with lightning-quick unconscious precision, defining the hierarchy of visual response. The process operates with a speed and vivacious complexity that rank among the miraculous commonplaces; even so simple an action as walking down the stairs involves the untraceable vitality of a living trigonometry impossible to capture in words or to diagram. I am thinking of something more elusive than the visual spectacle as such—certainly as we ordinarily think of it. I am thinking of the darting, impulsive visual flashes by which the space of action is defined, and, in a grander sense, the very process by which one *comes to* visual consciousness before most art and in everyday life.

Under the auspices of Duchamp and Warhol, this activity is silenced. It is rendered as a kind of quiescence. Perception is introjected and internalized; visuality itself loses its vivacity and is touched by an autistic, unresonating stillness. It is true that the endistancing game worked by these artists attempts to isolate perception in a way that will make the face on the canvas, the bottle rack, the silk-screened catastrophe acquire some paradoxical numen from the lost childhood world of new things. But, in their inwardness, the structures of awareness are also extended in a kind of passive meditation. It is an effect that castrates the gaze. The sighting, darting vivacity of the gaze becomes a stare.

It is a stare of distance, indifference, of mechanically complete attention and absolute contactlessness. I've said that Warhol can only achieve his romantic immediacy in the regions of alienated perception. But, of course, one can get help from friends. The romantic ideology, drugs, painting itself, are very helpful. Most important of all, there is a machine—one of Warhol's beloved machines—that performs and mimics that function, serving as both its reality and metaphor. It is the

movie camera. The Bolex sees without blinking, its staring, dead eye endows Warhol's alienated vision with a mechanistic impersonality. Of course, historically, film technique has developed in an effort to recapitulate and mimic that same vivacity of the gaze I have been discussing here. But Warhol brushes aside that commitment to vivacity in a single gesture that installs the unbroken stare as his formal trope and reinstates the camera in its condition of being a dead machine. This is the fundamental of Warhol's cinematic style, and, given the nature of his compelling, one might say almost pathological, modernism, he inevitably turned to film. "All is pretty," repeats the pallid mock naïf. But, though he speaks like a child, he does not see with a child's eyes. He sees with an intellectually airtight, very perverse, utterly mechanistic mockery of that childlike newness. A moving picture projector chatters as it casts onto the screen—a spectacle of stillness. In the background, we hear the dry cackling laughter of the man who made *Nude Descending a Staircase*.

The Polaroid flashes in our eyes.

Sartre said that every style reveals a metaphysic. Warhol *is* a style; *Vogue* is right to pay so much attention to him. To repeat, he is a mute, but extremely coherent, public statement about a way of being in the world. I doubt it is a very happy way, but it could be worse, and, in any case, it is not for me to judge. Surely it is about the presence, *in* serene *extremis*, of a profoundly withdrawn consciousness. His innovation has been to surrender to that withdrawal rather than struggle against it. Whether out of weakness or strength, surrender or mastery, he is *the* exemplar of a certain modern condition, one in which the presence of the self, for itself and for others, is forever in question, in danger. *Je sens une certaine difficulté d'être*, Cocteau quoted Fontenelle. Warhol plainly has the same difficulty. He has invented a spectacle of acceptance—not fighting against it, except perhaps in his most pallid and hidden recesses, afraid of the dark—and in doing so he has embraced a startling decadence. With gum-chewing impassivity he has allowed himself to manifest a worldly vanity and the cruelty of his psychological destiny in a way that, when considered in personal terms, stops just short of the appalling. Yet this shy, fearful little boy has flourished in the eyes of others—in *our* eyes—by aestheticizing his alienation and rendering it as a spectacle of otherness, an otherness in which he lost himself, from which Andrew Warhola of Pittsburgh emerged as Andy Warhol. His alienation, his otherness, has the power to fascinate—we stare at it—because when we look at it, at him (I cannot choose the pronoun) we intuitively know that, despite his glittering negativity, this man is also One of Us.

Silence

Warhol has passed through a series of phases as a film-maker, and the latest—if it is indeed *his* phase—is still running strong. It is the epoch of Warhol's "success" as a film-maker, success that accumulates grosses bankers listen to, that rates listings in *Variety*, that lights up Warhol's name on marquees across the land. But the success is not Warhol's; the present laughing era of commercial sex farces like *Flesh, Trash, Women in Revolt, Amour,* and *Heat* has been pulled together almost entirely by his collaborator, Paul Morrissey—their factual director, their creator, their energy. And—though Morrissey is a man who despises the ego that lives on risk, a true businessman—their success has increasingly made the disciple feel free to slip out from behind the shield of the more famous name and let the world learn the simple facts about his real role. These are the "Warhol" films most moviegoers have seen, vaguely knowing that they are not "really" Warhol films. A typical Warhol dilemma, that word "really." One can just hear the word crawling from the mouths of the Factory denizens: she didn't *really* say *that,* we didn't *really* do *that,* they don't *really* believe *that.*

And so, *Heat* isn't *really* a Warhol film—they're puttin' you *on*. The Vivaesque whine announcing these small revelations against the real resonates in one's ears; the boredom of it, *who* could tell the truth? People put down their three dollars and file into Cinema II, vaguely sensing that this isn't the *real* thing. Yet the coy aggression in that offense has no sting. They also vaguely sense that the real thing—Warhol's own films—are unattractive, painful, esoteric, unwatchable: They have a reputation surrounded by rumors of joyless perversity and killing tedium. What a relief! These movies are fun.

All of them were made after Valerie Solanis tried to murder him. And the brash, hyped, slick, yuk-it-up sensibility most of them purvey saved him from a dilemma in which he had been splashing around in the months just before. Warhol had begun to "experiment"—experiment very unsuccessfully—with new (to him) narrative forms, with pornography, with nudity in films such as *Nude Restaurant, Lonesome Cowboys,* and *Blue Movie,* a phase which had begun in early 1967, immediately after he made *The Chelsea Girls.* He was no longer painting, Viva and Joe Dallesandro had become the central superstars, the films were being made exclusively in color. Prior to that, in phase two, there were the black-and-white sound films, the portrait films, the works scripted by Ronald Tavel, and the epoch of the first superstars: a period which begins in 1964 with Warhol's first sound film, *Harlot,* and ends with *The Chelsea Girls* in 1966.

But the first age was silent. Marked by the films that were later most indelibly associated with everything outrageous in the Warhol name. *Eat*—forty-five minutes of a man nibbling a mushroom. *Kiss*—one close-up after another of people kissing. And then *Sleep.* The infamous *Sleep.* Dear God in heaven, six hours of some guy asleep with a towel draped across his groin. Six *hours!* And at last the triumph, put-on of put-ons, the final delight of all *avant-garde* delights. Eight uninterrupted hours of the Empire State Building. *Eight Hours of the Empire State Building!*

These are the films—I myself think they're among Warhol's most brilliantly successful and important—that people still associate with Warhol so strongly that they are surprised to discover that *Trash* and *Women in Revolt* are so different. When the silents were made, they were accompanied by a brush fire of word-of-mouth report, throughout New York. But that word-of-mouth was sufficient unto itself. They seemed plainly films to be talked about. True, since people were talking about them, they must, for some obscure reason, have some obscure value. But it was *very* obscure. Nobody had to go.

Unfortunately, another case of Warhol's genius for publicity obscuring his work. He is pegged in the public's mind as the maker of the

Campbell's Soup cans, but how much more immediately exciting, more swiftly and disturbingly ingratiating, are the complex configurations of the grieving Jacqueline Kennedy, the bizarre disaster series, the self-portraits, the series—portraits of some horrible celebrity—made from the electric chair. It often seems that the least interesting aspect of Warhol's theatrical gift was exercised in the Dada gestures that made him so famous. Likewise, the Dada gesture, the put-on, in these early works has obscured their sumptuous beauty.

* * *

1963 was a year of enormous activity, not only for Warhol, but for the entire independent film movement in New York. Much of it centered on the Film-Makers' Cinematheque then located at the Gramercy Arts Theater on 27th Street, as well as at the Film-Makers' Co-Operative at 414 Park Avenue South. Impromptu screenings had begun to take place each night at the Co-Operative, not so much of completed work but of rushes just back from the lab. As the screenings began to be known, an audience developed, made up mainly of film-makers and their friends, stars of the films, friends of friends. At some point, Andy Warhol became an inconspicuous member of this select audience, slipping in every night to watch the work-in-progress of the American Independent Film. Jonas Mekas remembers that, early in 1963, somebody came up to him after one such screening to say, "Pretty soon Andy is going to start making films. He's sitting here every night, he's seeing all these films, I think he's going to make his own." The imperturbable Mekas, utterly absorbed as ever in his quadruple role as film-poet, philosopher, Diaghilev, and one-man ambience, had somehow never noticed the famous man with the silver hair quietly arriving before each screening.

"Andy? Who's Andy? Which one is Andy?"

Who's *Andy?* Even then, the question must have provoked a double take. But, sure enough, Warhol shortly began to come in with his films —segments of *Kiss*, which Mekas promptly began to screen "as a serial," a new segment each week.

The response was immediate, and, by November of 1963—the month *Eat* was made—Warhol was, so far as Mekas was concerned, a major film-maker whose every new work was to be anticipated with excitement. *Sleep* and *Kiss* were given their public screenings and the controversy had begun, especially over the six-hour marathon of the former. At the second screening of *Sleep* at the Cinematheque, Warhol himself was present. Mekas greeted him with a rope, led him to a seat in the second row from the back, and tied him down. Somewhere half-

way through the film, Mekas decided to check that seat and see if the master had lingered with his disciples. "I found the rope," he recalls.

Actually, Warhol had begun to make *Sleep* before *Kiss*, even though the segments of *Kiss* were the first screened. People who have never seen *Sleep* (in other words, almost everybody) are sometimes under the impression that Warhol's notoriously immobile camera remains rigidly fixed for the full six hours, a mere mindless sentry perpetually at attention, gazing at a sleeping man. As a matter of fact, if not properly speaking edited, *Sleep* was assembled and constructed from several different shots of the somnolent nude. There were numerous shooting sessions; over a period of several weeks, the *avant-garde* poet John Giorno (who did the sleeping) returned repeatedly to slip off his clothes and resume his easeful task on the couch.

A man who is familiar with the corpus of *avant-garde* film as few critics have ever been, P. Adams Sitney, describes the particular visual effects of *Sleep* in his monumental scholarly study, *The Visionary Film-makers*:

> [Warhol] made famous the fixed frame in *Sleep*, in which half a dozen shots are seen for over six hours. In order to attain that elongation he used both loopprinting of whole one hundred foot takes (2¾ minutes) and, in the end, the freezing of a still image of the sleeper's head. The freeze process emphasizes the grain and flattens the image precisely as rephotography off the screen does.

But the fundamental way of using film in *Sleep* is very much the same in *Kiss*, *Eat*, *The Thirteen Most Beautiful Women*, and innumerable other silent films. A motorized Bolex would be set up, loaded with approximately three-minute, one-hundred-foot magazines. Shooting consisted simply in turning on a key lamp, starting the camera, and letting the magazine run out. There was never a camera movement and only a very occasional zoom (I can think of precisely one in *Kiss*; two or three perhaps in *Sleep*). Editing consisted of gluing together each 100-foot take on leader, invariably leaving in the weakening and whitening emulsion and the perforated tags at the end of the roll. It was in this way that the "serial" of *Kiss* (a new segment shown every week at the Cinematheque as a short subject, like *Merrie Melodies*) was transformed into a "feature." And it is how the portraits in *The Thirteen Most Beautiful Women*, *The Thirteen Most Beautiful Boys*, and *Fifty Fantastics and Fifty Personalities* were strung together.

The technique with the refinements Sitney mentions is the same in *Sleep*, but the effect of *Sleep* is slightly different. With each new episode-magazine, *Kiss* and the portrait films introduce new "stars"; *Sleep* simply changes its angle on the same subject. More than a series, it is a serial construction. In a tape recording made in 1965, Warhol re-

called that "it started with somebody sleeping and it just got longer and longer and longer. Actually, I did shoot all the hours of the movie, but I faked [faked?] the final film to get a better design." With each new cartridge of *Sleep*, Warhol chose a new camera position: a close-up of the breathing abdomen, a long shot taken laterally from the knee (the extended body swimming back into deep space), a near close-up of the face, slowly withdrawing in a very slow zoom from above, and the like. When the film was assembled, each take was used twice and made part of a cinematic structure conceived, as Warhol puts it, "for design."

Each of the several shots in *Sleep* is an arresting example of Warhol's most indelible pictorial style, and assembled together they invest the work with an architectural richness not found elsewhere in his films. *Sleep* is a serial composition in the tradition of Duchamp—a tradition that consolidates its quiet, implosive strengths by numbing itself in paradoxes of movement and stillness. That numbness is central to his art. One can seek to understand movement *as* stillness, stillness *as* movement. It was Duchamp's innovation to level a critique against virtually all art by shaming it as the dupe, the fool, of this paradox. Art is usually attacked from the perspective of reality, as the betrayer and corrupter of the sense of the real. But Duchamp's famous polemic (exercising itself with its mute, mocking economy across far more of the intellectual and artistic terrain than I could possibly sketch here) was hardly mounted from outside art in the name of the full-blooded and actual. On the contrary. Duchamp's mockery speaks from within the very paradoxes he wishes to challenge, from within a very perverse, extraordinarily indulgent engagement with them. Above all, the whole polemic seems dominated by a wry, tightly controlled, but very deep thirst for silence. For stillness. The polemic is no crusade; it is the exercise of yearning need. The joke turns out to be not a critique but a means of dealing with the problem of being alive; the rejection of "art" no disburdening, but a means of enlisting that same "art" as a prime device for dealing with the unmanageable. The ethic of cool is born, but cool's critique of art's inadequacies, far from being dismissive, seeks to expand art—with a sneer, if necessary—to the stability and usefulness of an ethic. Nothing so uncool, of course, as a religion of the aesthetic. But some means must be found to protect the poor, battered, overwhelmed perceptions from the inchoate, violent surrounding ocean of Fact and interaction, from the demanding and merciless Real. Some means must be found for protecting the existential solitude and quiet of the self caught in the despairing trap of simultaneously desiring absolute action and absolute stillness. A means, that is, other than suicide or murder.

The simultaneously indulged and mocked paradox of stillness and motion so essential to Duchamp's early career (I'd also argue, essentially the metaphoric paradigm for all of it) has this peculiarity from whatever perspective it is approached, and, in the end, invariably favors stillness. In the fusion of this immaculate conception, stillness is the dominant gene, motion recessive. A passive force invariably finally controls the work and our perception of it. "An explosion in a shingle factory," some pundit called *Nude Descending a Staircase*, and the insult has remained in the vocabulary as an ironic image. But the image misleads—the pundit could not have really *seen* the picture —because it speaks of an explosive energy. No. The energy of *Nude Descending a Staircase*, like a filmed explosion run in reverse, implodes toward stillness and an original order, not that of the nudes' stillness, but that of the surface of the canvas itself. Duchamp's dissociative paradox of movement and stillness invariably—though always metaphorically—moves toward *stasis*—toward hypostasis, to be precise. And that hypostasis speaks to the sensibility of our time—both through Duchamp, and through his most celebrated living inheritor—in a manner that is not marginal, but central to this book.

The *Nude Descending a Staircase* is a serial meditation on movement, conjugated and arrayed as quietude within the abstracted irreality of paint. *Sleep*, on the other hand, is a serial meditation on stillness, run through its variations and protracted within the irreal, yet temporal and concrete medium of film. Thinking of the *Nude*, I look for descriptive language, and the word "retinal"—hardly original, to be sure—leaps to mind. The painting recalls the crisis on the surface of the eye provoked by a strobe light, recalls the way the strobe shatters time's visual continuity and pins the autonomous action of the eye under an overmastering disjunction. Yet, no, the recollection misleads. The *Nude* is still. We look at it in the guarded, discreet silence of a museum. It does not move. The eye is not overwhelmed; it chooses its involvement in the painting as one might pick up a candy. And, though the *Nude* passes through space, her passage—surely she is female—is, through the dissociative analysis of that space, subdued within the peculiar timeless time that the surface of painting invariably presents.

Now, the proper medium of film is that same real time that Duchamp reduces to the condition of a surface. In *Sleep*, Warhol inverts the Duchampian paradox into a moving picture. Throughout, time remains itself, steadily flowing past at the speed of the clock, in the rhythm of the breath, of the heartbeat. And yet, every movement made by Warhol's nude carries us deeper into his accentuated meditation on the stillness of sleep.

Turning on a single paradox, both works share a single theme; it is

the dissociation of time in the name of a hypostatized quietude. The cocktail party's "Jesus God! Six hours!" is the clue to the film's innovation, its absolutely trenchant redefinition of what filmic time is and can be. For it is exactly in the arena of time—of speed, if you will—that *Sleep* is so radical. The film entirely modifies the very nature of film viewing. Obviously, very few people are able to sit through all the film and give it the kind of attention ordinarily given to a movie. At the early screenings, audiences came forewarned, intending to make an evening of it. People would chat during the screening, leave for a hamburger and return, greet friends and talk over old times. All the while, the film serenely devolved up there on the screen of the Film-Makers' Cinematheque. The Sleeper breathed, stirred sometimes on the couch.

One can imagine that hall of 1963. It is small and narrow. Though the tickets have been sold out, there are people in only half the seats. In the lobby, clusters of people stand chatting, smoking, somebody abstractedly tearing the rim of a paper take-out coffee cup he's using as an ashtray. A man and a woman step to the door of the screening room and stand there a few minutes staring. Then they return for more conversation. Somebody douses a cigarette, cracks a joke, and returns to his seat in the hall. He will be there for another half-an-hour. People come and go.

The film remains on the screen always. Its time is utterly dissociated from that of the audience: The Image glows up there, stately and independent. Its cinematic isolation on the screen exerts a bizarre fascination beyond its immediate pictorial allure. Even if one only glances at the image from time to time, it plunges one into a cinematic profundity; in a single stroke, that image effects a complete transformation of all the temporal modes ordinarily associated with looking at a movie. The knot of attention is untied, and its strands are laid out before us anew. We've been told that film records literal time; but the literal time of *Sleep* is undermined, rendered hallucinatory and other, by the use of silent speed (all Warhol's silents were shot at 24 frames per second, but they should be projected at 16 frames per second; the effect is an unchanging but barely perceptible slow motion). And yet as the minutes tick on, the work seems to insist upon its hallucinated literal time as few other films ever do. Meanwhile, the audience's participation in the image is never allowed to fall into the slot of that *other* temporal reality—that acceleration and deceleration of the audience's temporal sense created by narrative fantasy or conventionally edited structure, as in almost any other film one can think of.

Warhol is perhaps the first film-maker ever to concede that his audience might not wish to see every minute of his work. At the very

least, he is the first to be content with that incuriosity to use it. *Sleep* has its own temporal pace, of course, and a very different one from our own. But we slip in and out of that time at will. It is a meditative time, erotic, almost necrophilic, while ours is—well, our time is our own, and perhaps the clock's. The movement—and it is our *own* movement—from one temporal realm to the other is among the major sources of interest, and incident, in this masterpiece of quiescence. It is the meditative pleasures of dissociation that the film proposes to us. Its time and ours are not melded but irresolvably contrasted, and the operation of that contrast from minute to minute gives the film its life.

But there is a final trope in that contrast that is the film's stroke of genius: its subject, *Sleep*. What is sleep, after all, but the metabolic transformation of the entire experience of time, our nightly release from the clock's prison, filled and flashing with the dreaming motions of the mind and yet an immobility, a quietude in which seconds and hours are confounded. *That* is what we gaze at so voyeuristically in *Sleep*, bound to the unchanging clock of the camera's mechanical eye.

The film is obsessed with the quiescence of the flesh. The lovingly voyeuristic camera meditates on that quiescence, creating, by its very attention, a series of perceptual paradoxes within the realm of still-ness. I have described the opening frames in another chapter, but I can't refrain from speaking of them again. The screen is bright with a brilliant, almost blistering light playing over the sleeper's mov-ing, breathing abdomen. The effect is a kind of fleshly abstraction; one senses life before grasping what is being seen. Pictorially, the shots are often close to being abstractions on the body, and under the haunting slowness of silent speed and the stillness of the body, they convey the sense of the Person divested on anything but the essentials of life itself. In sleep, as in the orgasm, the personality veers toward the imperson-ality of a universally shared experience. The life one sees in this film is abstraction on the vitalism of the personality.

That abstraction is erotic. It may be that all sexual absorption has some of this abstract element within it. Certainly, a familiar paradox of sexual excitement is the union of very particular sensations with a universalizing instinct: The way this woman, this man I'm touching becomes somehow all women, all men. And the concentrated intensity of particular sexual acts, like the kiss, is a kind of abstraction as its pleasure invades the sensibility and the details of personhood are replaced by sexual openness. And then, of course, there is the orgasm itself.

But the orgasm is an event.

❀ ❀ ❀

Time is, of all modes of existence, the most obsequious to the imagination.— *Samuel Johnson*

I know what you mean by saying that Warhol's central metaphor is voyeurism, and it was an inescapable conclusion on my part, just from watching him watch the films, like the twenty-four hour film *Couch*, which is just twenty-four hours of people coming in and having sex in all different ways on this couch. He would sit and watch it with such contentment that I felt I was in the presence of a Buddhist who had achieved the desired transcendent state. Total satisfaction and total calm. Though in his case it struck me as being a necrophilia too; because what he was trying to move toward in the films was a stillness.—*Ronald Tavel*, in conversation.

Sex is always just on the verge of any Warhol film, one can feel it; but his early silent films are not really sexual in the way his later films became, all shimmering with crevices and organs and groins. (*Couch*, of 1965, is a conspicuous pornographic exception.) But the early works are erotic in a less obvious sense. They are the creations of a profoundly voyeuristic mind.

Now, the voyeur is a strange kind of person. *He is a man who absents himself.* He is a man who keeps his distance; and remoteness from the sexual scene is integral to his excitement. His passion and patience stand in a murderous equipoise. He is one who waits, waits with fanatical scrutiny, not missing the smallest detail. He is not a sentry, because he attempts to hide himself rather than give an alarm. Instead, his is a vigil in which the impulse to conceal himself becomes more and more intense as more and more is revealed. And, by thus extinguishing himself in his own excitement, the voyeur achieves a profoundly effaced impersonality, perhaps that impersonality that tends to dominate all compulsiveness. In the voyeuristic situation, his personality becomes radically diminished; the man who cracks jokes in the office and likes malted milks becomes merely someone watching, and all the energy of his personality is for a time diverted into that watchful persona. Since his is a sexuality in which nothing is shared, the voyeur's desire is peculiarly abstract—it is abstracted, usually faintly pornographic desire—and the woman or man is only all women or men, while the voyeur himself is merely One Who Sees. And, by defining himself as someone whose presence must remain unknown, as one who is not there—*there* at that point across the distance where all interest resides—his depersonalization is complete.

Viewed psychoanalytically, the voyeur might seem to be somebody who feels excluded from human contact, and for that reason a figure of pathos. But he has not been excluded; he has absented him-

self. In doing so, he is solving a problem. Presence is threatening to him: Distance is essential, itself a source of gratification. Distance gratifies because it resolves, and the voyeur's claim (if made) to be frustrated at that distance is almost invariably phony with half-truth: However ambivalently, he wants and needs it, and will defend it. What is his problem? He can find no wedge of entry into the primal scene: He cannot present himself where the love is. But he clings to his exclusion and protects it; unlike most people suffering from the sting of exclusion, he has no interest in at last breaking in. For the menace of some terrible threat hangs over the voyeur's impulse to present himself. One cannot speak generally about what this menace might be, except to say that it is very dire. Never underestimate its power; an entire personality and its most profound energies have been reconstructed, redefined to avoid what most people call gratification, to create what most call frustration. Somewhere in this is what the unconscious mistakenly understands to be the threat of death. Like all compulsives, the voyeur is trying to save his own life by refusing to live.

Even more than it does most movies, voyeurism dominates all Warhol's early films and defines their aesthetic.* Obviously, almost any important film-maker is likely to be a highly scopophilic individual, and, of course, film has always been the voyeur's delight, has always extended delicious appeal to the voyeuristic dimensions of us all. But works like *Kiss* and *Sleep* and *Eat* reconstruct in their eventless essentials a kind of paradigm, a structured filmic model of the voyeur's relation to the world. One could almost diagram it. And that paradigmatic structure, with its absented, depersonalized voyeur, and its uncaring, ungiving, self-enclosed spectacle embodies a kind of artistic and human drama felt moment by moment as the work reels through the projector, a vision of remoteness.

Everything in this paradigm follows from the situation of the camera in place of the absented voyeur. Before its witnessing and recording eye, the spectacle—the kiss; the sleeping, breathing torso; the man carelessly eating—is brought into the interplay of presence and absence that is central to Warhol's entire work at its best. Most important, in the hypertension between the spectacle and the camera, Warhol discovers a new dimension of the unreal.

Several peripheral elements impinge on the central effect. The first

* Voyeurism, the discovery of the height of sexual intensity in watching, should not be confused with scopophilia, the love of gazing endemic to all human sexuality. Technically speaking, voyeurism is a transfixed and compulsive diversion of scopophilic energy. In practice, the distinction between them can sometimes be rather vague.

is silence, that silence to which Warhol was condemned, out of techni-
cal ignorance, at the beginning of his career. It is an endistancing si-
lence, a mutism of otherness spread over the reality that the camera
so patiently records. It forces the spectacle into some region behind
the transparencies of film itself, a region from which no sound can
reach us, in which a past made present is silenced, and a minutely
recorded photographic reality made to seem, in its silence, remote and
unreal. These are surely among the most interesting silent films made
since it has been possible to choose silence.

In conjunction with that effect, there is the matter of the projection
speed. Almost all 16-millimeter film, including Warhol's, is shot at 24
frames per second. Warhol insists—it is strange to think of Warhol
insisting—that all his silent films be projected at what is called the
"silent speed" of 16 frames per second, with which most projectors are
equipped. The result is a *ritardando* exerted over all movement and
an effect that is extraordinarily alluring. Yet that allure is faintly para-
doxical, since the Warhol silents are famous for their supposed place-
ment within literal clock time. Indeed, literal time has sometimes been
pointed to as their chief contribution, proposed as evidence that War-
hol has renounced any of those transformations of reality required by
a romantic vision. But Warhol is, in fact, a romantic aesthete of a
peculiarly modern kind. Needless to say, anybody watching *Sleep* is
going to sense the slow, murderous crawl of literal time passing him by
moment by moment, but that sense of literal time is also retarded by
the subtle undertow of the most immediately alluring, the most dec-
orative of all cinematic techniques—the visual hush of slow motion.

It is a technique that faintly dislocates the pressure of real time, ex-
tends it, and makes it just slightly Other, in a lush, subtle experience of
movement and time possible only in film.

All these effects combine to create the fixated distance of the War-
hol stare. Watching *Sleep* and *Kiss*, watching even the portrait films—
remote from the sexualized quiescence of the sleeper, remote from the
kiss, from the grinding of flesh on flesh, we find ourselves voyeurs at
both a proximity and a distance no voyeur could ever know, both near
and far away as only the camera can be, unreal with its minutely re-
corded literal reality.

Flesh becomes filmic. The lovers are close-up on the screen, but we
in the audience sit at a distance from the screen. This *doubling* of
our witnessing proximity transforms the felt presence of the camera
—and all the while we hear the projector chattering behind us—into a
metaphor for alienated consciousness. And the filmic art as well.

This metaphor is a prism, with its facets both in consciousness and
the real space of the hall in which we see the film. Implicit in the

close-up on the screen is a certain space: the distance between the camera and the real lovers under the circumstances in which they were filmed, the distance of the camera's focal length. Meanwhile, the audience sits in the hall, and, excluded from any narrative fantasy of immediate identification, feels peculiarly conscious of its somewhat impatient location there in real space, looking on.

Sexual and filmic fascination meld. Though we watch with the voyeur's gaze, there is a central difference between our experience and his. We are held back from the sexual spectacle not by the voyeur's impulse to hide and withdraw, but by the fact that what we see is unreal, is film. The doubled experience of remoteness—the consequence of a brilliantly diffracted experience of film watching—becomes a criss-crossed metaphor for the interplay of the real and the unreal, in conjunction with a basic trope of language and perception installed in the nerves as part of the language and the experience of interchange and gratification. It is the notion of desire and frustration understood in terms of a distance in space. (The language is filled with the image: "You seem remote"; "Mr. X is withdrawn"; "We are very close"; "He was distant"; a figure of speech with images of heat and cold to describe human relations.) This metaphor for love as a distance in space is plainly a voyeur's ideal metaphor, and, in Warhol's films, a filmic metaphor for the real and the unreal melds and identifies a metaphor of human nearness and distance to shock us with a double truth—pitched on a *tao* of frustration—just at the moment that the perforated, torn piece of film end flashes by on the screen.

The most powerful of the silent Warhol films are dominated by the same voyeuristic aesthetic, but their immediate look modulates considerably from case to case. In *Sleep,* the languid, immobile frame changes from one sleek pictorial voluptuity to another; from the image of the breathing abdomen, to a long shot of the nearly nude body (shot from the knee at an angle just high enough to reveal the sleeper's entire body stretching back into space), to a close-up of the sleeper's expressionless face—frontally, in profile—and then back again, the pattern recapitulated. But, in *Kiss,* almost every shot is framed in exactly the same way: It is the standard close-up of the kiss and fade-out. In both *Sleep* and *Kiss,* light is used to concentrate the voyeuristic scrutiny on movement—or, rather, on stillness—as the moments slip by. In *Eat,* an entirely different photographic style appears. Eating his self-renewing mushroom—like the food in the palace of *Beauty and the Beast,* regenerating itself on its glistening platters after being consumed—Robert Indiana is shot with light values suggesting still photography, and a classically conventional usage at that;

richly contrasted, graded blacks and whites seemingly bathed in the photographic luminescence of sunlight flooding in from a source at a window—very like the fashionable French portraiture of the 1940's and 1950's, calling to mind Cartier-Bresson, for example. However striking, the image suggests again a classic aestheticism, terribly "good taste," a kind of photographic decorativeness.

Indiana sits in a high-backed wooden chair: He is wearing a hat; his face is bland, open, indifferent. At times, he seems to silently respond to what must be people out of frame, speaking to him; other times, nibbling on his mushroom, he gazes with meditative, wistful boredom out the window, the source of all that pretty sunlight. The camera makes a few listless movements: There is a zoom to his hand—without, however, revealing the precise identity of the shapeless substance he's munching—then withdrawing for a while to a three-quarter shot until deciding (one senses the decision being made) to move in, just a hair, on the profile. That studied profile with its sad, outward gaze.

Eat was the first released Warhol film portrait,* followed seven months later by *Henry Geldzahler*, a portrait of the museum curator puffing on a cigar. The temperature of the film is extremely cool—not that its immediate predecessors are hot with bristling, grinding passion. In *Eat*, the meditative disjunction between subject, camera, and spectator is simple, uncomplicated by any of the fleshly, sensual paradoxes informing the earlier films. Compared to them, *Eat* is a less demanding and finally less exciting work. It *is* a portrait, and as a portrait it gathers a kind of slow power on its own momentum. Indiana's meditative self-containment—his being, his very flesh seem to feed on that self-containment—is itself the subject of a meditation. But, filmically, the work adds nothing to what has been done before, seems even to provide less. *Eat* is the image of a man simply allowing himself to be. I confess that I am very near a merely personal

* But certainly not the first portrait film Warhol made. The film portrait dominated all Warhol's early film activity, and vast amounts have never been released. In those early days of 1963, Jonas Mekas reports that a Bolex had been installed on a fixed tripod in the Factory, a huge pile of film rolls beside it, and that it was never taken down. Any new guest—remember that in 1963 Warhol was entering the most conspicuous era of his fame; there were *hundreds* of guests—was put into a chair before the camera as soon as he or she arrived. They would sit through the roll, their film portrait being made. When Warhol wasn't there, Billy Linich or Malanga operated the camera: it became a standard and inescapable tradition of the place. Wherever those films may be now—lost, stolen, stashed in Warhol's basement for a rainy day—hundreds of them were made.

judgment here: One would have to find the purely meditative mode more exciting than I do (exciting is perhaps not the word) not to suspect that perhaps *Eat* comes near a rather clever preciosity.

Still, it does accomplish in its own terms what is so exciting in *Kiss*. Within the voyeuristic structure I have proposed, the endistancing accuracy of the camera is allowed to record the tropisms of life and response, sensitive to the smallest revelation of the Person within the face. Yet this, too, is wrapped in a paradox: The sleeper's deep distance from us, the lovers' absorption in one another, Indiana's placid contentment—all find themselves in the distances of silence, in a decorative disjunction of time, in the nearness and remoteness of film mingling in an experience of the Person revealed and withheld at once.

Blow-Job and Pornography

●●●

Warhol's filmic voyeurism was destined to eventually begin its inevitable move toward pornography, if for no other reason than that it was always sexual in some way. And so, when readers of the *Village Voice* in 1964 saw the announcement of the new Warhol film, *Blow-Job,* their shock was a minor shock of recognition, the small jolt in the mind that looks at the arrival of the inevitable and wonders what took it so long.

A rather vacuously rugged guy, his back against a brick wall, his face in close-up, looks into the distance, waiting for somebody to begin giving him what the title so succinctly proclaims. A masculine shoulder covered with black leather skims the bottom of the frame, someone kneels invisibly, the action begins. The length of the film purports to be the length of the fellation—though attentive spectators may wonder if *Blow-Job* might not be another work in which Warhol "faked it." Yet, it does seem to be a real live blow-job that we're not seeing. The climax—it's Warhol literalism—seems intentionally (and indefinitely) postponed by whoever was in charge of timing to extend the work to its running time of thirty-five minutes.

The high contrast of all Warhol black-and-white films is here only slightly modified by the near presence of the wall, putting the frame much more under the domination of black than in most. Like the others, *Blow-Job* is something of a portrait film—the portrait of an anonymity. The recipient looks like a once fresh-faced, foursquare Eagle Scout, a veteran of countless archery contests and cookouts, who discovers in the process of becoming the all-American boy some weak psychic nerves that send him helplessly gliding in activities for which no merit badges are awarded, in which he discovers the body he acquired on all those jamborees and tramps in the woods becoming a bit hollow-eyed, just a touch *faisandé*. Whereupon he takes that body to the Big Apple, where he finds it to be a very sellable commodity. Large numbers of Warhol leads began their careers as homosexual hustlers. It seems a pretty safe bet that the star of *Blow-Job* belongs in their company.

His face relaxes into the vacant anonymity of the drifting fellated mind, his obviously half-blinded steaming gaze insistently averted from his invisible servicer, wincing against the unseen darting movements, pulling back into it sometimes, sometimes closing his eyes, sometimes tightening the muscles of his face as he is lifted to another preorgasmic plateau, then relaxing again as he seems to drift a bit before the next big rise. Warhol throughout uses his standard cartridge technique, and the emulsion every few minutes flickering upward toward whiteness becomes almost laughably suggestive, a little metaphor for the convulsions of sensuality.

The film is a piece of pornographic wit. *Kiss* and its fascination rest on a paradox of proximity and distance. The same paradox is at work in *Blow-Job*, but that paradoxical space of the close-up (in real life the space of the kiss, itself) is compounded by the fact that the film's real action is taking place very much out of frame. Seeing *Kiss*, the audience witnesses a nearness and a distance impossible in life. In *Blow-Job*, that space is further displaced into an imagined focus of interest, twenty inches below the frame, which the face actually on the screen never for a moment lets us forget. Perversely obdurate, the frame absolutely refuses to move toward the midriff, insists upon itself in a thirty-five minute close-up that must be the apotheosis of the "reaction shot," never to be surpassed. But that same insistence, with equally obdurate perversity, diverts attention Elsewhere, lower down, toward the Great Unseen that is a major dimension of recent American art, in a procedure that Marcel Duchamp, *mutatis mutandis*, would doubtless have found very interesting indeed.

For this exercise in the evidence of things unseen is Duchampian pornography. Visually and sexually, Marcel Duchamp's art is invari-

ably involved (after his abandonment of painting around 1917) in the refusal to create a self-sufficient spectacle and the denial of the primacy of the immediate senses in favor of something more remotely locked within the perceptual structure. The Duchampian context invariably involves a displacement of interest from what is being seen into a visually marginal, imagined concern created within us by the shadow-play of perception, by the activation of thoughts and alternate responses, even when the thing before us is truncated, uninteresting in itself, or absurd. The locus of interest becomes the operation of these unseen perceptions, the inner examination of their ghostly movements, the appreciation of how a reality alternate to the thing seen is constructing itself and falling away in the mind as we pass through the charade of observing, of witnessing. The work may be cryptic, introverted, unresponsive, absurd. It does not matter: Its whole life resides in the displaced responses it provokes.

That possibility, and variations on it, have been the animating insight of vast sections of the American *avant-garde* over the past fifteen years. Warhol is one of its principle inheritors. It is a procedure that almost always smacks of perversity, and at times it can be impossible. But it is an inevitable consequence of Warhol's mind, in part because of his own coyness and perversity, but also as a consequence of the brilliance and daring he has discovered in those experiences. And they provide his films with their innovative power, insofar as they have that power. *Sleep* is a film made under the aegis of this idea; the recent films associated with Warhol, directed in fact by Paul Morrissey, are not. It may be faintly academic, but it is true to say that the central difference between films of interest made by Warhol and those made by his epigonus is the complete absence of the Duchampian inspiration in the latter. The elimination of Duchamp's influence in Warhol's films— which was for their early defenders precisely what made them interesting—is on the aesthetic level what is meant by the commercialization of the work in Morrissey's hands.

Which returns us to pornography. At the time he made *Blow-Job*, Warhol was involved in a model of desire that might have made him the most interesting pornographer of the century—certainly an ambition he entertained and cherished on a grand scale. But the direction Warholvian pornography took after 1967 has nothing to do with what makes *Blow-Job* the brilliant *jeu d'esprit* it is. Warhol's pornography is involved in a logic of frustration and evasion. Films like *Flesh, Trash, Blue Movie,* and *Women in Revolt* are involved in pornographic comedy with a few fillips, such as the introduction of the male sex object and the comedy of transvestism. Joe Dallesandro is the center *of Flesh* and *Trash*: His naked body, curving buttocks, dangling geni-

talia, classic torso, and good-boy face are *the* center of the camera's erotic attention. Everything else is farce. The camera's task is simply to pay attention to that body, and the relation between camera and object couldn't be simpler. Visually, the camera wants. Visually, Dallesandro gives.

In *Blow-Job*, the fellated penis is the focus of attention; it's excluded from the frame. In erotic and artistic terms, this exclusion marks the difference between Warhol and Morrissey as film-makers. Warhol is uninterested in a spectacle that gives quite that much: That perversity, if such it can be called, is perhaps what saves him from the risk he takes in every major work he has ever produced, which is to be a mere decorator. One senses the power of that refusal, and it becomes the theme of his art.

Warhol is a man who, for all his intelligence, does not really understand people very well: Personhood is a mystery to him. His works gain their power from proposing the structure of that mystery. His voyeuristic obsession with the portrait is the arena in which this aspect of his art is most obvious. On the other hand, he is deeply engaged in the impersonality of a pornographic experience of the Other: The alternate dimension of Warhol's mystified experience of the Person is a violent anonymity. Perhaps one—by no means normative, but at least hypothetical—way of defining pornography is to understand the Other as a mere extension of one's own fantasies and needs. It is a self-enclosed, virtually autistic experience in which fantasy plays the dominant role: Pornography is always about imagined sex. That is to say, it is about our own imaginations, about ourselves.

This gives it a certain sameness, an eroticism without adventure; it is "boring." It is interesting that so many people complain that pornography is boring. It *is* boring, of course; anyone who has ever tried to do more than dabble in it knows how boring it is. Yet it is also passionately interesting. It seems to me that pornography is dull because it is dull to wait—and pornography requires us to wait. We wait through it, hoping for the arrival of those few moments which actually touch the nerve of some private fantasy, game, need. We laboriously wait through its *otherness* until it at last gets to *us*. Pornography is a patient art. Those who speak of its immediacy are speaking in very considerable confusion. Those who speak of its excitement are being evasive with half truth. The experience of *not* being excited is just as important. Watching, one sits through a vague dissociated sexual awareness, incessantly examining one's own responses, wondering when the thrill will come, why one doesn't feel it here or there, searching for the wellsprings of arousal. In this vague state, the personality becomes diffuse, lax, attentive, merely open, waiting for that sharp singular instant

(that may or may not come) when authentic desire will leap at the screen like a dog snarling for its gratification.

While waiting, one invents. The sprawl on the screen, the face, the thigh, that breast, that groin are not quite right: The imagination is demanding perfection, and constantly proposing its vision of perfection to us as part of its refusal to bite. The fantasy and the image on the screen unroll in mutual disjunction, side by side. And they meet, if they do, with a bang.

What has this to do with our man's perversities, his Duchampian pornography? Only that his own pornographic films wait interminably. Their refusal to give with the sexual goods is as much the exploration of a mystery as are his portrait films. At the time of *Blow-Job*, Warhol seemed content with that mystery and the wit he could extract from it. But his commitment to Duchamp's strategies and the autistic, evasive mentality they represent, was at last overwhelmed by his own voyeuristic mentality. He could not keep himself from finally taking a good, hard-core look. And so, in the late 1960's, Warhol began to move toward more forthright pornography, a move that culminated in the last film he directed entirely on his own—the wretched *Lonesome Cowboys,* perhaps his least successful long film. Abandoning Duchamp and lacking Morrissey's greedier and more self-indulgent personality, he lost touch with whatever was interesting in himself as an erotic artist, and, in *Lonesome Cowboys,* finds himself thrashing around in cute, giggling, voyeuristic confusion. Duchamp's art is involved in transvestism, castration, sadomasochism, the refusal to give, the deprivation of the senses—the stuff of pornography, in short. And for a while—at least on the evidence of *Blow-Job*—it seemed Warhol might fill up the pornographic cup of his spiritual father. But he bungled the job.

Haircut

Like all Warhol's early movies, *Haircut* is very rarely seen, apparently existing only in an original print. But it is perhaps the most impressive Warhol film of late 1963, with the most complex internal structure of all his early silents I have seen.

Haircut begins in more of that tough blackness of the Warhol black and white—this deep contrast will not reappear until *Vinyl*. The film makes use of much more space than the other early films—the entire length of a New York City loft, though evidently not the Factory, lit with key lighting from a single spot. The loft becomes a vast umbrageous hall, all its peripheral details just about to be swallowed in darkness, revealing only enough to hint at the battered industrial wood floors and walls, the scuffed and broken Salvation Army furniture, along with some light breaking in a blur through a window nearly opaque with the city's grime. The far depths of the room vanish entirely in the emulsion's shadows.

The opening frames present three men standing in this space. In the middle distance is a dark young man with dark hair: It is Billy Linich.

Nearer the camera is another man with a faintly more WASP look. Nearest the camera, in the extreme foreground and brilliantly bathed by the key lamp, the most visible and conspicuous of the three, is a very nasty-looking type posing without a shirt. He wears exhibition-istically tight, and very dirty, white jeans that glare a bit in the lens. Both he and his clothes look as badly scuffed as the loft itself. Bluntly, he looks like he knows 42d Street as well as or better than the protag-onist (antagonist?) of *Blow-Job*. His face and body have the strung-out wiriness, the tough, undernourished gracelessness of a slum es-capee who survives on street food, on sausage sandwiches bought at greasy open-air stands, hot dogs, Pepsis, and amphetamines. His chest and arms swarm with matted masses of black hair, but whatever vital-ity he has seems deflected into a loveless, hollow-eyed preening over the groin that his (otherwise carelessly worn) jeans force into high relief. Close to the camera and literally in the spotlight, he preens and postures in a laconic, faintly nasty way.

The three men seem occasionally to speak to each other, seem some-times to visibly respond to each other, but, in general, attention is mercilessly focused on the raunchy narcissist under the light. The two others, literally recessed in the space, recede in attention. The tradi-tionally slow-moving silence makes each of their small movements slightly strange.

Then, after taking a few steps toward the camera, the shirtless poseur turns his back and very slowly begins to saunter toward the dark, far recess of the room. We follow him—though the frame remains immobile—as he regresses deeper and deeper into this space. Occasion-ally he pauses, looks back at the camera a little, then turns away again, resuming his stroll. His glaring white-jeaned conspicuousness becomes dimmer and dimmer, less and less visible as he goes, until at last he is virtually obliterated in the shadows. Then, in the inevitable Warhol rhythm, the emulsion begins to flicker and whiten, itself obliterated not in darkness but whiteness as the cartridge expires.

In the next cartridge, the haircut begins. Billy Linich is now seated in a chair at the rear of the room, where the camera and the key lamp have been moved for a medium close-up of the WASP type very slowly, and very slightly, clipping at Linich's hair. The barber hovers at the left of the screen; to the right of the chair sits the young man without a shirt—now wearing one, and he has added, inevitably, a cowboy hat—reading magazines, apparently paying no attention what-soever to the other action except to once in a while reply in a silent monosyllable to remarks made from the chair. All three men are smok-ing cigarettes. Nobody's eyes meet the camera. Linich sits very, very still.

After the next white out, the chair has been moved, and the space of the frame has changed, is deeper and at a different angle. Linich is still getting his haircut, but the cowboy has begun a coy game of filmic strip poker: The shirt has been peeled off again. The barber monotonously continues snipping, but the cowboy sits in a swivel chair at a small desk covered with much unbusinesslike, but desky, paraphernalia. He has sullenly absorbed himself in some activity that it takes us a moment to decipher in the darkness: Our attention is diverted for a few moments. It turns out that he is shaking pot through a sieve, deseeding what will eventually be put into a carved meerschaum and smoked. Attention thus becomes slightly divided: The cowboy is doing just exactly enough to occasionally distract the eye from the very emphatically composed and framed scene in the barber chair. Composition would have us concentrate on Linich; action diverts us to the cowboy. He methodically fills his pipe, then abruptly turns in the swivel chair, directly toward the camera, and lights up.

In the final sequence, the theme of *Haircut* suddenly composes. The barber still bends over his charge, clipping away. The cowboy is (apart from his immovable Stetson) entirely naked, facing the camera, though his legs are primly crossed. We duly note his nakedness, and then our attention returns to Linich. And our attention rivets itself on Linich, for something has very much changed. He stares directly into the camera. The gaze is strange, even bizarre, truly arresting, simultaneously intense and affectless, powerful and yet somehow uninflected, unmodulated, hardly blinking, unchanging. The barber continues to work around Linich's head, dutifully clipping. Linich remains absolutely immobile, his stare seems to drive into the camera. The naked cowboy sits in his swivel chair, slowly paging through a magazine. He then tosses his magazine aside and—surprise—uncrosses his stringy legs. It is the most pronounced movement in the segment, and, just for a second, we glimpse his penis. Everybody in the audience will find they could hardly help but notice. For a moment, there is the flash of a glance, a very different quality of attention. But almost immediately a tiny zoom edges this little spectacle away, and, exhibitionistic kicks at an end, attention returns to Linich in his chair. But things have changed again. Now everybody in the frame is staring at the camera with that same murderous gaze. The final flickering whiteness begins, the cartridge has almost run its course. Then, just before it ends, everybody in the act breaks into vast peals of silent laughter, and, the spell broken, begins to rub their eyes giggling in the last few moments before the white-out.

It is like the small, silent, convulsive waking from a dream that ends in laughter. The moment is a gently felt turn of self-consciousness

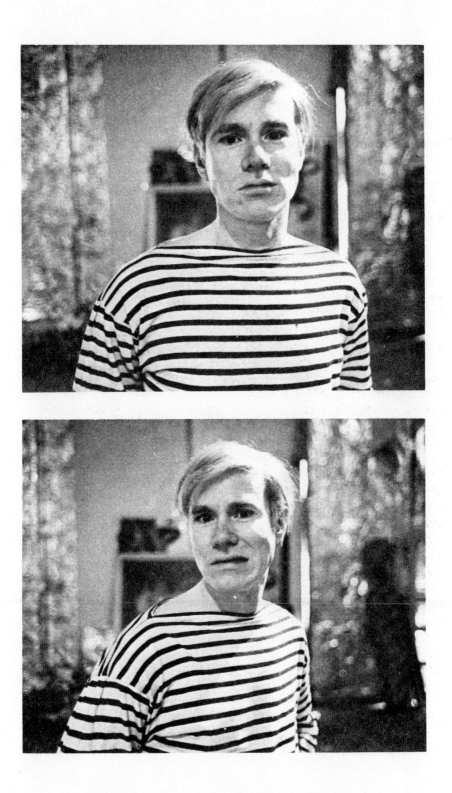

Eat, Robert Indiana.

John Giorno.

Sleep, freestanding oil on plexiglas, made from two frames of
Sleep. Collection, John Coplans.

Blow-Job.

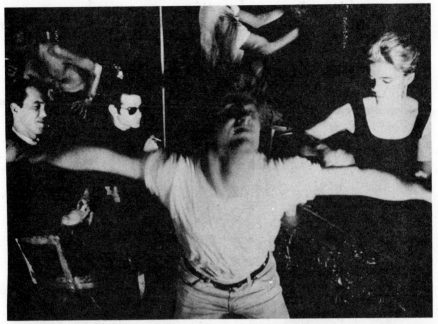

Vinyl, Gerard dances.

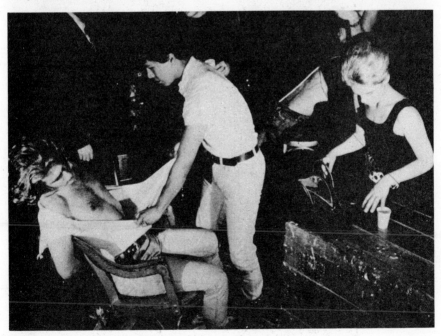

Vinyl.

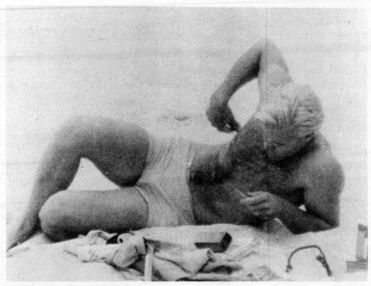

My Hustler, Paul America.

My Hustler, the towel slips. Paul America and Ed MacDermott.

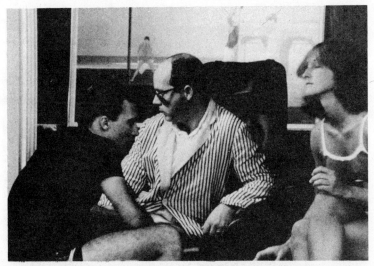

My Hustler, Ed MacDermott, Ed Hood, Genevieve Charbon.

Chelsea Girls, Ondine and Ingrid Superstar.

Chelsea Girls, Malanga and Marie Menken.

Chelsea Girls, Mary Woronov, Patrick White, Ed Hood.

Chelsea Girls, Mary Woronov as Hanoi Hannah.

Ondine's rage in
Chelsea Girls.

I, a Man, Valarie Solanis in her single Warhol film appearance.

I, a Man, strip of a night freeway.

Lonesome Cowboys, Taylor Mead.

Lonesome Cowboys, the rape.

Blue Movie, Viva and Louis Waldron.

Lonesome Cowboys,
Viva.

Flesh, Joe Dallesandro.

Flesh, Joe Dallesandro.

Flesh, Joe Dallesandro.

Flesh, Joe with his child.

Flesh.

Flesh.

suggesting the gentlest of put-ons—a put-on not in the sense of artistic fraud but one implied by a kind of Prosperolike cadenza (if one may compare great to small), a breaking of the spell. With it we realize that, like all the other early films, *Haircut* is about the hypnotic nature of the gaze itself, about the power of the artist over it.

But there are some very important differences, elaborations on the early films. As in all the films, the spectator's gaze is kept extremely close to complete stillness (there are, however, as in the early films, some very slight, and very slow, movements of the camera, though almost exclusively as zooms). But, in *Haircut,* that stillness is not entirely unbroken; it is, in fact, invited, is even *directed,* to move. For the first time in Warhol films within the silent style, a visual *event* occurs (for example, the near vanishing of the cowboy into the darkness of the end of the loft); for the first time, attention is not held in focus on a single and singular visual phenomenon, with its small changes. It is forced to notice things and disregard others, however momentarily; one finds that one must choose where attention will be given. It is a very directed choice, but a choice. The monody of Warhol's early filmic voyeurism develops a visual counterpoint (just as *Blow-Job* introduced a perceptual counterpoint), all the more felt because it is so minimal, and an element that would shortly become a very important element in the style of the sound black-and-whites.

Somebody may wonder if something so slight, and occurring so very late in the history of film, is deserving of paeans of praise. I recently watched a Sherlock Holmes film (with Basil Rathbone) on television; at any point in almost any frame of one of those clutzy hack products of thirty years ago, the eye will find enough to distract it to four or five points on the screen. The same is true of almost any commercial film one can think of. But Warhol's minimalization of visual events (and of the visual field through the contrast) transforms the process of the eye's movements, its shifts of attention, into a peculiarly conscious process, for the very simple reason that those slight changes of attention are *all that is happening.* His pretexts for these changes are sometimes anecdotal (the deseeding of the pot); sometimes sexual (the slow stripping of the cowboy, that quick little flash in the final reel). Sometimes Warhol plays on an enigma (the unreadable, purely formal nature of the movements in the first segment) and on our visuality, such as the white jeans disappearing into the filmic black. And he employs the standard devices of composition: particularly with the device of the haircut, framing Linich's face in the immobility of the chair and reinforcing that focus of attention on his face by the movements of the barber's hands and scissors around his head. Finally, there is the pictorial composition of the frames themselves.

Linich is sitting for his portrait in that barber chair. The frame almost suggests some kind of Renaissance portrait of a central figure with two attendants hovering nearby.

But underwriting all this is the cinematic drama of the gaze, reaching its final and reflexive development in the last segment with Linich's riveting stare. Yet, in all of the last three segments of the film, as is the case with those Renaissance portraits they suggest, the internal structure of the space is very powerfully defined by the sight lines of the protagonist's eyes. It is in the final segment, with Linich's gaze outward, that that structure fuses with the invisible architecture of the voyeuristic, filmic gaze exerting itself in earlier works such as *Kiss* and *Sleep*. All that I have said about *Kiss* and *Sleep* applies, *mutatis mutandis*, in *Haircut*, except that, as we gaze at the spectacle, Linich returns the stare.

That is why I think that *Haircut*, of all the Warhol films, bears the most interesting relation to the art of painting. Much can be said about the other works and their relation to painting: *Sleep*'s frames, for example, are all fine examples of Warhol's excellent pictorial eye. We've noted (in a somewhat different arena) the sophisticated nods in the direction of still photography in *Eat*. And almost every one of the early works is marked by a very strong—not to mention rather stable—pictorial composition; all immediately suggest Warhol's earlier choice of photographs for his silk-screens. In fact, he made some very fine silk-screens in the characteristic style from frames of *Eat*, *Sleep*, and *Kiss*, and could undoubtedly do a great many more.

Yet these are mere reflexes of Warhol's general talent and style. *Haircut* uses its pictorial elements in a very different, more specific way. The earliest films are, certainly, very sophisticated works, and they are self-conscious works in the sense that merely to experience them demands a very self-aware response on the part of the audience. They isolate the audience in an experience not many people would have previously connected with films at all, putting it, literally and figuratively, in the *place* of the voyeur, filmically redoubling the alienation that involves.

To understand this we must return to Duchamp. In all successful art, the audience of course perceives the elements that compose the work. But in the works modeled on the aesthetics suggested by Duchamp, the audience finds its own perceptions as integral parts of those metaphoric structures that make the works succeed. Since all work must be perceived by an audience, the notion of a purely autonomous work is patently a critical fiction. But for most art, it is a useful fiction, because the general terms of the work's apprehension are internal and can be more or less completely described without resorting

to the "impressionism" of private whims. But in works built on the Duchampian paradigm—which most certainly includes the Warhol silents—the minute by minute reactions of the audience must be an integral part of a description of the work's structure, for the audience itself is one of the terms of the metaphor dominating the whole conception. Without a description of the functioning perceptions of the beholders, the work is entirely deprived of life, and becomes as dull as a bottle rack, a movie in which nothing happens except that a man lies on a couch and sleeps for a very long time. Interestingly, the Duchampian paradigm often finds itself complemented by the structure of a psychopathology. It is in the metaphysical structure of voyeurism that Warhol finds the means for making that paradigm vital, just as Duchamp found his own in the structures of autistic schizophrenia.

Haircut is the only Warhol silent I know (to repeat: some are unavailable) to install a recapitulation of this principle as an integral part of the events *on the screen*. It is the only one I know to invite the voyeuristic response, and having invited it, to speak back to that response in full self-awareness. Linich and his friends rub their eyes and laugh as the emulsion begins its inevitable final disintegration. ("As you from crimes would pardoned be/ Let your indulgence set me free.") But the film also speaks to its own metaphoric means by what seems to be a high degree of cinematic allusiveness.

A word or two more should be said about the compositional style. As noted, it rather resembles that of a painted portrait, far more so than of any photographic style. To speak in general terms, the instantaneous precision of photography quickly redefined the aesthetics of portraiture, and did so deeply—particularly with respect to the *pose*. There was not merely the obvious difference in the length of time involved, from weeks to split seconds, but in its very nature, its *look*. Around the concrete technical need to have models *hold still* for a long time, and in its tendencies to stylize the nature of movement itself, painting developed a profusion of conventions—conventional poses to suggest the capturing of life *sur le vif*—yet installed in almost all, and in the essence of painting itself, was that quality of *holding still*. There developed a vocabulary of poses for the quotidian movements of life. Photography wiped them away in a single stroke: Its instantaneous, merciless realism showed them as "stilted," mere frauds. And so the sitter for a photographer must either be authentically caught in some candid movement, or he must frankly pose (forgetting all pretense of "doing something normal") as if for the portrait and nothing else.

Haircut is about holding still: It is about a cinematic paradox of movement and stillness, borrowed, among other things, from the aesthetic of the painted portrait and transposed to film. (The haircut is

surely one of the few stray hours in the life of modern man in which he experiences something like the rigidity that must have been the ordeal of Ingres's sitters.) Linich holds still to have his hair cut, to have his picture taken, to have a movie made about him. A movie about the stillness and motion of the eye itself. *Because,* as Tavel put it, *what Warhol was trying to move toward in the films was a stillness.* Here we must pause, for if this stillness is indeed Warhol's theme, its strange meaning is not yet clear.

The Last
of the Silents

●●●●●●●●●●●●●●●●●●●●●●●●●●●●●●●●●●●●●●

Sometime in 1963, a young man named John Palmer, barely eighteen, came to New York from New England and, after working briefly with Jonas Mekas at the Cinematheque, began hanging around the Factory. Palmer had made a brief and frenzied appearance in one segment of *Kiss*, and had undoubtedly walked through a few other silents during that year. Presently, he became something of a personage around the place. The period of Warhol's silent films was drawing to a close, and some people had been fascinating the master with the amazing information that sound equipment wasn't all that hard to operate. And so, as the swan song of the first phase, Palmer suggested the ultimate Warhol silent, the farthest out of the farthest out, the celebrated *Empire*.

If ever a film was devised to be discussed and not seen, *Empire* is surely that film. Shot from the 44th floor of the Time-Life building, the camera gazes for a full eight hours of moronic unmoving rapture at New York's venerable 102-story monstrosity while the sun majestically sinks through the afternoon toward darkness in an all-too-literally

breathtaking smog. Warhol had just bought his first Auricon camera
—a simplified sound camera that permits single-system synchronous
shooting without laying sound on at the editing table. With progress
so easy, Warhol couldn't resist. But, with typical perversity, after the
camera was bought, he and Palmer (assisted by Jonas Mekas) used
the new machine to shoot the most profoundly mute motion picture
ever filmed, and then, the farewell to silence complete, Warhol pro-
ceeded to his first real talkie, the inaudible *Harlot*.

Empire is so stupendously perverse it is almost awesome. Utterly
disregarding any possible source of visual interest for the audience,
it follows a cinematic witticism to the bottom of the night, subsuming
the greatest and most hilariously debased of all monuments to War-
hol's beloved Art Deco into a work of absolute vacuity. "The E
State Building is a star!" Warhol exclaimed during s at
last elevated navel gazing to the monumental, epic style.

Nonetheless, certain events do occur in *Empire*. Th ves
through the sky. At dusk, the floodlights illuminating per
thirty floors come on. (The spectator must be attentive; t tic
moment is brief and easy to miss.) But, after all, as is c to
say of such works, the "plot" and "content" of *Empire* aren lly
important thing. *Empire* has interest, if at all, in only two w is
a fact; it was made: The other, a question; why?

Understandably enough, the resonating media response Warhol got
for *Empire* came to some other film-makers like a slap in the face. It is
not pleasant to work and work in an expensive but unprofitable art,
arduously pursuing difficult ends, only to discover that the limited
public attention available to Independent film is being absorbed by
someone who comes on as the merest chic prankster. *Empire* seemed
less a challenge than a taunt. And the critical label, "put-on," sug-
gested the smirking success of the wise-guy, the wheeler dealer, the
snotty infantilism of putting something over and getting away with it.
No matter: Warhol could indeed get away with it. A "major artist"
makes a film that seems to have precisely nothing to offer except its
own unwarranted success as a put-on. "Fan–*tas*–tic P. R.!" exclaimed
Warhol's friends and enemies alike. Those, after all, were the days of
the topless 'cello player Charlotte Moorman, when it was a familiar
axiom among mediocrities south of 14th Street that fame lay just the
other side of any outrageous, silly public act—and *Empire* seemed only
another contender in that long line. Those days are fortunately gone,
and if *Empire* were nothing but one of their relics, it would deserve
nothing but a snort of dismissal and a swift heave-ho.

Perhaps it does deserve exactly that. Yet *Empire* retains a spooky
staying power as a *locus classicus* not of the screen but of the mind.

The Last of the Silents

●●●

Sometime in 1963, a young man named John Palmer, barely eighteen, came to New York from New England and, after working briefly with Jonas Mekas at the Cinematheque, began hanging around the Factory. Palmer had made a brief and frenzied appearance in one segment of *Kiss*, and had undoubtedly walked through a few other silents during that year. Presently, he became something of a personage around the place. The period of Warhol's silent films was drawing to a close, and some people had been fascinating the master with the amazing information that sound equipment wasn't all that hard to operate. And so, as the swan song of the first phase, Palmer suggested the ultimate Warhol silent, the farthest out of the farthest out, the celebrated *Empire*.

If ever a film was devised to be discussed and not seen, *Empire* is surely that film. Shot from the 44th floor of the Time-Life building, the camera gazes for a full eight hours of moronic unmoving rapture at New York's venerable 102-story monstrosity while the sun majestically sinks through the afternoon toward darkness in an all-too-literally

59

breathtaking smog. Warhol had just bought his first Auricon camera
—a simplified sound camera that permits single-system synchronous
shooting without laying sound on at the editing table. With progress
so easy, Warhol couldn't resist. But, with typical perversity, after the
camera was bought, he and Palmer (assisted by Jonas Mekas) used
the new machine to shoot the most profoundly mute motion picture
ever filmed, and then, the farewell to silence complete, Warhol pro-
ceeded to his first real talkie, the inaudible *Harlot*.

Empire is so stupendously perverse it is almost awesome. Utterly
disregarding any possible source of visual interest for the audience,
it follows a cinematic witticism to the bottom of the night, subsuming
the greatest and most hilariously debased of all monuments to War-
hol's beloved Art Deco into a work of absolute vacuity. "Th E
State Building is a star!" Warhol exclaimed during s at
last elevated navel gazing to the monumental, epic style.

Nonetheless, certain events do occur in *Empire*. Th ves
through the sky. At dusk, the floodlights illuminatin per
thirty floors come on. (The spectator must be attentive; { tic
moment is brief and easy to miss.) But, after all, as is c to
say of such works, the "plot" and "content" of *Empire* aren lly
important thing. *Empire* has interest, if at all, in only two w is
a fact; it was made: The other, a question; why?

Understandably enough, the resonating media response Warhol got
for *Empire* came to some other film-makers like a slap in the face. It is
not pleasant to work and work in an expensive but unprofitable art,
arduously pursuing difficult ends, only to discover that the limited
public attention available to Independent film is being absorbed by
someone who comes on as the merest chic prankster. *Empire* seemed
less a challenge than a taunt. And the critical label, "put-on," sug-
gested the smirking success of the wise-guy, the wheeler dealer, the
snotty infantilism of putting something over and getting away with it.
No matter: Warhol could indeed get away with it. A "major artist"
makes a film that seems to have precisely nothing to offer except its
own unwarranted success as a put-on. "Fan–*tas*–tic P. R.!" exclaimed
Warhol's friends and enemies alike. Those, after all, were the days of
the topless 'cello player Charlotte Moorman, when it was a familiar
axiom among mediocrities south of 14th Street that fame lay just the
other side of any outrageous, silly public act—and *Empire* seemed only
another contender in that long line. Those days are fortunately gone,
and if *Empire* were nothing but one of their relics, it would deserve
nothing but a snort of dismissal and a swift heave-ho.

Perhaps it does deserve exactly that. Yet *Empire* retains a spooky
staying power as a *locus classicus* not of the screen but of the mind.

The idea of the film (rather than the experience of watching it), in which the movement of the sun can be codified as a thought, the passage of the day encapsulated in a single stroke of eidetic shorthand, is in itself impressive and rather beautiful. Of course, the disjunction between the pristine idea and the eight-hour reality is literal and incommensurable. Indeed, that may be the point. In *Empire,* the knot between the conceptual and the concrete is conceived in its simplest terms, literalized, and simply untied. It is one of Warhol's most striking techniques: The dissolution of central imaginative and metaphoric tropes that dominates the art are literalized and thereby dissolved. (The subject will come up again, on a more elaborate scale, when we get to *The Chelsea Girls.*) And, of course, *Empire* is a major element in that by now well discussed little drama of utterly perverse human attention, Warhol's theme.

In a famous proto-Duchampian *aperçu,* Baudelaire spoke of preferring to look at the chandelier hanging from the theater ceiling rather than the play. It is easy to imagine that tilt-up of the Warholvian camera from stage to chandelier as the actors drone on and on, excluded and invisible. *Empire* is a massive, absurd act of attention, attention that nobody could possibly want to give or sit through. Indeed, nothing cou'd possibly tolerate it—and here's the point—but a machine, something that sees but cannot possibly care. The film completes Warhol's Duchampian dehumanization of the cinematic eye. For the machine is also being exercised in a very human choice: the choice to use the camera in that way, with a subject inspired by the rhetoric of monumentality—the tallest building in the *world!*—and a brainlessly sly sexual joke about the fluted stainless steel phallus. *Empire* is preposterous and even offensive in its imposition of the very human wish for dehumanization. It is impressive—yes, impressive—in the conceptual and technological force and beauty of that deplorable dream. After this last interminable eight-hour squeeze, the grip of the Duchampian aesthetic over Warhol's work began to loosen.

In any event, by 1964 Warhol was drifting elsewhere, though certainly the influence would never leave him, and it can even be argued —it *has* been argued—that the further he drifted from the Old Man's inspiration, the less interesting and important his work became. And there has indeed been a considerable faltering. Warhol was from the beginning in a remarkable artistic rapport with the Duchampian terms of perversity, apperceptive distancing, even wit—though I vastly prefer Warhol's American version. And, within those terms, when they held unbreakable sway in the early 1960's, Warhol could hardly make a false move as an artist. And, with the arrival of sound and the slow release from Duchamp's influence, he did indeed begin to make false

moves. Such a purist argument may be reminiscent of the aesthetic controversy that surrounded the arrival of sound in the late 1920's, in which the proponents of pure film saw before them the risk of the true cinematic language falling apart in the service of the narrative and literary developments that dialogue seemed to force upon the medium. And Warhol did indeed confront this problem as an artist and in terms of his grander ambitions. He is an artist with absolutely no gift for conventional narrative: The presence of that narrative in the later films is entirely the consequence of Morrissey's influence. Yet sound did present him with certain problems connected with narrative, which he proceeded to deal with in various antinarrative ways, probing at a problem that he would not fully solve until he reached *The Chelsea Girls*.

But there was also, in the context, a shimmering lure. The palm trees were beckoning; Warhol had begun to toy with at last forsaking his modernist sources in the plastic arts and making his move to his beloved, adored Hollywood. "I love Los Angeles. I love Hollywood. They're beautiful. Everybody's plastic, but I love plastic. I want to be plastic." There were even several trips to the Mecca in 1965, feeling out possibilities. Warhol was, of course, to remain a member of the *avant-garde* for several more years, but the idea, the dream of the move was already dancing before his eyes, irresistible. Strange dream, not of the future but the past, ephemeral as a black-and-white vision of Dietrich's lifting eyebrow.

The Talkies

●●

His new Auricon camera in hand, the master was ready to begin on the second phase of his recapitulation of the history of film. But new personnel were required, and among the first "discovered" was a young man named Ronald Tavel, a poet and novelist whom Warhol had heard reading on tape from his novel *Street of Stairs*. The story goes that Warhol had found Tavel's "voice" impressive, and for talkies you need voices, right? Tavel was contacted, and the relationship that was to determine the direction of most of Warhol's films for the next two years was begun.

"He was not interested in the narrative aspect of my art," Tavel says now, speaking of the changes he and sound brought to the Warhol aesthetic. He reports that, after he became the "scenarist," he asked, "Well, do you want a story, do you want a plot? And I remember most specifically that he answered 'no, not plot, but incident,' which was incredibly specific of him. It must be the most specific statement he ever made to me."

And so the first sound film, *Harlot,* was shot with Tavel's help in De-

cember, 1964, the camera steadily framing the newly discovered trans-
vestite, Mario Montez, in high drag, reclining on the Factory couch
beside Carol Koshinskie, while behind the couch stand Malanga in a
tuxedo and Phillip Fagan, mute sentinels to the film's visual action.
That action consists of Montez lasciviously devouring banana after
banana while Miss Koshinskie holds a small dog in her lap and stares
into the distance, stupefied with boredom. Meanwhile, Tavel, Billy
Linich, and the poet Harry Fainlight, out of frame, carry on a more or
less inaudible discussion about the great female movie stars.

Herein lies a device, the first Warhol chose to deal with the prob-
lems and possibilities of sound. The more-or-less complete elimination
of the speaking voice from the frame, so that the voice can be played
against the visual scene, as if in response to the call for a contrapuntal,
"dialectic" use of sound in the celebrated "Statement on Sound Films"
made by Eisenstein, Pudovkin, and Alexandrov in 1928—though there
would have to be an interesting codicil on Warhol's relation to the Old
Masters' fear that sound would retard the tempo of montage. Using
technique, Warhol uses sound as the voice of the voyeur (in *My
Hustler*), or the superior commentary on a patronized spectacle
(*Beauty #2*), or a complex narrative played against an unchanging
and simple visual image—as in *Suicide*, a perhaps lost film I have been
unable to see, but which Tavel conceived as a man's account of an
attempted suicide as the camera stares for a very long time at his
scarred wrists. Finally, there is in *The Chelsea Girls* a successful effort
to ceaselessly play sound against image in an elaborate mechanistic
counterpoint.

Harlot was done without a script, it was merely an idea. "We dis-
covered," Tavel now explains, "when we used stars or potential stars,
that very few had enough steam to go their own, and that a great
many of them panicked when the camera was turned on and they
didn't have the security of a script to work with." The idea was always
to evoke the presence and responses of the superstars. Just as in the
balmy Hollywood of old, the screenplays were invariably envisioned
as "vehicles" for this or that Factory celebrity. They were never in-
dulged as works of interest in their own right, just as many a major film
was written strictly as a pretext to get Joan Crawford back into those
wedgies and crying.

Warhol wanted to work at an almost alarming rate. Approximately
one or two "features" a month were to be made. A feature meant two
reels of thirty-five minutes apiece. Tavel remembers that "when we
organized, there were two a month. He would tell me one day what
he wanted; two or three days later, the script was ready and at the
end of a week, it was shot. Two, three days later it was processed, so

that two weeks was about the time between his telling me what he wanted and when it could be shown in a theater." And so, throughout 1965, film followed film, just like Warner Brothers of old: *The Life of Juanita Castro, Suicide, Horse, Vinyl, Prison, Inner and Outer Space, Hedy, More Milk Yvette, The Closet,* and then, in 1966, *The Kitchen.* And meanwhile, various unscripted films filled the interstitial tissues of production: *Poor Little Rich Girl, Beauty #2, Restaurant, Camp, Lupe.* The array is bewildering and in part now unseeable; many are lost films, perhaps never to be seen again. Some of those that remain are, it must be confessed, bad to a degree that is barely credible. Others I cannot locate at all, even to suppose them lost: Tavel wrote a script based on *Wuthering Heights* called *Withering Sights,* and I've been unable to dig up any evidence except a sparse filmographic note or two that the film even exists at all. More typical are the last reels of *Horse*—Tavel considers it the best film he did with Warhol— which have simply disappeared. I have seen only the first reel, an inaudible thirty-five minute view of a kid named Larry Latrae attempting to get a horse (which had been brought into the Factory on the freight elevator) to neigh. The horse doesn't. There may be more to say about *Horse,* but I am sorry to say that I cannot say it.

Warhol was the director of these films only in a very special sense. That special sense is the absolutely dominating attitude toward the role of the camera and the nature of the "incident." But he did not direct actors, or even the cameraman. It seems he was hardly present for some of the shooting, or, if present, only in a very remote way. Specific cinematic details were in the hands of the actors, Tavel, and the cameraman, who in most of these films was a man named Buddy Wirtschafter. In addition, Chuck Wein is in most filmographies listed as the "codirector" of several of the most significant sound films: *Beauty #2,* for example, *Poor Little Rich Girl, Restaurant,* and *My Hustler.*

These films make the question of authorship an intriguing and baffling little matter. They have a uniform style, the true Warhol style. They are about his relationship to time, his displaced experience of the camera, his remote fascinations. Yet some of the finest and most extraordinary moments in the films were sudden inspirations of technicians and stars, and Warhol had nothing to do with them at all, except of course create the situation in which they could occur. Jack Smith does a performance in the film underground revue, *Camp,* that is surely among the strangest and most bizarre anywhere in film. It was obviously unplanned, but perversely executed by Smith, among other reasons, to force Warhol to move the camera. One of the high moments of *Vinyl* is a sudden, violent zoom as Malanga sinuously

frugs before the camera: The hysterical speed and flutter of the movement picks up the silver shining in the factory walls to create an almost retinal effect. This stunning innovation, it turns out, was Wirtschafter's desperate solution to a broken zoom mechanism discovered during the uninterrupted shooting. So it goes. The single film of this period for which Warhol seems entirely responsible for the camerawork is *Hedy* (alternately known as *The Shoplifter, Hedy the Shoplifter, The Fourteen Year Old Girl, The Most Beautiful Woman in the World*). Depressingly enough, the camerawork is so far superior to that in most of the other films of the period that it becomes clear that Warhol's indolence with the others was bought at a real artistic price.

But it's futile to complain about that. All the films could be better. Excellence, like authorship, is finally not the point with this work. It was in the midst of this period that Henry Geldzahler at last left the Factory in exasperation with what he now calls "Andy's Grandma Moses attitude toward those films," and, as he left, he wrote on the blackboard, "Andy Warhol has stopped making paintings and doesn't know how to make films yet." Without necessarily going that far, it should be said that these films are above all the realizations of a certain attitude toward films and reality, and should be judged in those terms rather than as fully achieved individual works. The only work of this period that can be considered in the terms one ordinarily uses to consider masterpieces is the film that ended that period, *The Chelsea Girls*. The interest of the others as films comes from their casual extemporaneousness, from those half-choices reverberating within the Warhol mystique, and, now that the Warhol mystique is on the wane, a large proportion of them are insufferably dull. And so I will speak of those that can be seen and are not.

Beauty #2

The odd thing about *Beauty #2* is that it was always a relatively unknown film, even in the cocktail-party circuit of 1965. Which only goes to show about such circuits, since it is an almost ideal example of Warhol's technique of the period and one of the strongest films from any period in his career. It is about Edie Sedgwick, and Edie Sedgwick is one of the three or four people who justified the Warhol fascination with the superstars that characterized this epoch of his life. Not because Sedgwick was particularly gifted as an actress or performer—not like Ingrid Superstar or Ondine. And to say that Sedgwick had the qualities of a star in the old Hollywoodian sense— that she was a presence who was ideal when herself—seems like a

desecration, too, seems to invite the same inflated fantastic comparisons that did so much of the Factory in. No. Better to speak of her in another way, about the specifics of her presence.

She was among the most touching of the poor little rich girls to enter the entourage. For a while in 1965, she was queen of Warholvian chic. Most important, she was unique among the women superstars because she never played the female clown. All the others—Baby Jane Holzer in the grotesquerie of her voguishness; Ingrid Superstar, a perfectly conscious comedienne forever varying on the theme of the dumb blond; Tiger Morse (who appeared more often at Max's Kansas City than in films), camping and squealing like a schoolgirl; Viva, with her interminable frizzy-haired account of schizophrenia, lascivious priests, and a badly damaged female ego—all of them were in one way or another involved in a more or less comic display of their fears and weaknesses and overcompensations as women. But Sedgwick always kept her cool. When she spoke she made sense; her response to a contretemps on screen (and part of the technique was to create those contretemps) was never the customary hysteria but a visibly intelligent effort to cope. In *Kitchen*, which is a comedy, Sedgwick is noticeable as a grown-up woman, good-naturedly playing along with the joke: Ingrid Superstar, on the contrary, rises to one of her highest moments of Judy-Hollidaylike hilarity. Of course, like all denizens of the Factory, both male and female, Sedgwick glows with absolutely self-absorbed narcissism, and, God knows, she played the game of posturing chic everyone else around her played. For a few glittering months, the razor-cut cap of streaked blond hair, the thick eyebrows and lavish but meticulous eye make-up, the huge hoop earrings, were *le dernier cri*. But there was also something else residing in that face, that carriage of her frail body—perhaps a certain rich girl's self-confidence, a certain unshakable attention to the real, a certain belief in the truths of her presence as a woman. In any event, she was unflappable. She could be surprised or hurt or angered, of course—and is in *Beauty #2*. But her presence could not split, she could not be the fool. As a woman, Edie Sedgwick had what used to be called class.

All this makes her far more interesting than any of her compeers, and the ideal subject for a portrait film like *Beauty #2*. It has been perhaps a little too long since Lumière for us to be enthralled at the magic of film itself and with the simple fact of human movement on the screen. Yet (assuming one is thoroughly taken with Sedgwick; it is hard to imagine not being so), in this work precisely that magic is felt once again. The documentary vitality of film's record of time and light reasserts itself in erotic terms. Sedgwick sits on the edge of a bed, ice cubes in her glass tinkling (one associates tinkling with her

presence, of ice cubes, jewelry, and her voice and eyes), and when she reaches down to pet a dog named—what else?—Horse, the fascination of movement itself overcomes the screen. Beside her on the bed is Gino Peschio, playing presumably a kind of gigolo supplied by Chuck Wein, whose voice is heard along with Malanga's, out of frame, throughout the film. Chuck Wein is a former lover, her Beauty #1, and, in the triangular situation, he has brought her this Beauty #2. She reclines on the bed, her extraordinary eyes sharp and warm and alive with a delicately attentive sexual awareness that is riveting.

Lithe and small-breasted, she's wearing a pair of black bikini panties, her long legs alternately girlish and regal. Her movements are nothing but the merest business: sipping her drink, fiddling with her pack of cigarettes, patting the overly friendly dog, until such small stuff at last resolves itself into an attempt at love-making with the silent Peschio (who, shortly after the opening of the first reel, strips to his underwear).

But, throughout, there is a continuing and largely inaudible conversation with Wein and Malanga out of frame. The visual field is assailed by their disembodied voices provoking the astonishingly various and precise textures of Sedgwick's responses, the nagging intrusions on her peace that proceed to make her portrait come alive. But those remarks being made at her are also ideal illustrations of a much favored directorial mode in the Factory at that time: Taunt and betrayal. Tavel reports that one of his assigned tasks as a scriptwriter was to interview potential superstars and discover personal secrets that could then be surreptitiously inserted into a script to induce the inevitable responses of shock or anger or shame or confusion for the camera's placidly witnessing eye. Under the influence of this technique, the conversation in *Beauty #2* moves from trivia to desperation. There is even a terrible moment near the end in which Sedgwick (who died of a barbiturate overdose in 1971) speaks more or less inaudibly, but from real fear, of her horror of death. In other places, certain things are said off camera (I have been unable to decipher them) that plainly hurt and offend her (some others provoke the small miracle of her laugh); later, as the lovemaking demanded by the scenario begins, a series of cutting, catty remarks from the kibbitzers at last make her abruptly pull herself up, fold her arms around her knees and stop in unflustered, but visible, fury.

Warhol very consciously based his techniques at this time on the films of the 1930's—it was from the "Stars" that he developed the notion of the superstar appearing in what is essentially a pretext for a portrait. Speaking of that idea now, Tavel says, "You feel that films are very much history . . . the most authentic history books we have.

They record infallibly how people think, because when you watch them in those silly stories performing, what you really watch is the flesh at work, and the mentality, the thought that is ʾjehind the drooping of an eyelid, what is behind the inadvertent." So it is with *Beauty #2*. One does not indeed watch the flesh at work as erotic personhood; one sees the thought necessary to that living history Tavel speaks of, and finds in Miss Sedgwick the ideal subject for that purity.

Vinyl

Vinyl is the first film version of Anthony Burgess's famous novel *A Clockwork Orange*. In March of 1965, Warhol handed Tavel a copy of the novel with the remark that it might be easier to compose a scenario based on fiction than one spun out of pure fantasy. He had acquired the rights to the Burgess book for $3,000, he said; it ought to make a good movie. And so it did.

It's not hard to guess why Warhol was impressed by *A Clockwork Orange*. (I should mention in passing that, contrary to the myth he propagates, Warhol is quite widely read.) The book is filled with the sexuality of violence; it features a tough, erotic juvenile delinquent joyously dominating a gang of freaks; it confronts a psychology driven by a soulless, terrorized image of the mind as a mechanism, a machine; its theme is humiliation within a landscape that is simultaneously sordid and unreal. Finally, there is the question of class. Throughout his late work, Warhol is fascinated by the tough male illiterate: One senses him responding to the image of rough virility with a thirst to encompass—encompass and humiliate—that virility within the fey delicacy of his own aestheticizing mentality. I think Warhol participates very deeply in America's best kept secret—the painful, deeply denied intensity with which we experience our class structure. We should not forget that we are speaking of the son of semiliterate immigrants, whose father was a steelworker in Pittsburgh. Within the terms of his own intensely specialized mentality, Warhol has lived through American class humiliation and American poverty. And *A Clockwork Orange*, although British, is very much about the sexuality of social class as it merges with spiritual domination.

Tavel wrote his script in the customary three days, and shooting day was duly scheduled. A more exacting film artisan than Warhol would have found the conditions of those shooting days at the old Factory grounds for madness, for despair—but with his characteristic coy taste for frustration and perversity, Warhol seemed to take positive

pleasure in creating situations that would obliterate all hope for a "well-made film." For one thing, the press was invariably invited to attend, and attend they did, in large numbers, squisi.ed into a giggling whispering gallery around the performance area in company with a throng of friends, beautiful (or not so beautiful) people, hangers-on, freaks. The sense that making a film was work—that it should involve the concentrated attention of work—was utterly banished, and on shooting day the Factory merely played host to another "Scene," another party. Tavel recalls his frustration attempting to get his script properly rehearsed, which he thought necessary because shooting consisted of a complete run-through of the script as a performance, with few if any interruptions. But Warhol did not want the script to be rehearsed. Rather than simply announce that fact, he insisted upon interrupting and disrupting rehearsals that Tavel actually had scheduled. When a read-through was about to begin, Warhol would quickly dispatch Malanga, who was playing the lead, on some very long errand. Further to enhance the look of casual disarray, Warhol insisted that Malanga accompany him each night prior to shooting on an exhausting round of parties. And so it happened that Malcolm MacDowell's predecessor in the role of Alex (called Victor in *Vinyl*) hadn't even glanced through his lines before the big lights turned on and the camera began to roll.

In some preposterous way, Warhol's effort to surround the enterprise with short tempers, confusion, and frustration works for the film. The script is hard and knotted with the sharp intensity of the sadomasochistic rigmarole, filled with excruciation and rage and dehumanization. There is no way Warhol would allow his deep fascination with these subjects to turn into something unequivocally felt and real on the screen. For all its fistfights, arm-twisting, groveling, whining, sneering, for all its he-men pilloried and tortured, *Vinyl* is silly with a look of farcical cornball amateurism. The actors—very visibly reading their lines from idiot sheets out of frame—are hardly able to get the words right, let alone believe what they are being made to say. The film is laughably self-indulgent with its subject. Obsession and disaffection, cliché and confusion, the monstrous and the ridiculous skitter all over the screen like the peal of a long, embarrassed giggle.

And yet, there is something deadly serious about it all. I saw *Vinyl* for the first time at Warhol's discotheque, The Exploding Plastic Inevitable, over the old DOM on Saint Mark's Place in 1966. Part of the environment, the film was projected on a screen high above the stage amid five or six other films, light shows, and bursting and sliding abstract images all over the walls. Silently running high up there on the wall, *Vinyl* seemed to drown in the rampagant sound and overwhelm-

ing, blaring fantasy of that first light-blasted multimedia discotheque. And yet, in that ear-splitting, wall-shaking music box, as deafening recorded rock alternated with the utterly deadening music of the Velvet Underground, the Warhol rock group, *Vinyl's* remote, silenced vision of sexual violence assumed a strange admonitory authority over the hall. The silent spectacle of Malanga at his most preening and indulgent, dancing, beating up an "intellectual," having his shirt ripped off before he is strapped into a chair to endure the torture of his "reconditioning," all of it seemed to silently beat like the heart of that vast, jangling room laid bare. The Plastic Inevitable seemed at first a merely barnlike, faintly tacky discotheque. There were tables placed around the place, and various things were served. There was a dance floor. High on the walls, high above the immense floor-throbbing woofers and merciless tweeters, the films and light shows poured like an endless, drenching visual rain. But as the music alternated between cacophony and the hideous "acid" maundering of the Velvet Underground's insufferable navel-gazing guitars, the effort to create an exploding (more accurately, imploding) environment capable of shattering any conceivable focus on the senses was all too successful. It became virtually impossible even to dance, or for that matter do anything else but sit and be bombarded—"stoned," as it were—until that bludgeoning made weariness set in and one left, cursing the six-dollar admission fee.

And, above the stage, the image of *Vinyl*, the vision of Malanga rolling his groin and flexing a chain, followed by his torn-shirt excruciation, bound and gagged, at the hands of the "scientists," seemed perfectly subsumed into the core of the dominant fantasy of the place, the then fashionable game of "ego obliteration." Such, at any rate, was the ideological intention, as it was then being espoused by various seers such as Norman O. Brown and Herbert Marcuse and Timothy Leary. And of course, more simply, that environment was very much about the drug culture. The word is the clue: Trying to simulate being "stoned," the environment became a chamber of sensual assault, its aesthetic a battering. Now, of course, the response to such an environment has nothing to do with abandoning the ego, but something far less grandiose. One tends to withdraw more and more into self-enclosure, bombarded by a totally overdetermined sensory environment, staring for a long time at a single element of the environment (such as *Vinyl* up there on the high wall), less because of interest than as a means of screening out all the rest. And—in a way that I hope is by now plainly typical of Warhol—this focus becomes entirely dissociated from the ordinary experience of apprehension, having nothing to do with curiosity or gratification or associative understanding. Percep-

tion ceases to be an active process. One merely sits holding tight, forced into the enclosures of self-protection and refusal. Groovy.

This model for ego obliteration turned out to be, in fact, a vast chamber of passive aggression leveled against the senses themselves. *Vinyl* was not enshrined in that ambience by accident: Seeing it up there made me realize for the first time how deeply the then all-admired theories attacking the "ego" as the root of all evil and unhappiness had become for the *avant-garde* the grounds for a deeply engaged metaphor of sexual sadism, for "blowing the mind," assaulting the senses; it came home to me how the "obliteration" of the ego was not the act of liberation it was advertised to be, but an act of compulsive revenge and *resentment* wholly entangled on the deepest level with the knots of frustration. The fabled expansion was a contraction; the senses did not explode into liberty but imploded into withdrawal. I sat there struck by how deeply that dimension of 1960's intellectual fashion amounted to little more than an elaborate seductive lie: How transparently the paradise to be regained was turning out to be indeed a Velvet Underground in which the enraged, impotent ego—enraged and impotent from the beginning—was protecting its wounded, stinging experience in a nifty murderous little game of loser wins. Liberation was turning out to be humiliation; "peace" was revealing itself as rage. Such were the thoughts passing through my mind as Malanga strode out in person onto the stage, dressed in black leather from top to toe, and began to writhe through his Whip Dance.

About the film. Since no less than three versions of Alex the futurist juvenile delinquent now exist, I'll pass directly over *Vinyl's* plot to what Warhol did with the material filmically. But first a psychological note: The intense homosexual inflection given the film suggests the psychological strategy of first theatricalizing as sadism the unacceptable and threatening "male" property of aggression, the better to punish and redeem that masculinity in a sexualized and rather evasive ritual of masochism. The way the film plays with its hypermasculine roles is conspicuously inauthentic: A. D. MacDermott's effort, for example, to act and speak like a rough, blunt, ungrammatical cop teeters hopelessly as a performance between the depressing and the hilarious.

The space of the frame is deep and dark. At the extreme left of the screen, the Factory's mirrored turntable perpetually turns in the very deep space. In the middle distance, stocks and gibbets have been set up. The foreground is filled with Gerard Malanga, playing at being rough trade. He beats up a hapless passerby who is as old-fashioned and uncool as to read what the script refers to as "books" (in practice, a pile of old *Playboys*), whereupon Gerard celebrates his

brutality by dancing to rock in his best pelvis-wrenching go-go-boy
manner, flexing his chain and sneering until he is arrested. Time for
punishment. His shirt is ripped off and he is tied writhing into a chair
to be "reconditioned." And so Malanga remains bound and stationary
through most of the film until he is at last released and falls abjectly
to his knees before his torturers. Throughout all this, a group of maso-
chists have been chained to various implements of torture set in the
shadowy middle distance behind the main action. One squints to focus
on the dark, scarcely visible hints of their various agonies, which
seem to include arm twisting, having their clothes ripped off, being
force fed, being slapped, and so forth. That may sound like a lot of
action, but, in fact, *Vinyl* is very far from being a fast or crowded
film. Though it is almost unique among the films of this period by
varying its pace *slightly*, the over-all impression is of a rigidly sta-
tionary frame.

The film is, in fact, little more than a series of cinematic tableaux, a
set of sexualized poses. The screen is drenched with theatricalized
sex, sex that flexes its muscles, fills its chest, grimaces, and then (natu-
rally) *holds still*. The movement of the film through the projector is an
insistent reminder of the possibility of movement film itself promises,
but that possibility is very much at odds with a posturing immobility
—a sexual immobility—that is in fact what the film is about, both for-
mally and in its content. Yet there *is* movement in *Vinyl*—one move-
ment in particular that is the most spectacular in the film. When Ma-
langa begins to dance after beating up the hapless "intellectual," the
camera zooms in on his dance, then out again; then back and out
more and more rapidly, until the old in-out is flying as fast as the
frenzied hand can move the zoom lens or the eye can see. The screen
is transformed; against the silver paper lining the Factory walls, the
beating of the zoom lens becomes a brilliant flashing effect that pul-
sates against the eyes like the woofing of a sound. Certainly it is what
the art critics would call a retinal effect. One blinks against it. But,
when the dance is over, the camera returns to its quietude.

As a contribution to the cinematic vocabulary, the film's interest is
its changes between an erotically drenched stillness and frenetic move-
ment. And then back to stillness. And one cannot see the film without
being struck by the way Malanga's bondage in that chair seems a mes-
sage about that stillness. Within the realm of its formal structure, the
stillness in *Vinyl* has the same motive as does bondage in ethics. *It is
a consequence of guilt*.

That is the secret fascination of *Vinyl* and its language, the reason
for its place among the most interesting films made within the cele-
brated vocabulary of sadomasochism. Warhol's filmic language in *Vinyl*

involves itself in the horrors that underlie the 1960's' frenzied grace and frozen hysteria. And, as in all of Warhol's best films, the effects seem to be located at an extraordinary cinematic distance from our perceptions. That distance that was literalized the first time I saw the film up near the ceiling of that huge dancehall. 1965 was a moment in Warhol's career marked by something that can only be called perfect taste—special and perhaps unattractive, but perfect taste. The film's isolation in that resonating barn of a hall was one such flawless choice. The struggle of *Vinyl's* static pictorialism with movement is ideally viewed through a distracted awareness. One does not precisely watch the film, but rather one looks at it and then looks away again. Attention is held, only to be released and taken again, an effect that is surely an appropriate consequence of the film's whole *daimon.*

It was a byword of the American Independent Cinema of the middle 1960's—Jonas Mekas the most impassioned and eloquent spokesman for the idea, critically—to patronize the "well-made" film and the "slick" commercial product that "grips" its audiences in favor of a fertile amateurishness. In his columns, Mekas himself drew an analogy—later recapitulated by Annette Michelson in her essay, "Film and the Radical Aspiration"—between this fertile carelessness and the techniques and ethic of Abstract Expressionism. *Vinyl* is a careless film, careless with its obsessions, careless with its structure, careless with its iconography, technique, and performances; it is filled with that indifference to effect that makes even people who admire Warhol welcome and prefer the later films done by Paul Morrissey, in which the ideals of slick commercialism—for they *are* ideals in this country— make a consistent effort to entertain.

Vinyl's effects are much deeper, if perhaps more open to question. If *Vinyl* is intended as entertainment, it must be judged a failure. It is, as so often happens with Warhol's films, not a self-contained spectacle but a work that creates a situation for its spectator, playing with his perceptions, his indifference and his fascinations, his curiosity and his anger, in that careless way that indeed proved a valuable source of artistic achievement during the 1960's, but that the 1970's are repudiating in a moment of sickening morning-after distaste that threatens to last another ten years. The distancing effect of *Vinyl*, the yanking but limp-wristed alienations it induces, function to destroy the prospect of a familiar, immediate gratification—narrative and sexual pleasure—in favor of another, more remote and less familiar experience. That secondary pleasure—if such it can be called—is an absorbed, titillated disinterest that looks away and then back again in a peculiar psychic interplay between an experience of self-containment and frustration. This is precisely what the plastic and fleshly dreams of *Vinyl*

are all about: the perversity of an attentive inattention, the indulgences of a grimly believed inauthenticity, the sexualized bypassing of love.

Hedy,
or *The Fourteen Year Old Girl*,
or *The Most Beautiful Woman in the World*,
or *The Shoplifter*

To his extreme delight, during the middle 1960's Warhol made the acquaintance of Hedy Lamarr, the shoplifter. And her experience of being arrested as recounted in *Ecstasy and Me* inspired *Hedy*. This multititled but seldom seen work is unusual among the Warhol features. It is the only film of the period for which Warhol himself was the cameraman, and is therefore the single sound film of this period that can be called without debate the work of Andy Warhol, film *auteur*.*

The work is once again dominated by a certain pictorialism, but here the camera moves, following its characters through sinuous, undefined corridors of space, seeming to make the quadrilateral hall of the Factory a twisting shadowy region of distraction and confusion. In perhaps his most interesting performance for Warhol, Mario Montez plays Hedy, the Most Beautiful Woman in the World. "Ahhhhhhhhh" (a jab of the hip) "am the most beautiful woman in the worrrrrrld. Wheaaaah is my purrrrrrrrrse." The first frames of the film are in extreme close-up shot from above through a small surgical magnifying glass that fills the entire frame. This decorative little pictorial shocker is intended to be

* Here is Tavel on the subject of authorship: "See, I always read the credits, incidently. I was the credit man; they were always read—the title, the credits, and so on. And he kept turning the camera off and telling me not to read that credit. I'd say, 'but so and so worked on it.' 'No they didn't and they don't deserve it.' Which was the first time that politics was interfering with me. . . . But when I came back in 1966, he was definitely behind the camera in *Hedy*, and it's what I think makes it one of the outstanding films that we did together. Because finally the master took over, and we could see his eye behind the camera. This was the second moving camera film . . . and I hated it when I first saw it because it came very close to destroying my script, the way he moved the camera, but I loved it for what he did. Because I'd never seen that sort of thing before: As the action would move toward its most dramatic, move toward its point, its shattering, unbearable thing, the camera eye would move away, the camera eye would become bored with the action, with the story, with the problem of the star, kleptomania and so forth, and would begin to explore the ceiling of the Factory. Well, I was just wiped out. I said this is just like something else. Beautiful. Horrible in terms of the script. . . . And that's why I always tell people that argue about why they're not called Tavel's films instead of Warhol's films. I say, well, go see *Hedy*."

our first view of the great siren, a doctor's-eye view as she lies on a surgical table going through her annual face-lift. The camera then recedes very slowly from its expanded minutia to show the movie queen rising from her bed of pain to examine herself in the mirror, and then strut back and forth across the set: *"Ahhhhhhhh am the most beautiful woman in the worrrrld."*

And so she departs into the big world—in practice, more strange and shadowy Factory space. Her departure initiates a journey through a kind of filmic space for which it is difficult to find an exact precedent. To begin with, it is a rather theatrical space, not in the sense of the essentially proscenium framing of *More Milk Yvette* (another film with Montez), but theatrical because it moves from region to region in a single shot and defines the regions of that space through Montez's theatrical announcements. Hedy leaves the doctor's office for the store where she shoplifts; thence to the room where (once captured by the store detective Mary Woronov) she is interrogated; thence to her own apartment, to which she returns with her captor. This is, in fact, only one space, the space of a peregrination through a key-lit confusion of light and darkness. Montez is dutifully followed by the camera as if it were a very inattentive dog, constantly distracted by the fly on the ceiling. For the camera work of *Hedy* is much belied by the merely attractive opening shots through the magnifying glass: that camera is much closer to a wandering Baudelairean fascination with the vagaries of the walls and ceiling than it is to a Robbe-Grilletian scrutiny. One thinks of other filmed plays, like Jonas Mekas's remarkable film of the Living Theater's production of *The Brig*. There is once again a single uninterrupted shot within a confined space, one which is known in its particulars by the audience, the space, respectively, of the stage-as-brig and the Factory itself. In each case, the sinuous movement of the camera plays against the precise definitions of that space, and makes it completely other.

One can understand Tavel's distress at the discovery that his script had been so casually transformed—*Hedy* is one of his more elaborate efforts as a scriptwriter, following Hedy's ordeal through the robbery to that mortifying capturing hand on her wrist saying put it back; the interrogation by her dyky, beautiful captor, and the sexually titillating visit to the star's "home." The end is Hedy's eventual trial, which consists of the throngs of her ex-husbands taking the stand to explain what is wrong with her, her sins, her smallnesses, her multifaceted evils. The film ends with Hedy's own final little redeeming triumph, "I take back nothing. Nothing. Nothing." It is not precisely protoridiculous theater in the manner of *Gorilla Queen*, but just the same it is a kind of document in the art of mocking ironic transsexual sentimentality.

Worse luck for Tavel, the camera "got bored." It follows Hedy's flamboyant ambling through the spaces of her purgatory, but it gives her nothing, no attention, no flattery, hardly able to get itself to look. And even the camera's attention is an affront, when it looks it doesn't care, it is always threatening to return to that fascinating ceiling up above. A kind of antagonistic space is thus established. When the camera is indeed so kind as to have a look at Hedy and her problems, we are invariably in an amorphous, faintly expressionistic, theatrical and dreamlike space. But, when the camera looks away, in order to zero in on a scab of paint or a pillar or the battered wood of the floor, we are abruptly returned to the concrete, to real space and real time, bereft of its theatrics by a simple flick of the cameraman's wrist.

The inattentive camera is one of Warhol's most pronounced stylistic habits. That camera *will not* give the spectacle before it its full concern. One senses the constant tug of its refusal to submit to the domination of the scene and its idea, its interest; that camera is like a restless child who keeps looking away, staring around the room, not giving in to that dominating experience that is everyone else's concern. Or to change the metaphor, the camera exerts its refusals as if in a seduction, it is like a woman who absolutely will not acknowledge the sexual situations a man is obviously attempting to create. The camera will not give in; will not say to the spectacle, "yes, you have me, I am absorbed." On the contrary, the camera's wandering inattention is a subtle, passive method of guarding its own autonomy and even primacy: It utterly withholds itself from the threat of transparency that hovers over it; it refuses the illusion of nonexistence and willingness. But, of course, the camera has no final autonomy: It is only a watcher. In that sense, it bears an analogy to that human consciousness for which Warhol uses his camera as a metaphor. For we have no autonomy, either.

It is as though Warhol's camera was threatened with the existential dilemma of its transparency, its dependence on the real. The film-maker does, of course, have his dialectical relation to reality: He can use his medium to assume reality—real things, real space, real time—and *act* upon reality, transform it, make it coalesce with his will. But that option is temperamentally inaccessible to Warhol: His relation to the opacity of the real is far too deeply endangered to actively engage with it, to face it and take it on, as it were; his fundamentally passive temperament either falls into the mute transparency of an absorbed inexistence before the spectacle of the real, or must subvert reality's power through the stratagems of evasion and frustration. It looks, and looks away at once. It will not submit.

For, of course, these stratagems of self-assertion as frustration and refusal are the counterpart of the existential condition of the War-

holvian voyeur's willing depersonalization, just as the inattentive camera of *Hedy* is the counterpart of the immovable, staring eye of *Sleep*. The camera is used to realize a dialectic between the most extreme experience of presence and absence as it is felt before the power of others, the power, indeed, of that ultimate Other that in this context is simply the world itself. We are looking at the aesthetic of a consciousness threatened with the insubstantiality of its own being. It is a consciousness that, on the one hand, seeks a reality before which an autistic isolation can be utterly absorbed in the other, can become an insubstantial self lost in its own transparency and depersonalization, as it is in *Sleep*. But then it proceeds to redeem that lost sense of substance and autonomy by the opposite strategy of refusal and inattention, in which the rapt stare of a self blissfully forgetful—"a Buddhist who has achieved the desired transcendent state"—changes into the wandering, perverse gaze of a consciousness that *will not* look, *will not* acknowledge the power of anything over it. And the threat of a deep thirst for inexistence is the motive of these changes, trapped within the metaphors of transparency and passive power. Both options are metaphors for existence. Both are underwritten by the near presence of inexistence itself, seductively hovering near like death. And the ego, thus drastically defined, with the experience of its own power construed in terms of the most minimal and absolute prospects for life itself, paces between the desperate terms of both its existence and inexistence like an animal imprisoned in a transparent cage.

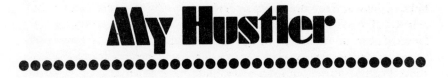

My Hustler

My Hustler is a crevice quite unlike the other films, based on an idea with none of Tavel's absurdist inspirations, an idea with a plot of a kind; not only a plot, but a plot that does not disjoin itself from the visual interest of the film, but runs with it, strictly neck and neck, merging, *being* that interest straight to the end. *My Hustler* is a piece of psychological realism. Even today writing this sentence feels strange. In 1964, one would not have expected ever to write it. It is a structured little piece of film about a probable human situation that is intended to hold the interest of all those people out in movieland. It is a film made at the end of a very long road from *Sleep*.

Was Warhol becoming bored with the pace of the compulsive theater of the ridiculous absurdity that had produced *Kitchen* and *Juanita Castro* the winter before? Had Warhol tired of not caring in the special way he seemed not to care about his films? It was summer, it was perhaps time for something new, there were new people around. Paul Morrissey, for example, had recently joined the entourage, and he was not impressed. From the beginning Morrissey was a kind of anomaly

in the Factory. He was in no way a member of that street culture that
it had assimilated in the years before. He was another, far more famil-
iar kind of person: Somebody who very much wanted to be somebody,
a very typical young man in a hurry. That was not really the Factory
style: Pushiness was out. Morrissey liked most of what he saw in the
Warholvian world he had hurried into, but he didn't like all that fool-
ing around, didn't like arty movies for small chic audiences who ar-
rived late and left early, who made jokes among themselves about
ennui, who "just *loved* your movie, Andy." And he wasn't so sure about
the lingering ambience of the art world, either. His attitude toward
such things was simple—that is, if Viva's accounts of them in her *roman
à clef, Superstar,* can be believed. All this high-culture stuff is just a lot
of self-indulgent fooling around, and nobody really gave a damn, they
were just a bunch of people sitting around waiting for the end. The
end of a boring movie. The end of high culture. There were only two
kinds of *real* artists in America—which means the world. There were
the "Pop" singers. And there were the high commercial film directors,
the biggies of Hollywood. As for the rest, they were a bunch of freaks
and losers trying to talk themselves into thinking they cared. That's
putting it bluntly, but then, Morrissey is a blunt man. "There's an Eng-
lish word for the people who think *Empire* is the height," he once told
a German interviewer. "It is snob." To hell with this pretentious bull-
shit, Sam, it's no way to waste a life.

Morrissey's concrete role in filming *My Hustler* may not have been
much. His influence had not yet really begun to rise, he was just an-
other new person around. Yet the atmosphere of the place was imper-
ceptibly changing, hardening. Chuck Wein is credited as the "director"
of *My Hustler:* Its somewhat anomalous quality may be attributed to
the possibility that it is "really" Wein's, not Warhol's film. But the film
is not entirely discontinuous with the other work. Certainly its subject
matter binds it to the *oeuvre:* Hustling joins transvestism as the sexual
subject that must completely interest the Warholvian eye. With an
artistic algebra that is the critic's dream of simplicity, the film inte-
grates that subject into those stylistic concerns I have been trying to
elevate into Warholvian principles. The voyeurism is neatly dovetailed
into the narrative scene. The opening frames show a wide expanse of
sand seen from a great distance. The surf is far beyond, breaking
against the shore in the deepest regions of the screen. It is a brilliant
summer day, and out on the beach there is a small human speck. It is
none other than Paul America—another raunchy Eagle Scout in War-
hol's long line of male sex objects—seen from an almost squinting dis-
tance until the camera begins to zoom in on him. On the sound track—
out of frame, naturally—are the voices of Ed Hood (the Factory's

then resident literary intellectual) and two other people quarreling about the luscious number out on the beach. They are obviously eyeing him with lascivious attention, the camera their gaze, as it brings him at last full into frame, clear and large in his casually muscled splendor, whittling at a piece of wood with a switchblade, sometimes brushing sand from his rippling shoulders with its blunt edge.

The hustler of the title is Paul America, and the dominant voice on the sound track is his edgy owner, Ed Hood, who, with the sharp, precise, mercifully audible voice of a language-proud, middle-aged queen, snaps at Ed MacDermott and Genevieve Charbon: "Don't even try to look innocent, you can't fool me. I know what both of you are here for and what you're after. You don't want to see me. You're after that blond down there. I know you, you're not exactly complex, neither one of you has anything better to do with your time except to go around vamping faggot's tricks. Well, I'm very sorry to tell you you're not going to get away with it this time. He's mine. Mine."

"Where'd you find him."

"What on earth *can* you mean, where did I find him?"

"I mean, like did you just pick him up on the streets?" It is Mac-Dermott speaking.

"The street! Hardly, my dear. That sort of thing is more your style. Street pick-ups are for aging out-of-work hustlers like you who've decided they've gotten to like it. Oh no—the streets, indeed."

"Well, where then?"

"I have my means."

"Whaddaya mean by that?"

"Just exactly what I say. You're surely not *so* dull-witted that—"

"Yeah, but what means, exactly?"

There is a long pause. "There's a certain agency I know."

"An agency? What agency, what's it called?"

"It happens to be a very good place, you wouldn't know. Very personalized service."

"Yeah, but what's it called?"

"It's called Dial-a-Hustler."

The camera—worrisome, watchful voyeuristic eyes of Ed Hood—has not left the sexual spectacle on the beach during this entire conversation. The frame does not move, though Paul America sometimes does, glancing over his shoulder at a man and woman who spread a blanket near him and roll into a beachy necking session. But he hardly notices and returns to his business, whittling away. He is very isolated out there, there is no camera contact whatever. He seems viewed through a telesc pic len spied upon.

Sud ly—t *shock* of it in a Warhol film—there is a quick cut. A

real, edited cut. Ed Hood is sitting on the deck of his house, having a drink with his tormentors. And they're really *acting*, too!—appraising Dial-a-Hustler's prize stock. Hood perpetually peers anxiously out at the beach, wincing with terror at the thought that his "property" may be spirited away, but in the meantime subjecting Genevieve Charbon to some sputtering misogyny and MacDermott to insults about his past in the auxiliary of the oldest profession. But MacDermott manages to take fairly good care of himself. "You've been a cheap hustler all these years and just exactly where has it gotten you?" Hood asks.

"It's gotten me onto your beach, for one."

A bet is made, and the "plot" thereby established. Both neighbors will try to seduce the hustler away from his rightful "owner"; in a shaky, overconfident display of bravado, Hood accepts the terms. Genevieve instantly leaves the deck to begin her vamping job on the beach. And with that—the *double* shock—the camera begins a long, slow, 180-degree pan, away from the deck, sliding past the house next door, inching by the scrubby grass blowing at the tide ridge, out onto the footprint-battered sand, past one or two people walking in the distance and stopping at last on the blond, exactly as he was, whittling.

"Where in hell is that woman, God knows what she'll do with him. Oh, there she is." Genevieve appears in the frame. "Look at her. Will you look? Disgusting. It's really just disgusting. She really stops at nothing." The girl proceeds to introduce herself and within twenty seconds is smearing suntan oil on our Eagle Scout's back. "It's all broken glass and rusty razor blades, anyway." Whereupon, arbitrarily, the reel, along with Miss Charbon's poor, truncated chances with Paul America, comes to an end.

That pretty much gives the feel of it. In its time, *My Hustler* must have seemed strange to the audience at the Cinematheque, it was so very different from what people had come to expect from the man with the silver hair. It is a film without mystery—without filmic mystery and with few psychological mysteries, either. It seemed to be more like a "real" movie. That word-of-mouth made the film popular, lots of new people came to see it, which was a relief because Warhol had been steadily losing audience at the Cinematheque. It became one of the "underground films" that the general audience of New York—let's say the generally "hip" audience—actually came to see. For a change, the Cinematheque seemed to have a popular hit. If not precisely entertaining, *My Hustler* was at least very interesting on some very simple level. There were real people up there, there was a situation on the screen, the situation was being consecutively played out. It had human interest —is there another kind?—and just a bit more as a result of its subject.

Let us not forget that these were the days before the pornography of the 1960's had really gotten under way. There was still almost no nudity on the screen, and almost nobody had ever looked at homosexuality straight on, as it were. So *My Hustler* had sex on its side.

But what about the film now? The rest of the film industry has long since caught up and bypassed it in that department and left *My Hustler* with only the specialty of its particular texture, the special electric information generated by its somewhat documentary style, fictional though the film may be. Jonas Mekas prizes that achievement somewhat more highly than I do—at least with respect to this film; in his *Movie Journal* he speaks of the *cinéma vérité* (he calls it "direct filming") achievements in documentary realism, seemingly in a resurgence in 1966 through the combination of Leacock-Pennebaker, Truman Capote, the Maysles Brothers, and our man. But these surely are very different varieties of documentary fish. However interesting Capote's effort to return prose to its roots in journalism, as a writer he seems *hors de combat*. The interest of film documentary is filmic, one's absorption in the reading of visual signs; in the way Stravinsky's very old hands hold the handkerchief he touches to his chin; the way Mick Jagger smooths his silk scarf as he steps back from the microphone. No information is more highly prized than the information of the idol's success. An immense anecdotal industry thrives on it. Yet *My Hustler*'s documentary style films not the signs of the idol's success but the signs of what is typical and failed. And it is all in the second reel.

The subject is the theatricalization of masculinity: In reel two it's MacDermott's turn to seduce Paul America—Paul America, the pop name that stinks of locker rooms, a name that flies in the wind from a late-1950's convertible sailing down the pike, making a laughable narcissistic fist. Shifting from the wide-open spaces of the beach to the tiny, enclosed space of a beach-house bathroom, we see the two men together after having come in from a swim. The reel is a document in masculine coquetry without parallel. MacDermott stands before the mirror, shaving, combing his hair, washing his separate fingers one by meticulous one, performing any other act he possibly can arrange rather than leave his carefully chosen forced proximity to the blond bruiser, who is likewise arranging to shower, rinse out his suit, urinate, lean against the wall to pass the time, casually "waiting" to take MacDermott's place before the all-beloved mirror. The atmosphere is electric with the tension of pretending not to notice, of two large bodies near each other, and the potentiality of flesh brushing—accidentally—flesh. The action is tense with its obvious little truth, that this sequence is about two men's bodies, that they have become, in this

situation, sexual objects, without admitting that simple fact or rather only admitting it on two different levels: MacDermott on the level of seduction, America in the realm of a certain coy evasion.

The interest in documentary is information: For the documentary, its attractions must be about the nature of film information, the meaning of visual information, seeing and catching the signals that curl out from the real, posing for the artist the problem of how to hone one's eye for the hot sign, catch it with the Bolex in one's hand. But the critic has precious little to say about the specific gravity of that learning process as a filmic matter in *My Hustler*. This is one of the first Warholvian works—certainly the first discussed here—in which the work's fundamental qualities as film don't happen to be particularly interesting.

What is interesting is that interchange between the two men, not the way its information was filmically discovered in the movements of their two bodies. Filming it was simple: The directorial achievement consisted in finding two men competent to stage that particular glimpse of the real, then choosing the ideal, confined narcissistic space of the bathroom for it to take place, and then setting up the camera. Aside from hardly perceptible adjustments of the zoom lens, there are no camera movements of any kind in the segment. No, it is not the filming that can hold attention: It is the movements of those bodies, filled with the clichéd tics of the national vocabulary of masculine body language —so familiarly parodied everywhere that they have become absurd; we Americans have caught on to at least that much. Yet they are also informed with something that is almost primordial; a complex interchange, probing the realities of the body's space and its meanings, like the movements of cats or birds, sniffing at that space, crouching sometimes for the leap, moving to a new angle of possible danger and access, backing away, moving in, sometimes flying off only to return to enter the attack zone for another probing move, the final transgression within the space of affection or combat, one doesn't know which, the elaborate routine of coming to know the other, never careless, though hopefully filled with the nonchalance that the preconscious, in its obscurantism, its effacement of motive, just barely keeps from becoming pretense. And sometimes the preconscious fails, the motive escapes, and the game becomes theater. Either way, it is the elaborate, dancing mystery of what men do about the fact of each other's incarnations. What they do about the space of the body, the heat and smell of the flesh, the secret sexual (though by no means always erotic) acknowledgment—*I am like you*. The preconscious motives for the dance of intelligencing, the ritual of reading the body's signs. That is the second reel of *My Hustler*, with this addition: The dance has become one of

seduction, it has been eroticized, and thereby rendered conscious and parodistic. It is a hungry parody; admiration has become a dimension of the flesh's hunger, and the body itself is using its signs to say only one thing: That it is orgasmic, a *promesse de bonheur*. Johnny-One-Note so to speak; it's a touch dull, that part of it. More interesting by far is the parody of nonsexual body language that is part of the vocabulary of people whose fantasy it is to have names like Paul or Captain America, the comic indulgence of the hidden language of the locker room, seizing the clichés of garden-variety masculine narcissism and raping them with their dirty little secret of desire.

And so is introduced a new theme, which will become more and more powerful as the Career proceeds toward those four pistol shots and then survival. Warhol was shortly to begin—more and more in collaboration with Morrissey—his long filmic meditation on the male body, the pornographic indulgences of which were to lead him, and thereby us, into the regions of some pretty vile vulgarity, but also into regions of obsession, some new filmic techniques, and the collapse of a cinematic idea, the idea that had sustained him throughout his early career. But these high events will not take place for almost another year, and that year stands between us and the denouement, and before we enter their declining mazes, there is still to be discussed the Major Work.

The Chelsea Girls

●●●●●●●●●●●●●●●●●●●●●●●●●●●●●●●●●●●●●●

In 1966, Andy Warhol's latest movie left the Film-Makers Cinematheque to open in a "real" movie theater—the Regency at 72nd Street and Broadway—and the time had come at last, it was all up there in lights on the big marquee:

<div align="center">

ANDY WARHOL'S
THE CHELSEA GIRLS

</div>

But though *The Chelsea Girls* was Warhol's first strong step in his drive toward the big world of the feature film's public—a drive that has grown more and more pronounced with each of his films since *Flesh*—it remains an experimental work, still tugging at the limits of the spectators' perceptions, still operating within the modernist tradition from which Warhol has since been progressively withdrawing. Much can be said about what is gained and what is lost in this development. But it is not what has to be said about *The Chelsea Girls*.

For to enter the world of the feature film is to enter the world of imagined time, that arena where film uses the momentary and con-

crete to seduce the mind into illusions of duration. But *The Chelsea Girls* does not imagine time. It attaches itself to literal time, and, by drawing it into a context of total disjunction, confounds the sense of duration under the suzerainty of the steadily ticking clock. True, like a conventional feature, it concerns itself with the relation between time and event, but it presents both of them in a state of radical dissociation, a structured but irresolvable disarray in which the life of narrative is disjoined and made a function of the machine.

The machine in question is, of course, the camera. *The Chelsea Girls* is composed of twelve reels, each a separate episode in which various members of the then entourage talk, and talk, and talk—playing at being themselves in more or less beguiling ways. Each reel is entirely unedited and of identical length; all have sound tracks; eight are in black and white, four are in color. The camera is invariably on a fixed tripod; its entire movement consists of zooms and swiveling on its stand. Each performer is set in front of the camera and told to stay there playing until the reel runs out. And so they do, pinned by the camera against a wall of time. "Dear God," Ondine asks at one point, "how much longer do I have to go?"

But the wall of time to which they are pinned is also a split screen. The film is projected two reels at a time, in a phased relationship that separates the beginning of each by about five minutes. Tradition, rather than Warhol himself, has established the standard sequence of the reels; the first time I saw the film (at the Cinematheque in 1966, when it was presumably under Warhol's direct supervision) they were in an order that I have never seen repeated since. Theoretically, any arrangement is possible—and since every reel has a sound track, that arrangement would permute with any interplay between sound and silence theoretically conceivable. The sequence of the film freely offers itself to tradition or randomness or taste or invention; playing with it, the projectionist at last has his day as *chef d'orchestre*.

The screen strikes one first. Entering the theater, one instantly notices its unexpected elegance, its ratio far wider than any in ordinary use except Cinerama, but quite serenely flat. According to what is now established tradition, the film begins in the right half of this space with a sequence in color. Under a lurid red filter (which from time to time sinks so deeply toward the infrared that the print looks almost like a negative), a blond boy (Eric Emerson) slowly toys with his fleshly presence before the camera, lost in a blinking, lip-licking masturbatory trance. He stares at his fingers, sucks at them. He squeezes his lips. He plays with his hair. He twists a flexible mirror between his hands, gazing with hanging lips as his face smears. Filters change; blue succeeds red, and it, too, ranges from a virtual indigo to the metallic electronic

brilliance of an arc light. The sound track is on, but we hear only the steady murmur of its tracking, interrupted by perhaps an occasional cough or the small clatter of equipment outside the visual field. Once or twice, the boy makes some noise somewhere between speech and a moan. We suspect, rightly, that it's only a matter of time before the narcissist up there begins sliding his clothes off, and losing himself in the vertiginous caverns of exposure. The camera pulls and jabs through the field with nervous, probing, swiveling zooms, but, throughout, the fleshy stillness of the autistic spectacle drips with quiescence, a kind of sexual waiting. This filmic massage continues uninterrupted for about five minutes.

Whereupon the left half of the screen lights into black and white: The sound of the color sequence on the right is extinguished and replaced on the left. Two sections of a couch have been placed back to back; draped over one of them in a hooded black robe, Ondine, one of the Factory's most compulsive and amusing talkers, turns directly to the camera and starts speaking through the polished confident grossness of his Bronx accent. He is a priest, so where the hell is somebody to come and confess? Then we hear, edged out of vision by the perverse inattentive camera, the shrill, absurd voice of Ingrid Superstar.

And so, in an unequal but contested struggle for attention, silent color vies with sound and black and white, talk with eroticism. (After the sound in his episode is lost, the boy on the right begins his inevitable strip tease. He also begins to speak, though, of course, his lips move in silence.) The complete disjunction of the split screen, along with its width, makes any simple composition of its entire surface impossible. One's eye moves uneasily back and forth, guided in part by the simplest reflexes of primary perception (for example, the tendency to look in the direction of sound and attend to someone speaking, as opposed to the tendency to pick up on color, particularly brilliant color). These operate with or against the happenstances of personality, since a given person is more or less interested in Ondine and Ingrid's interminable verbal sparring, or Ondine shifting from priest to analyst to gossip to one of the girls. The field of vision is disjoined; the disjunction is compounded by the compositional style on each separate half of the screen. The swiveling of the camera on its tripod repeatedly confounds the sense of a fixed frame suggested by the absence of editing and track shots, and does so most spectacularly in the color episode where Marie Menken assumes the preposterous but beguiling pose of being Gerard Malanga's mother, railing at him over his equally preposterous claim to have married Hanoi Hannah, who meanwhile sulks in a far corner of the room huddled in mute fury. The room is thus split between logorrhea and solipsism. The camera moves in manic,

crazifying agitation, both with and against the structure of visual interest in the room and the flow of conversation, driving its own movements into a thoroughly asserted counterpoint to the field. In other episodes, such as the instance of Brigid rapping in her room at the Chelsea Hotel, the camera is relatively peaceful. But whatever its mood, the style is consistent throughout. Anywhere, anytime, the camera may suddenly swivel and exclude something "crucial" from the field. Abruptly, it zooms. Focus is manipulated, at times bringing the image to virtual obliteration. Yet most of these lunges on our attention create the effect of further decomposition, and would probably be called distractions if we could only define precisely the thing from which we were being distracted. For the framed field is only the nominal point of interest; that sudden zoom may concentrate on an "irrelevant" point in the field's space, or it may dive directly to its logical mark. In group scenes, the speaker may, in the midst of his frenzy, be edged out of the frame, drawn into a perfectly balanced close-up, or simply passed over by a rapid, unnoticing sweep of the camera eye.

The result of this restless, irresolvable pacing of the imprisoned camera, this drama of disjunction, is to relentlessly set the operation of cognition against the arbitrary. As one becomes aware of this experience, one becomes equally aware that, despite the implied mechanistic rigidity of the subdivided compositional field, despite any effort to concentrate on the simultaneous minidramas before our eyes, almost every *movement* of awareness is actually being determined at the outer edges of perception: some sweep of color; a small, quirky, screwball twist of Ingrid's mouth; an abrupt, irritable, uncalled-for zoom; the silent movements of the boy's lips as he speaks; a new tone in the muffled Bronx honk of Ondine's speech. Playing against this are the psychological subtleties of the Warholvian talk performance—about which much remains to be said—as they conflate with the peculiar fascination of silence. Already a matter of major interest in the earlier films, silence here begins to scatter itself in a dialectic with sound. The varied sensory resonance of silence—the contradictory implication of distance and separation; a certain subtle *ritardando* that it exerts over the visual tempo; its spectral resemblance to the operation of the eidetic and memory and, in consequence, a certain look of *pastness*; its somewhat truncated appeal, combining with the intuition that it is more emphatically filmic, more serenely an experience apart—all this begins its long operation quite literally with sound in one's ears. The result is strange. The relation between what is seen and what is heard seems to be repeatedly gathered together in the mind only to fall apart and be lost. But this is only one dimension of a single effect. *The Chel-*

sea Girls is not so much a narrative as a spectacle, but it is a spectacle in a state of perpetual disintegration. As one looks at this cool, wide, virtually complete array of sensory dissociations, one becomes aware that the simple impulse to center one's attention and then *move* with time is being incessantly confounded at the outer edges of perception, and that, at those edges, duration, the sense of human time, is being broken to bits. And the moment one realizes this, one realizes precisely what the dramatic interest of *The Chelsea Girls* is all about.

Once again, Warhol has located his work squarely in that arena where perception stands witness to itself. Any one of the twelve episodes of *The Chelsea Girls*, were it to be shown individually, would ensconce its spectator in merciless clock time, though it would be clock time with a precisely anticipated end, the mechanically defined duration of the length of the reel. Using this rhythmless, though timed, unit, Warhol sets into motion the absolutely metrical alternating progression of the phased split screen, subsuming the crack-brained conversations of each episode into a stately formality. There are twelve reels, but there might be a hundred. The film's progress is potentially interminable. No episode "leads" to any other, though in two cases basic situations are repeated. There is no story, no narrative process, none of the events on the screen lead one to anticipate an end. There is no project in time; one is asked never to remember, never presume. One watches, one waits, patiently or impatiently as the case may be, knowing only that the film will, at last, conclude—conclude literally by closing in on itself—resolving itself into a single image on a single half of the screen. *The Chelsea Girls* is not a narrative work, but it does move through time in the rhythm of narrative. It does develop, in a strictly structural sense, toward a finality, as opposed to a mere termination. But it is a finality that functions only by virtue of bringing the eye to rest. Indeed, it does even better than that: When the final reel at last stands alone, its image vanishes after a few moments, and the sound track continues imageless as the house lights return and the poor pestered senses are released.

The fact is that *The Chelsea Girls* retains narrative structure while entirely dissolving narrative time, and it does so by literalizing both of them on the simple device of the split screen. Structurally, the film has a coolly conjugated, recognizable, and distinct beginning, middle. and end. But the very device that makes that possible (a kind of substitute, by the way, for the editing process) removes any possibility of filmic, reinvented, narrative time reaching us. By dissociating time, the device makes it submit to the tyranny of the clock. Let us suppose we make some move to escape that tyranny—and we naturally will. The slow trickle of seconds through the tiresome routine of a middle-aged

homosexual in bed with a male hustler begins to pall; on the right side of the screen is, let's say, the icy but beautiful Hanoi Hannah snarling in voiceless sadism at various girls draped around her room. Literal though the movement of time on the left half of the screen has been, to some degree one will have entered into the particular quality of the duration that those moments of steadily observed reality induce. The mere movement of the eye from left to right makes one absolutely lose that subtle sense of participation in the film's time, and, slipping instead into an entirely dissociated temporal realm, one is thrust back upon oneself, upon the beat of the clock and the beat of one's own darting eye. In this and analogous ways, almost every movement of perception induced by the film has as its effect the disintegration of one's capacity to dominate or subsume the moment, or, for that matter, even to participate in it in any but a very complex way.

The merest horror film or thriller is, above all, an invitation to participate harmlessly in its violent time. But the way *The Chelsea Girls* seduces the clock constitutes something closer to a prohibition, a refusal. In this sense, *The Chelsea Girls* seems almost an act of aggression, though it must be called aggression of a very special kind. A cliché leaps to mind: The film is mind-blowing, an inept cliché that has leapt into a good many people's minds. The work overloads the circuit of perception. Some may find it a little explosive and shocking, there is a great deal of sadomasochism in it, and a great many needles shooting methadrine. And, for its pleasures, the film may seem to fellate consciousness in a contactless voluptuity. Fine, but I dislike the cliché. I feel a certain contempt for it. We should prize our minds more highly, and *The Chelsea Girls* seems to me, on the contrary, mind-defining. That is its special little secret. However deeply involved in an aesthetic of disintegration the film may be, it is nonetheless an aesthetic. At the risk of sanctimoniousness, Dachau is mind-blowing, the prospect of nuclear war is mind-blowing. In remembering (or hearing once again) the rhetoric praising psychic and social disorientation, the flattery of madness and loss of self in which the 1960's specialized, one should also remember that the unbearable has, as its prime characteristic, being unbearable—and no fooling. *The Chelsea Girls is fooling.* Its special characteristic is to flirt with the idea of entirely abandoning any aesthetic, stretching itself across the realm of disorientation while at the same time quietly announcing its coherence.

The coherence is located in the elegance of its refusal, the serene coolness of the way it says *no* to the conventional experience of devouring filmic time. It is located in the voluptuousness of a spectacle that does not give. The finger of time drifts across the skin just at the point of sensation, and the film operates in that extremely interesting area,

the point just before the point of boredom. The film engages us, but engages us in its denial of conventional coherence. As a result, perception is thrown back on itself, and the film becomes an exercise in apperception. *The Chelsea Girls* is a work in which one must incessantly choose to disregard something, in which every act of attention explicitly involves some withdrawal of attention, in which every assent to the film's appeal must converge with some refusal, however delicate. Led nowhere, perception must constantly choose to find *itself* somewhere. Finding itself, it begins to follow itself through the movements of its own changes, witnessing its own scattered conjugation through time; exercising itself within its own willfulness and passivity; shadowing itself like a spy through its own regions of curiosity, amusement, intelligence, eroticism, distaste, sensuality, tedium—all the while running through its repertory of ways of looking at film, unsuccessfully attempting to establish itself in some singular mode of looking, until it becomes plain that, despite the cool self-containment of the spectacle on the screen, the only undissociated way of looking at this film is to look at oneself. And looking, one promptly finds oneself in a state of dissociation. In that state, one looks back at the devolving, serene spectacle on the screen.

I speak of elegance—elegance in *this* film, where Ondine swigs from an outsize Coke bottle and loudly belches; where Brigid snaps into the telephone, "Listen, I can't talk now, I'm on the john"; where an aging queen snipes, "I want my property," jabbing a pudgy finger into a hustler's skinny shoulder. Well, let's say it is the elegance of the 1960's. Or let Warhol say it: "People are so fantastic. You just can't take a bad picture." Finally, this cinematic spectacle is about the self-containment of a certain elegant discretion, the discretion of Baudelaire's dandy, the aggressive perfection of a passive nonchalance. The discretion of mutism, of separateness, of perfect placement. It doesn't matter that at the same time it is talkative, chummy, and in disarray, for this discretion is about an ironic mode of consciousness that perpetually undermines its own means. It's within that mode (if you can get into it; not an easy matter) that you just can't take a bad picture. While it plays at disorienting and shocking the senses, it is, in fact, seducing them with the impression that it couldn't care less.

By the way, I don't mean to suggest that *The Chelsea Girls* is so dreadfully elegant that it is not entertaining. In the vulgar sense, it is the most entertaining work I know within its particular tradition of elegance. In any event, every time I see it I repeatedly laugh out loud, though I'm sometimes the only person in the theater who does. As it proceeds from reel to reel, its solemn mechanistic stateliness is repeatedly undermined by the almost ostentatiously charming and repel-

lent freak show on the screen. The film is so deeply involved in its ironic mode that it subsumes everything to it: its use of time, its apperceptive drama, its claim to seriousness, its place in an artistic tradition. *The Chelsea Girls* seems to flicker not only on the edge of seriousness and of cinema, but on the edge of existence; no work has ever less portentously commanded us to know ourselves.

"Listen. I am too economical an artist to go on with this," Ondine asserts, his eye fixed on the camera in a steely gaze of mock determination during the middle of reel 10. Brrrrrrrrrrrrring! "There's my telephone, so sit down and shut up." A very fat lesbian, who claims she is no longer able to cross her legs (but who promptly, though with effort, crosses her legs), picks up the telephone. "Helleau?" she says, exuding mock sweetness.

There is a special kind of actor's presence in which Warhol specializes, and it should be possible to talk about it quite exactly. To do so, we must naturally talk about his actors' relation to the camera, and the most obvious fact about it is that it is a relation invariably more or less forthrightly acknowledged. "Okay," asks Ondine. "Should I start now?" Twenty years of television have undoubtedly had some influence on the style: From the beginning, television's unintimidating small screen and absurdly poor resolution of detail have encouraged the close-up and an "eyes-front" (therefore "frank"), variety of camera presence, causing what in 1939 would have been thought impossible, an even greater accentuation of the narcissistic show-biz dimension in the commercial media than had existed before. Along with this came an endless insistence on comedy; television quickly became the medium of the comic double-take, and, in fact, very much the same thing that makes us smile at Brigid on the telephone makes us smile at Carol Burnett's arching eyebrow. Likewise, one can trace to TV's revival of vaudeville the burlesque idea that one's role on the stage or screen is too absurd to maintain, that one can't help breaking up, stumbling out of the posture, kibbitzing on one's own role. Finally, there is the mystique of the star, about which we will have more to say.

But more decisive factors probably are Warhol's refusal to edit and the use of the stationary camera. They result in a kind of performance otherwise almost never seen on the screen. Each one swims in a shoreless little half-hour ocean of time. Both actors and audience in *The Chelsea Girls* confront the problem of what to do with the length of that inexorable reel. But Warhol's almost flawless personal taste stands him in good stead; there is virtually nobody in *The Chelsea Girls* who fails to have a relation to the camera that works. Everybody is a good talker, except for those like Nico who never talk. Everybody lives with

ease in the realm of narcissism, in which living and *being seen* conjoin, and their self-absorption operates in a way that puts it on constant display. They are amusing. They are hip. They are, in short, ideal.

And their acknowledged relation to the camera, whether it is direct or in some way deflected, whether burlesqued or done in character, becomes, above all, a structured means for playing out a narcissistic self-involvement—while a major factor of fascination in each performance is the specific texture of that relation, that means. Through the actor's awareness, one perceives the camera's felt presence, as if in a mirror. And, within the presence of that mirrored structure, the performance comes to life and is forced almost literally to reflect upon itself, driven by the camera into that mode of ironic sensuality and presence that is the Warhol style. It is at this point that the film can lay claim to an almost literary high seriousness. For *The Chelsea Girls* is haunted, dominated, by the problem of authenticity.

It is sensed through an extraordinarily delicate, though usually comic, exploration of its actors' presences, as their eroticism is sensed through those presences. Everybody has surely guessed that, within the psychological structure of *The Chelsea Girls'* aesthetic, there is an important link between the whole operation of the film and the exclusively homosexual, sadomasochistic sexuality that pervades it. Unfortunately, it is a link so important and complex that it deserves its own, separate consideration. But the film is also an anthology of variations on an almost cautionary style of personal presence, something that has its own little drama, its own story. I would like to discuss only one instance, the most pyrotechnical performance in the film, and one that has the advantage of being both exemplary and perfectly linear as it operates at the outer limits of a style.

In it, Ondine loses his temper.

The left side of the screen is once again in black and white. The set is the Factory, where the two sections of the couch are still placed back to back. Once again, Ondine sits down on one, though this time without his black robe. He has with him a paper bag, from which (with much noisy crinkling on the sound track) he extracts a syringe. Using his belt to tie his arm, he proceeds through the methodical ritual of giving himself a shot of methadrine. He releases his arm from the belt; again, with noisy crinkling he replaces the syringe in the paper bag and carefully sets it aside. He has that peculiar relation to objects most often seen in women wrapped up in an almost pampering relation to their bodies, who pick things up and set them aside with a particularly fleshly tactile discretion. Except that this time he is pampering a needle. Ondine then turns to the camera and asks if he should begin. "Okay? Okay. Well now, let's see." He arranges himself

more comfortably. "As you are all aware, uh, I am the Pope. And, uh, the Pope has many duties. It's a crushing job. I can't tell you. And—uhhhh—I've come down here today in order to give you all some kind of inside view of my life, and what I've been doing with my uhhhhh"—there is a long tracking pause—"Popage? Right, my Popage. Not just the Pope as Pope, but the Pope as a man. Right? First of all, you will undoubtedly want to know who, or what, I am Pope of. Well, uhhhh," a mock faggot groan, running his fingers through his hair. "Jesus! There's nobody left. Who's left?"

Time is being filled. The eye drifts to the right, where, let's say, a silent sequence shows a kind of light show playing on members of the cast. But now, back on the left, a woman walks on; somebody new has come to give her confession to Ondine, as Ingrid Superstar did at the beginning of the film. As she sits down and begins to talk, something seems slightly wrong, slightly off: the woman on the screen has a certain vanity all right, but it is a pedestrian, banal vanity. Worse, she seems faintly intimidated by the situation in which she finds herself. She's a touch "heavy." But we know that won't stop Ondine. The eye drifts complacently back to the right. The light show continues; Ingrid is smoking a cigarette and laughing. After a digression, the conversation on the left drifts back to confession and begins to spar. The girl seems to sense that this sparring with Ondine is part of the game, and so, somewhat smirkily, she sets out to question the Pope's spiritual authority. She announces that she is hesitant to confess. Exactly Ondine's meat. "My dear, there is nothing you cannot say to me. Nothing. Now tell me, why can't you confess?" The inattentive ear hears the remark fall: "I can't confess to you because you're such a phony. *I'm* not trying to be anyone." Ondine seems at first able to duck this little rabbit punch easily, and, still playing for the camera, tosses it back at her, his voice filled with mock music. The girl repeats her remark. Ondine has been holding a glass of Coca-Cola in his hand; he throws it into her face. She is startled; it takes her an instant to remember that this, after all, is only a movie. She pulls her wet hair from her eyes and comes back smiling. "I'm a phony, am I?" snaps Ondine. "That's right," the girl replies, and is instantly slapped in the face. The right half of the screen, as it were, vanishes. A sadomasochistic spectacle is, by now, very familiar—but still. "Well, let me tell you something, my dear little Miss Phony. You're a phony. You're a disgusting phony. May God forgive you," and Ondine slaps her again, more violently, then leaps up in a paroxysmic rage. With his open hands he begins to strike the cowering bewildered girl around the head and shoulders. "You Goddamned phony, get the hell off this set. Get out." In a momentary lull, we see the girl's eyes again. They are squeezed shut. At last, she seems to

grasp what is happening to her. "Stop it," she says. "Stop it. Don't touch me." She is unable to move, but her voice is, at last, authentic. Ondine rages on. "How dare you call me a phony? Little Miss Phony, you disgusting fool," he begins to strike her again. She leaps up and runs.

There follows a torrential, self-righteous, hysterical rage. How dare she, the moralistic bitch. Who the fuck does she think she is coming onto a set and pulling something like that?—"did you see it, did you see it?"—she's a disgrace, she's a disgrace to herself, she's a disgrace to humanity, the fool, the moron; she thinks she understands friendship, she understands nothing, she betrays, she insults. Ondine circles the room, hysterical—"I'm sorry, I just can't go on, this is just too much, I don't want to go on"—it is the longest camera movement in the film. Her husband is a loathsome fool, she is a loathsome fool, and so it goes. Phase by slow, self-justifying phase, Ondine, who has been beside himself, slowly returns to himself—that is, to the camera. And, as he calms himself, the camera reasserts its presence.

In an ordinary narrative film (that is, one in which the actors play to the convention of an absent camera) such an incident would be thought of as a stroke of personal passion, and it would function as a piece of self-revelation, a moment of truth. At first blush, Ondine's outburst seems to do exactly the same thing. The point, however, is that the moment of truth begins to function at precisely the moment the cowering girl's face comes to the realization that this is not, after all, just a movie; at the moment when, understandably enough, the presence of the camera ceases to have any importance to her and she reasserts herself, eyes closed: "Stop it. Stop it. Don't touch me." Poor child, she was ill-equipped for her job. Trying to be ironic, trying to be authentic, she could do neither, and she found herself in big trouble instead. For that particular game, she had sat down at a table with pros. And it was exactly her incapacity for the task, subtly evident in her presence from the beginning, that provoked Ondine into his rage. It is interesting that the all-provocative word was "phony."

Phony? It's impossible to imagine that Ondine could be so enraged, even with the help of methadrine, merely by this silly epithet. It was the way she was there that set him off. In more or less perfect innocence, the girl provoked the peculiarly angered embarrassment one feels for a person trying to be funny among people with a great gift for wit; or somebody trying to be brilliant among the very intelligent, trying for physical flash among athletes. It was the teeth-searing scrape of the chalk, behavior that, however mortifying for the person doing it, nonetheless seems like an act of aggression. The girl made the mistake of turning her mortified aggression into words. She was not mis-

treated for a lack of brilliance or wit or grace: she had stepped in front
of the camera insensitive to the life it was structuring and that it re-
quired; she failed to understand that in front of it she had to live
within its irony, and that she was among people for whom that irony
is life. Phony? One suspects that Ondine would be prepared to be
called a phony by anyone, and at any time, provided they did not
claim for that particular truth any authenticity whatsoever. He found
the girl's remark judgmental and righteous, and so it was. But Ondine
was himself perfectly adept at righteousness; ten full minutes are de-
voted to elevating his disgraceful behavior into a saintly act. What he
called the girl's moralism was, in fact, the violation of a style, a style
of life, and one that was being made to function at that moment in its
most pristine form. Disastrously for her, she had tried to divert atten-
tion—ours, Ondine's, the camera's—from the mode of consciousness in
which Ondine and the other important people in the film locate their
capacity to live and act. Trying to be cute for the occasion, she vio-
lated the flicker of Ondine's, and the film's, life. Revenge was preter-
naturally swift.

Those for whom selfhood is located in the ironic mode of Ondine
and his world are in the habit of calling any violation of that mode—
any "heavy"—a "bore." It is one of the most favored words in their vo-
cabulary. Needless to add, it was one of the many epithets Ondine
slapped into his wretched victim. Boredom? It is an uneasy boredom.
Feeling it, such people hold their breath against the unbearable. What
really went wrong? Had the poor girl lacked a certain delicate touch?
So what? Had she called Ondine a nasty name? *The Chelsea Girls* is a
three-and-a-half-hour parade of nasty names. None of this can have
had the slightest importance. As she clumsily faltered within that life
style to which *The Chelsea Girls* is a monument, the girl tried to pick
up the beat she'd lost with a feinting little lunge of mockery. Wasn't
mockery, after all, what everybody else was indulging? She failed to
realize that, once you've stumbled out of the cool, vibrant life of inau-
thenticity, mockery is absolutely forbidden. Her little ploy turned out
to be a little act of ontological aggression, one that confronted poor,
high Ondine with an unexpected but intense little metaphor for death.
Some bore. "You phony! You fool! You moron," he shrieks, the last
remnant of a mind beside itself, absolutely fixed on the camera, "You
misery, you're a *disgrace*, a disgrace to yourself. May *God* forgive you."

Degradation

●●

It was a triumph. Throughout New York, and then across the country, *The Chelsea Girls* was being both talked about and seen. There were actually lines at the theaters, *Variety* began to list the gross, and Warhol's fame began to radiate into regions where his painting and early films could never have made him visible. *The Chelsea Girls* had a certain scale; it was grand enough to sustain its own life. The work seemed, for once, bigger than its maker. It was possible to see this film and not have it be primarily an experience of Warhol, its invisible maker. One saw the film itself, complete in itself. Those Who Know—even those hostile to Warhol and the film underground—stopped spluttering about dilettantes and their childish games. Warhol began to be understood as a film-maker. And in the *grand monde* outside mere critical opinion—a world from which Warhol never diverts his attention for long—it became obvious that *The Chelsea Girls* had really done it, was going to make it big, this was the real thing.

But something was changing in the Factory's internal life. The change was at first perhaps imperceptible, and the sequence of events

is difficult, perhaps impossible, to reconstruct. Warhol and the entourage left on a national tour with the film, and certain tensions began to be felt. One hears vague stories of ferocious quarrels in San Francisco, especially about money. The earlier films, without prospects of income, had been indulgences. But now there was real money flowing in, and very little of it was flowing in the direction of the superstars. Along with this came the rising influence of Paul Morrissey, who was the business manager of the windfall. At one point, Ondine replayed his tirade, but without the camera, in a restaurant where he felt a friend was being mistreated. I'd hazard the guess that, during the first flush of *The Chelsea Girls* success, it became obvious that Morrissey was to be *the* first lieutenant, and some of the people in the entourage foresaw in that event the end of their old world. For something was changing; the sweet smell of success was changing it, Morrissey's ambition was changing it, and, perhaps, the depletion of Warhol's own cinematic ideas was changing it. But its effects would be simple. There would be two more films deriving from the aesthetic ideas that had animated *The Chelsea Girls: The Twenty-Four Hour Movie* and *Imitation of Christ*. After that, there were to be no more "art movies." The taste of the big world was not going to be rejected: Once admission to such a feast had been gained, neither Morrissey nor Warhol had any intention of walking out of the banquet hall. There might be pretense of a kind: People felt that Warhol's name gave them permission to work with careless technique, gave them permission for a certain kind of "boredom." The sense that such things were part of the "name," the kind of thing one could get away with, revealed the contempt felt by some, Morrissey included, for the early works, almost as if he had seen nothing in the style on which his own was shortly to be based except its technical carelessness and its audience's ennui. These would be retained, but the kind of radical imagination that had given its poetry to *Sleep* was not to function again. In the height of the intoxicating success of *The Chelsea Girls*, an era in the history of Warhol's art had come to an end, and, along with it, perhaps the era of the works that give him the claim to be a major artist.

But the country was changing, too. The sexual revolution had penetrated the boondocks: Main Street theaters that had only recently been featuring the Gidget films were showing *I Am Curious (Yellow)*. The wave of Swedish pornography was getting audiences used to seeing writhing vaginas and dangling penises. Permission—a permission partly given, a permission that seems to have activated the pornographic dimension of Warhol's mind. Activated and disoriented it. Early in his film career, Warhol had made *Couch*, not for release, and it is (reported to be) sufficiently pornographic to outdistance the

Swedes by a very wide margin. Warhol's mind—so one gathers from the films—is filled with the writhing impossible bodies of the pornographic vision: an untouched and untouching intensity seen without feeling the smack of flesh. At its literal roots, the word pornography suggests ihe representation of sex; sex transposed to the distance of mimesis, which is, above all, in whatever medium, sex in which the eros of *touch* is unknown. And the image of eros in the mind of this man who does not like to be touched, who has transposed the world into a purely theatrical realm, where he himself acts as witness, this endlessly coy genius of evasion, smacks of a perversity and a passivity extending well beyond the mere ordinary outlines of those experiences in mere ordinary sexuality. Warhol's sexualized and theatricalized eros had informed all his early work, blatant in its coyness, ideally endistanced by film into its untouched perversity. But, when general cultural permission was given for the pornographic spectacle, something emerged from Warhol—a violation of his own artistic sensibility, which is far more shocking and repellent than any imaginable violation of sexual taboo.

I cannot explain what the dynamic of that new aspect of his work was or how it operated as a psychological force. It is tempting to enter fiction to find an explanation—and Warhol once suggested I make this book about him a work of fiction: "It would be more interesting that way." But no, I will stick to the evidence and the relative poverty of critical opinion, to say only that in the works immediately following *The Chelsea Girls* something absolutely grotesque happened to Warhol's two finest gifts: his visual intelligence and his taste. It was simply this: Degradation. *The Loves of Ondine, Nude Restaurant*, and, to a lesser degree, *Lonesome Cowboys* are degraded and degrading works. Even one who prides himself on strong nerves must recoil from them. Though one also feels, in that recoil, for the first time the temptations of the lurid in considering Warhol, this man who transformed the lurid so deeply one hardly thinks of it before most of his work. And there is, indeed, something compelling, resonant with novelistic terror, in the spectacle of the 1960's' blue-jeaned *arbiter elegantium* collapsing to the level of *Nude Restaurant*. It is like Beau Brummel at the end, unshaved, obese, his dingy linen reeking, the waistcoat stained with slobbering.

I cannot find a critical *idée reçu* to make this phase of Warhol's career more tolerable. "Only a really good artist can make a really bad work," the conventional wisdom reassures us. Perhaps, but that does not sweeten the disgrace. And the failures of these films are not the failed risks of daring. They are the failures of perversity and contempt: The mind takes a cold downward glide at the thought of how

deeply despised the audience they were made for had to be. What
kind of debased idiots and fools did Warhol and Morrissey suppose
would be prepared to come to a theater and watch such work? Of
course, Warhol's name and the success of *The Chelsea Girls* assured
them of some audience for anything they might make. But I can hardly
imagine that any director has ever responded to his audience's loyalty
with such contempt. And that contempt must surely have involved
self-loathing as well, as if Warhol had come to agree with his most hos-
tile critics when they claimed that he was a mere fraud who could put
any junk he chose before his mindless audience and expect adulation
for it. It is only on the crudest conceivable level of artistic mannerisms
and subject matter that the intellectual and artistic slop these films
purvey can be linked to what makes *The Chelsea Girls* the film it is.
Bereft of metaphysical grace, voyeuristic passivity becomes the mere
incapacity to make a coherent film. The ennui ceases to be a medita-
tive and perceptual adventure and becomes mere stupefaction. The
perverse refusal to make or shape the material becomes an affront, the
absence of directorial assertion merely nauseating mindlessness. Of
course, we are not talking about a bad artist. We are talking about
a very good artist. That is precisely the affront.

The Loves of Ondine begins auspiciously enough: Its title suggests
its structure. The film was to be a series of incidents showing Ondine
exercising his wit in various sexual situations. It was to be a reprise on
the most celebrated sequence of *The Chelsea Girls*. And so it is, for
the first twenty-five minutes or so. Ondine is seen with a series of
women, among them Ivy Nicholson, the fashion model who was then
a major Factory celebrity, and later Viva (her first time on camera),
playing a prostitute. In *Superstar*, Viva gives an account of how she
came to be asked to be in the film, how she decided to add such de-
tails as putting Band-Aids over her nipples before going on camera,
and how they then became the pretext of a pretty fair comedy rou-
tine. One can see why Warhol was immediately attracted to Viva after
this sequence: In her drawling way, she was almost the equal of On-
dine, while the other women were pretty much always dancing to On-
dine's tune. Connoisseurs of Ondine's wit find some pretty respectable
instances of it in these first sequences of *The Loves of Ondine*, though
he never reaches the pyrotechnic heights of Pope Ondine.

And then, meaninglessly, the atrocity begins to happen. And per-
sists. The scene changes: It is no longer a film about the loves of On-
dine. We are looking into the large, fancy kitchen of what appears to
be a country house by the seashore. Into this room file a large number
of young Spanish-American men in various stages of undress. (*Loves
of Ondine* is the first Warhol film to feature a large amount of nudity.

Hurray.) These young men proceed to the large, very full refrigerator and begin to pull out the food. Then they throw it at each other. They dump quarts of milk over each other's heads. They grind mashed lettuce leaves into their groins and buttocks. They fling flour on the walls. They force-feed each other pickles. They squirt orange juice at each other's rear ends. They continue to do these things for a very long time.

That's it. Nothing less than the featured segment of the film made by the most conspicuous cinéaste of the *avant-garde* immediately after his major public and artistic triumph. One cannot decide whether to call it loathsome or merely hilarious: Other, more merciful critics have passed over the film in silence. Ondine (who will not soon forgive what was done with the film that bears his name) attributes the passage to Morrissey, adding, with typical vituperation, "because Paul is a garbage collector, to be perfectly frank with you. He collects every piece of garbage he can get." But Ondine is looking for a fall guy: "He's taken the art out of Warhol, which is something you can't do." For Ondine, as for most of the *avant-garde* ambience, Morrissey is the fall guy of Warhol's failures. This is evasive: Attribution is unimportant. These films bear Warhol's name, and he has always had that power of decision that forces on him the responsibility of authorship.

The film is indefensible, and for that reason is interesting to discuss in the context of the critical concepts about excellence and artistic integrity that Warhol's successful works so brilliantly disarm. Warhol is the most frequently invoked example of the collapse of standards inflicting the world of *avant-garde* plastic arts and film. He is a *decadent*; those hostile to his work see that fact and understand it to be a symptom of the decadence of the visual arts as a whole, and the phenomenon of his fame gives their view the most heady reinforcement. But the power of Warhol's decadence at its most effective—in *Sleep* or the *Disaster Series*—is a very different matter from the vulgar stupidity of *The Loves of Ondine*. It is one thing to disarm some of the platitudes of what is too loosely called humanist criticism: that criticism which finds itself in search of art's "triumphant affirmation of life," or seeks the confirmations of private vision as opposed to the forces of cultural socialization or dehumanization. (In any event, some would deny that Warhol is in any way outside this humanist tradition: *Vide* Jonas Mekas's *Movie Journal*.) There is no respectable critic who, upon examination, could not be discussed as a humanist: Criticism is, by definition, a humanist enterprise. There is no other kind. In the meantime, the question of one's enthusiasm for Warhol is irrelevant. It is only a major artist who can be exemplary on this level: And the difficulty with works of the debased kind represented by these films is

that by losing touch with his art he loses touch with everything, including what makes him interesting as a purely social figure.

* * *

One turns from *Loves of Ondine* only to confront *Nude Restaurant*. It was 1967 and porno time, Warhol's answer to Fun in the Sun. A restaurant is found and rented. A large group of men, and one woman, are decked out in little black *cache-sexes*, because that is thought to be a terribly cute response to the new pornography. Viva plays a waitress, Alan Midgette a waiter. (At the same time and in the same place, a film called *Restaurant*, not to be confused with *Restaurant* made with Ronald Tavel, was made without the *cache-sexes* and without the woman. It was not for release.) Some of the Spanish-American horrors of *Loves of Ondine* reappear, though, mercifully, this time without any garbage to throw. People talk. One can hardly listen. Other nudes are present. Some leave. Others arrive. They talk. Watching and attending is laborious. One tries to pay attention. There are numerous shrieking in-camera jump cuts called "strobe cuts." The camera weaves around a little. The waiter and waitress move from table to table, trying without success to think of something amusing to say. Hairy tushes laconically slide from point to point. Taylor Mead (one of the most mythologized of all "underground" film stars) sits smirking at the fountain. He conducts an exceedingly long conversation with Viva about her Catholic childhood, and we are favored with more information about the lascivious priests so important to Miss Hoffman's personal obsessions. There is more strobe cutting. At one point, Viva turns to the camera and asks that it be turned off. The camera is turned off and, after the unperceived interlude, turned on again, so that Viva can continue this monologue. More people arrive. Others go. It is absolutely impossible to imagine how anyone could conceivably give a damn.

To be sure, this film is not so repellent a failure as *Loves of Ondine*, though, unlike that movie, which has at least some amusing moments before the catastrophe, I cannot think of a single inch of footage in *Nude Restaurant* that seems to me worth looking at. Watching it is rather like being present at the most boring party of one's entire life. Looking at all those bodies and g-strings, a wave of murderous indifference passes over the mind and clamps itself down, never to move until the last dull frame has been run through the projector. One thinks, pathetically, there is a book to write, surely there is something here. Did he perhaps imagine he was doing or saying something about pornography? One is too bored even to speculate.

Oh yes, the superstars. They get on one's nerves.

Lonesome
Cowboys

●●●

Whether he knew it or not, Warhol's career was in a crisis by the end
of 1967. He had made some of the most remarkable films in the canon
of the film *avant-garde*; with *The Chelsea Girls*, he had put together
the most lavishly renowned and admired "underground" film ever pro-
duced in America. He had created a body of film work based on ideas
that were resonant, original, and his own: And he had carried those
ideas to a climax of achievement and success. And then—then he be-
gan utterly to fall apart, deserted by his taste, his artistic intelligence,
his touch. I hardly know whether Warhol was even partly conscious of
the full desperation of his plight, whether he acknowledged it as a
problem at all. Quite possibly he was completely absorbed and (in his
quiet way, of course) intoxicated with the new manner and the new
people around him. He may have been turned on by the sloppy,
raunchy sex he now felt free to indulge on screen without the slightest
hesitation. Perhaps he was bemused by the idea of grabbing the big
low-down audience where it lived, and hyped with that ambition (he
had his own "real" theater in New York; in big cities across the coun-

104

try, his films appeared in "real" theaters), he may have wanted to unceremoniously shed the exhausted elitism upon which his earlier work had been based. Whatever his motive, the new disastrous phase was utterly indulged. Yet, to an outsider, it all seemed filled with the shuffle of confusion and a faltering step. Warhol was losing in the midst of what seemed to be triumph. He was reaching for what he could not do.

Such as *Lonesome Cowboys.* Warhol's Western is a bad film, even an abominably bad film. It is sloppily made. It does not do what it wants to do. It is very boring. But, even though it is bad, it is among the most critically interesting of Warhol's bad films, because it is a pivotal work in his career both as a film-maker and as a public personality. It is the last film he completed before being shot, the last properly attributed to him rather than Paul Morrissey, the last he directed entirely on his own. And, in that sense, it is very suggestive, particularly about the relation between the master and his pupil. For there has been a real artistic transaction between Warhol and his epigonus. The subject of *Lonesome Cowboys* is alive, even in its aborted confusion. It touches a nerve. And Paul Morrissey has made that subject his own. Even though the two men seem in most respects mutually incompatible talents (Morrissey utterly blind to the refined complexity of Warhol's experience of the world; Warhol wholly incompetent to assemble the often beguiling commercial product Morrissey sells under Warhol's name), the student has learned much more from Warhol than a mere manner. Silently underwriting all of Warhol's work is an obsession, a preoccupation that Morrissey in his relative crassness has been able to make forthright and overt. I am speaking of a characteristic and drastically alienated experience of inhabiting the male body, a racking dilemma of the flesh, masculine flesh. For that dilemma is what *Lonesome Cowboys* is all about. And so is *Sleep.* And so is *Trash.*

Aside from this thematic unity, the exact nature of Warhol's "collaborations" with Morrissey is, for the time being, obscured by evasion, a good many lies, and public relations. It is known that Warhol had nothing (or next to nothing) to do with making what is probably Morrissey's best film, *Flesh*: The film was shot and edited in its entirety while Warhol was hospitalized in 1968. And Warhol admits to (boasts about?) having had next to nothing to do with making *Heat.* (Asked by UCLA film students what precisely he *did* do, since he did not conceive, write, cast, shoot, or edit the film, he gave the Warholvian answer: "Well . . . uh . . . I go to the parties.") As for working exchanges between the two men on *Trash, Women in Revolt, Amour*—pure conjecture will produce as satisfactory an answer as any.

But *Lonesome Cowboys* is definitely Warhol's own. He wanted to make a Western about sex, and, however deep his interest in that idea,

this very gifted man had no gift for dealing with it. The concept immediately suggests an almost spectacular array of crosscultural possibilities, but Warhol couldn't handle them. The reason is simple: Warhol has no gift for assembling, for putting together under his own hand, any version of human interchange. And I mean *any* version—not realism, not comedy, not Surrealism, not any available narrative concept for structuring human changes. In his earlier works, "narrative" *happened* before his camera: It was extemporized or based on one of Tavel's scripts. But, in *Lonesome Cowboys*, Warhol undertook to rely on the format of the Western, on the direction of actors, on his resourcefulness at the editing table, and on luck to create an intelligible or interesting sequence of human events. He entirely failed.

But, in his failure, an idea had begun to peep through, begun to nakedly present itself to us in however chaotic a shape. It is an idea about the male body, a certain theory about the relation of the personality to the flesh. The film displays what I like to call an "anthropology" —a private theory about the basic structures of possible (or desirable) human interchange, a notion of who others are and what they want from us, a vision of what happens between men and men; women and men; and (though *Lonesome Cowboys* is indifferent to it) women and women. We all carry such an anthropology in our minds and inscribed in the flesh itself: An unspoken belief about the felt prospects for human contact, a private vision of the possibilities of love—with whom, when, how, and at what price. I say it is unspoken. It may be completely different from what we feel compelled to claim we think love is about. It may be a dirty little secret. "Little" indeed. It defines the very terms of life. Behavior may try to belie it, try desperately to find some uneasy peace with it. And one can have the greatest difficulty even defining its terms, baffled by the need to juggle mutually hidden imperatives of what we suppose we want, and what the flesh keeps insisting it fears, or refuses, or needs. For a great many people, the problem is simply insoluble. It helps a great deal if the private anthropology bears at least some near resemblance to that of other people, offers at least some hope of contact. If not, one is condemned to the most painful solitude. I very much suspect that this is a solitude to which Warhol is condemned.

In *Lonesome Cowboys*, that anthropology begins to emerge overtly. I should make very clear that I will be discussing here what the *movie* proposes: It would be a serious mistake to naïvely suppose that the movie's terms of human relations are those Warhol himself experiences in his daily life. All that can be said is that this is a theme with which Warhol as an artist is fascinated to the point of obsession. His absorp-

tion in it is very deep. If it is not what he believes the world to be, it is at least what he puts on the screen.

He is obsessed with masculine narcissism, it is his *tao*. The form that this obsession takes in *Lonesome Cowboys* is, at first glance, simple, but I think also deceptive. It is too simple. The raw anthropology looks like this: Relations between men and women are filled with hatred, contempt, violence, humiliation, and disgust. Relations between men and men are filled with tenderness, comfort, spontaneity, joy, freedom. The *Lonesome Cowboys* ride into town (in front of the saloon), where they meet Viva (dressed in a riding habit and black derby) and her "nurse," Taylor Mead. Instantly, the air is bristling with sexual insult. Whining and squealing, Viva splutters with disdain. Big men. They're probably all impotent, to touch one would be revolting. "I can't stand men who don't have long hair." They're disgusting, she can't stand them. In counterpoint to Viva's disdain for so-called *machos*, Taylor Mead cowers behind her, giggling and echoing her tirade, though obviously a good deal more taken with the boys than she is, making no secret of the fact that he'd be delighted if one of the brutes got mad enough to dismount and beat him up.

But the brutes do not dismount for violence. They wander through the streets aimlessly, speaking to each other as if Viva's assault had gone unheard. Eric Emerson and Joe Dallesandro discuss ballet exercises and how to get more zing into the pelvis when you walk. Their only concern is with their own bodies, how they come on. Only Louis Waldron, assigned the role of gang leader, makes a pretext of playing out the *macho* role; after being intolerably hectored by Viva, he knocks her down.

Whereupon the Lonesome Cowboys decamp for the big, open country and real happiness. Quite apart from the vision of human relations so arbitrarily sprung in the opening of *Lonesome Cowboys*, Warhol's idea had opened up to him a cinematic concept that, if used, might have made the film a really interesting work. He might have been able to refract the present and the real through the Western myth of an idyllic past. Warhol had placed himself squarely in that cinematic situation to which Jean-Luc Godard refers when he speaks of documentary becoming fiction and fiction becoming documentary. Godard has, of course, explored this possibility in numerous films, most conspicuously (and relevantly) in *Alphaville*, in which the real setting of the real outskirts of a very real Paris become not only *la capital de la douleur* but of another world. And Stanley Kubrick has done much the same thing when he sets the futurism of his *Clockwork Orange* squarely in the center of present-day London, when the badges of

his police bear the emblem: E II R. Chastening a fictional genre with the energy of current reality, both artists become involved in what Annette Michelson, discussing *Alphaville*, has called imminence: The imminence of the future within the present; the monstrous within the familiar; the fantastic within the real. Possibly a similar concept presented itself to Warhol in *Lonesome Cowboys*: He might have made the overflowing narcissism of his men stand in relation to that hackneyed vocabulary of masculine presence and behavior promoted by the standard Western, and he might have vivified that possibility in a surreal interplay of past and present.

But the idea doesn't work. Both Godard and Kubrick—each in his different way—are extremely attentive to the perceived relation between the polarities of myth and fact; each, with a different kind of energy, seizes and reveals that relation; each is attentive to the *crises* of that imminence. When it happens, they know it and do something about it. But the crisis of the fantastic within the real, the past and the present, is secondary in *Lonesome Cowboys* to a crisis of lies—lies embedded within the flesh about the nature of manhood, a crisis of energy and access to love that comes and goes across the screen without ever once penetrating Warhol's consciousness. Once again, we watch his unconscious obsession dance before us and do not give a damn.

There are no crises in *Lonesome Cowboys*, because there is no critical consciousness. One senses that Warhol does not know what to do with his double vision of the world and the flesh, and that, even if he knew, he wouldn't or couldn't do it. Only a critical consciousness could undertake such a task—and Warhol has, from the beginning, pitched his very being on the complete refusal to assume critical consciousness. *He is a man to whom the world happens.* The active principle enclosed within his passivity is the brilliant structure of his perceptions. And they do indeed make the world happen to him in a certain very interesting way. But he seems entirely untouched by that consciousness that seeks to name and enter some privileged *truth* about what happens. The world happens to him and he sees. At any rate, that was his experience until the day when Valerie Solanis entered the Factory, and what happened almost killed him.

This refusal of critical consciousness, which was so important to Warhol's role as a culture hero of the 1960's, not only explains the complete failure of *Lonesome Cowboys* as a work of art, but it also manifests the same essential experience of the world that the film displays. A certain self-knowledge, energy, capacity to act, is *refused*. In place of that is a self-indulgent, drifting, wholly bemused belief that whatever it is and sees is right. *Lonesome Cowboys* as a work does not

know itself. It merely manifests itself, exposes itself, as it were, puts itself on display. It is a film that will not confront its fear, its demon.

When the boys ride into God's country, they immediately shed their clothes, and nudity fills the screen. Now we see them—their "true selves"—divested of the costumes of the *macho* that we were so crudely asked to believe Viva despised in the first reel. In all their naked purity, the boys enter their goofy narcissistic idyll, and we are asked to believe that this is joy. Nakedness is central to this joy. It is as if exposed flesh were innocence and freedom. What is this innocence and freedom? It is to present oneself as someone who is above all an object of desire: a presence that is flesh above all. Or so it seems.

Mr. Peter Gidal, an intensely moralistic and attitudinizing exponent of Warhol's work, looks on the joy of the Lonesome Cowboys out on the range with the most glowing enthusiasm: Their sweet, naked bliss represents, he says, "an alternative . . . a radical ideal." In his discussion, Gidal participates very deeply in a certain widespread idea about what seems at first the *morality* of being male in this (and presumably almost every) culture. For him—as for other, more articulate exponents of the view—there is something that amounts to something very close to evil itself in what is ordinarily understood to be a "virile" experience of things. Therefore, the renunciation of that unnamed property and that very vague "virility" amounts to something very close to rediscovery of a radical innocence. Sweetness. The polarities of *Lonesome Cowboys*—the *macho* spectacle of the conventional Western, as opposed to the sexuality of the Factory—are thus very provocative for Gidal. The image of the naked cowboys in the sagebrush is nothing less than the image of "what should be," while, in the presence of the woman, they parodistically mime "the masculine rituals that, if performed in seriousness, end in the horrors of our obscenely sick society." Opposed to their innocence out beneath the stars is "their sexually ironic potential"—that *macho* incarnated by the Western—evil itself, "which in turn reflects accurately the American psyche," what Gidal sees as wholly unacceptable "manifestations of impotent, fixated, cigarette-ad masculinity."

Mr. Gidal is the first commentator since John Wayne to think that the Western "accurately reflects the American psyche." But he is by no means the first to suggest that the narcissistic ideal of *Lonesome Cowboys* represents peace and fulfillment itself. Who could conceivably question the idyllic spectacle we see in the film? Out beneath the Big Sky, the boys are open and free, they are tender and gentle, sweetly rolling two by two in their sleeping bags, "brothers," no— "friends who sleep together." In the silence of the huge Western night,

they exchange still, delicate, intimate conversations while lightly strok-
ing each other's thighs. Yet they are energetic and exuberant too: Just
like at summer camp, they plunge into a naked, beer-splashing fight in
a wild free-for-all that ends with them collapsing in laughter against
the boulders, beer dripping from the ends of their pricks. Then they
throw kisses to that unforgettable camera.

To further demonstrate their "sexually ironic" potential, they put
their *macho* costumes back on and ride off to Viva's ranch, where they
roughly fling aside the panting, delirious Taylor Mead and "rape" the
tormenting woman. Gidal calls this parody, and it is, indeed, a very
strange rape. In a film wholly absorbed in nudity and its meaning, the
naked Viva is "violated" by men fully clothed and buttoned up: Never
(except in violence; a female hand slapping a male face) does flesh
touch flesh. It is all *buffo* shadow play. Ironic, indeed. Is its function
to show the horror of relations between men and women? I think not.
In *Lonesome Cowboys*, clothes represent costume: They are the image
of falsity. Since the violent *macho* identity is false, the men are unable
to remove their clothes to rape; more perplexing, they are unable even
to show their penises, the very organs of their innocence and passivity.
This is no display of violent, cruel passion. Its function is purely nega-
tive: It attempts to associate aggression with precisely nothing at all.
It attempts to associate desire with precisely nothing at all. Under the
façade of rape, the episode is finally a statement of how deeply Viva is
not wanted, is an insistent assertion that she does not effectively exist.
And, for that reason, the film consoles itself with the lie that her effec-
tive existence must end in brutality and crime, in order to spare the
film an inevitable humiliation.

It is one of the peculiarities of the American mentality to persist-
ently confound the experience of innocence and liberty, to suppose in
some blind, exhilarated state that the two are somehow the same. No
culture offers a more impoverished or abreactive vocabulary for en-
countering the experience of guilt, no culture more lavishly indulges
the rhetoric of guilt while insisting on innocence, innocence. This con-
fusion is one of the major sources of moralism in our onerously moral-
istic land. As we know, the narrative pivot of the Western is the Good
Guys against the Bad Guys. The same is true of *Lonesome Cowboys*,
except that here both Good and Bad are One. Of course, our sancti-
mony has its other side: We love Jimmy Cagney for his wickedness—
who else, after all, could shove a grapefruit into a woman's face? Then
there is Bogart, forever discovering Goodness emerging from the ethic
of his Badness. There can be no doubt that one of Hollywood's princi-
pal accomplishments has been a series of big lies about virility; has
been the propagation of just as many lies about the relation between

Trash, Joe Dallesandro and Jane Forth.

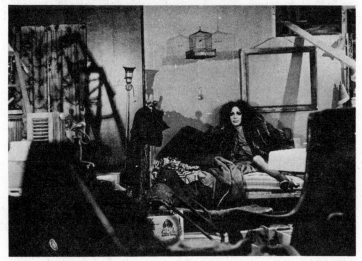

Trash, Holly Woodlawn.

Trash, Holly Woodlawn, Michael Sklar.

Heat, Sylvia Miles,
Joe Dallesandro.

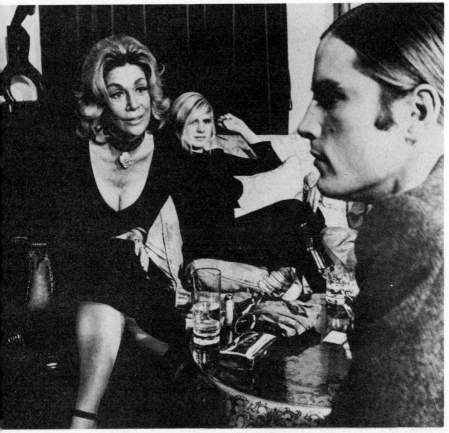

Heat, Sylvia Miles, Andrea Feldman, Joe Dallesandro.

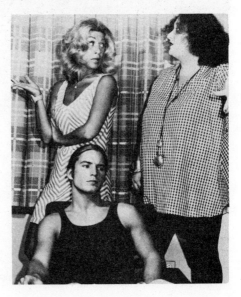

Heat, Sylvia Miles,
Joe Dallesandro, Pat Ast.

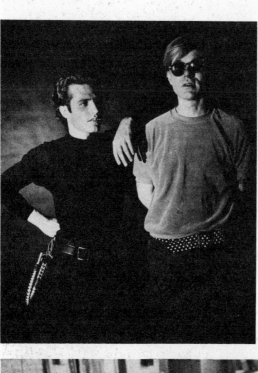

Malanga and Warhol.

Warhol and Malanga.

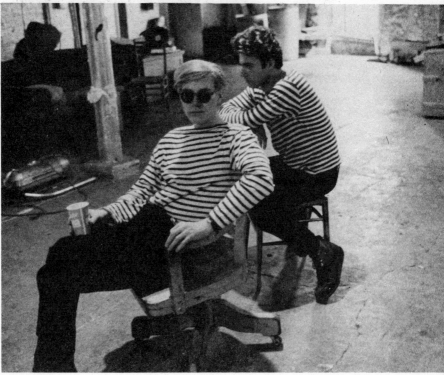

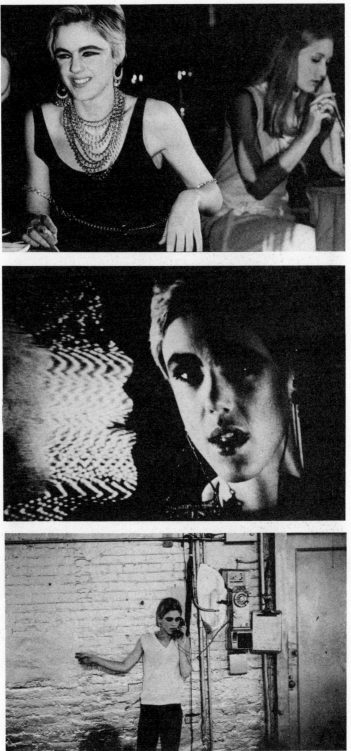

Edie Sedgwick.

Shooting *My Hustler*.

Warhol shooting Marie Menken.

Billy Linich in the "old" Factory.

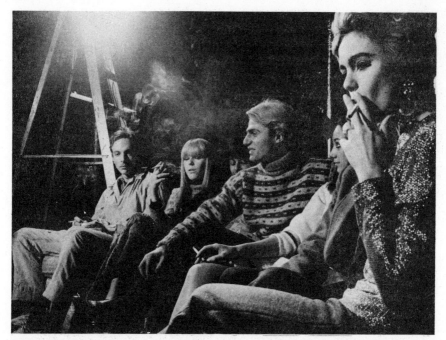

Edie Sedgwick, Malanga, and friends.

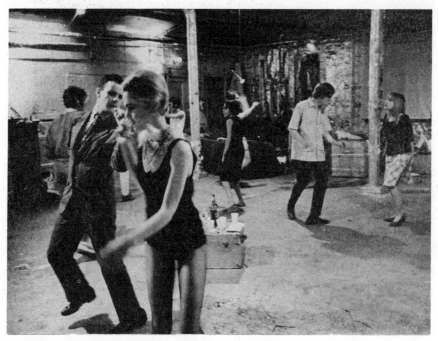

Edie Sedgwick in the "old" Factory.

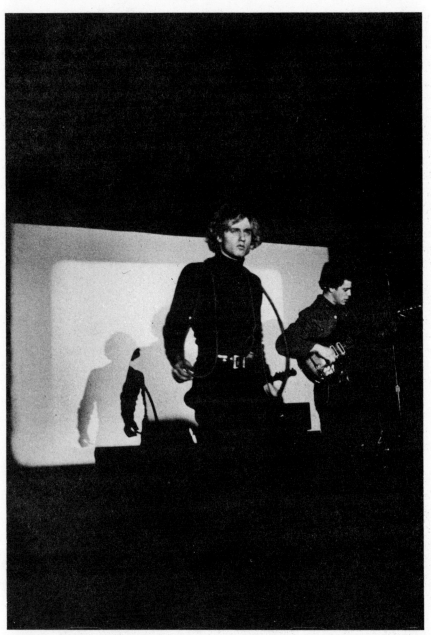

Malanga doing his whip dance.

Briget Polk in the Chelsea Hotel.

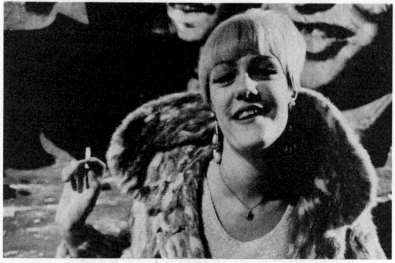

Ingrid Superstar.

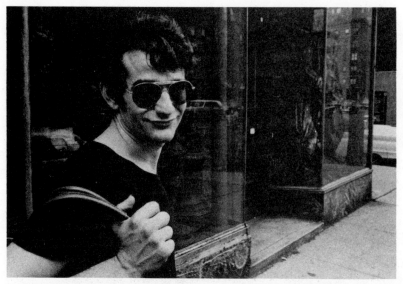

Ondine.

Paul Morrissey.

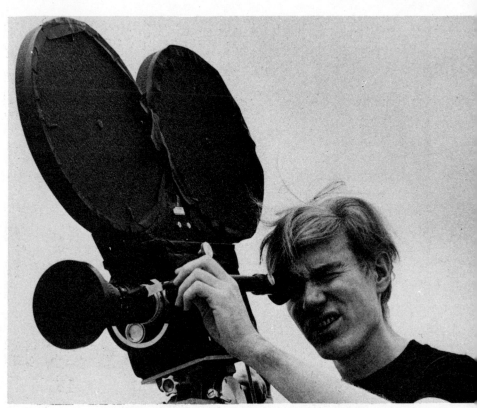
Warhol.

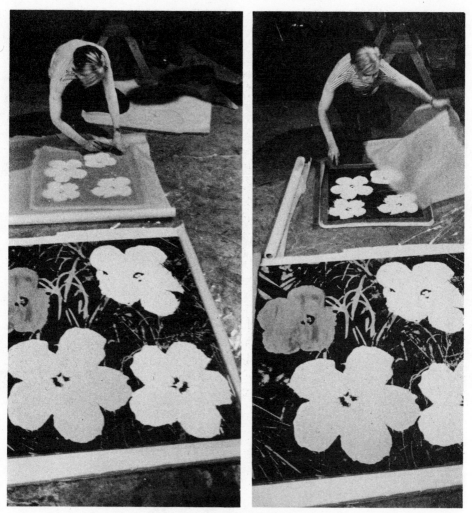

Warhol at work in the "old" Factory.

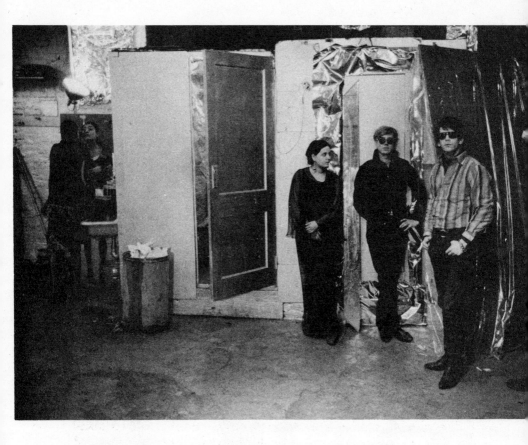

being strong and being good and being tender; lies about the nature of strength and goodness and tenderness. And, within their and our hopeless confusions, *Lonesome Cowboys*, Warhol, and we have inherited the whirlwind of these lies.

Driven by the obsession with innocence, we have also been the most supple and open of all countries to the great revolution in consciousness represented by the twentieth century's understanding of motivational psychology. No other country has so deeply assimilated Freud as a staple of thought itself. The benefits of this cultural event have been many, but we above all should not recoil from looking at its soft white underbelly. We have seized at it in the throes of what sometimes seems the national neurosis. We have a vested interest in understanding bondage as merely the enforced delusion of an irrational guilt. The Truth, we insist upon believing, is Freedom. And, when our researches bring us to the conclusion that the truth is more modest, more stringently normative, and crueler, we desperately try to expand the myth and then call that expansion "radical." Radical, conservative—it doesn't matter. We are only trying to invent a way out. Above all, we must be Innocent. We must be Free. Lots of luck.

And is the anthropology embodied in *Lonesome Cowboys* really in touch with Innocence and Freedom? I ask the question not because *Lonesome Cowboys* is an important fact in our cultural lives, but because its obsessions *are*. Superficially, the film presents itself as a Manichean struggle between homosexuality and heterosexuality. I am completely convinced that any argument that attempts to understand our emotional destinies in these merely behavioral terms is condemned to futility, dishonesty, and stupefaction. For a given sexuality is not a need. *It is a way of satisfying need.* And no discussion of sexuality will make sense until the discussion of behavior becomes subordinate to an understanding of the structure of need.

The attitudes in which Mr. Gidal participates have a definite grounding in theory. So let's have a look at that theory. Despite the fact that "radicals" are, at the moment, involved in an orgy of repudiating Freud, the theory is Freudian, as it has been transmitted by Herbert Marcuse and Norman O. Brown. I must confess that I am not entirely comfortable with the terms of the discussion as they derive from Freud, and I leave a margin of doubt both for their normative accuracy and even their hypothetical descriptive aptness. Nonetheless: What Mr. Gidal claims to find wicked is what Freud would call "phallic" sexuality. Another phrase is "fully genital." (We speak, of course, of men.) As refracted through the writing of Brown and Marcuse, this type of sexuality is understood to be aggressive, obsessed with domination, and radically limited in its sensory capacity for fulfillment and

peace. Not Freud, but Brown and Marcuse see it as culturally aberrant, "unnatural." Opposed to this is a vision of a sexuality that is filled with sensory openness: peaceful, sweet, tender, passive. Named with Freud's term, "polymorphous perversity," which Freud thought characteristic of the newborn infant at the earliest stages of its development (which is where the notion of "aggression" and "genital" sexuality comes from). Seizing upon these polarities, pop philosophy has tended to insist that what Freud thought "infantile" behavior is "good," and what he thought "mature" (or genital) behavior is "bad." Crucial to this assertion is what is supposed to be the absolute openness of "polymorphous perversity."

But, if we speak in Freud's language, we must stick to Freud's language. In a way that I hope Norman O. Brown did not intend, the term that he promoted, "polymorphous perversity," has, in pop philosophy of the last ten years, come to be used with entirely inadmissible inaccuracy. The perversity of the boys in *Lonesome Cowboys*'s particular band cannot by any stretch of the imagination properly be called "polymorphous." It is exclusively narcissistic (specifically, narcissistic sadism), an entirely different and far more advanced stage of sexual development than the "pure infantilism" of the newborn. Its claim to pure passivity and utter freedom from motive—therefore, complete freedom from responsibility—simply cannot be sustained.

From this theoretical perspective, we return to the notion of the wicked "phallic" and the innocence of the prephallic experience. At the moment, Pop Culture is filled with the moralism of this polemic. The women's movement has made the assault on "phallic" feeling very familiar indeed. Male "genitality" is a chief demon of the movement: Interestingly, the movement has been very vigorously trying to define and espouse female "genitality," which in their discussions turns out to be a wide variety of orgasmic possibilities, so long as they exclude male "genitality." The men's assault on "genitality," however, has taken a different tack, in which an Oedipal demon is erected—yes, erected—as the object of a ferocious masochistic rage. One interesting aspect of radical feminism, as opposed to certain types of masculine political radicalism at the moment, is that the women "genitally" insist that it is their absolute right to assume power. The men, on the other hand, "polymorphously" insist that power is, by definition, "evil." And, the better to promote their innocence, the men insist upon the women's right to be "evil." They are able to do so because the question has little to do with good and evil. It is about renunciation.

Other varieties of this moralism (as men espouse it) divorce themselves entirely from an economic base and become purely "psychological" radicalism. Examples could fill a separate book: They surround

us in the "liberated" press. I'll choose one from what is thought to be a very respectable source, and another from what most people would dismiss as entirely beyond the pale. Eric Bentley, in *Theater of War: Comments on 32 Occasions*, engages in a prolonged defense of homosexuality as a morally privileged experience and adds, speaking of men who desire women, "any enemy of this heterosexuality is, potentially at least, a friend to women." It is distressing that one of our most conspicuous theater critics understands "homosexuality" to be an "enemy" of "heterosexuality." On the far side of this masculine renunciation of the "phallic," one finds a minor branch of the gay liberation movement called the "New Effeminacy," which insists that any vile wretch so unfortunate as to be born with a penis has a high moral duty to "wipe out the man in himself" by castration, whether actual or psychological. (Reports have not yet been received about which members of the movement have physically opted for the Supreme Sacrifice.)

Does any of this sound familiar? The idea—implicit in the whole direction of this polemic—that the masculine experience is (save for certain rare saving graces) utterly unbearable by virtue of being wholly debased and vicious, in fact, the very Enemy itself, is an idea that has played no small role in Warhol's life and has very nearly brought him to his death. These theories about ethics and the flesh, as they proliferate in the popular culture, have brought us into the most startling proximity with the ideas of Valerie Solanis, whose *S.C.U.M. Manifesto* repeats them, only to move beyond them to a position that we shall shortly discuss. But surely it is no accident that our analysis of the intellectual underpinnings of *Lonesome Cowboys*—a film completed just before that day in June when Warhol was shot—has brought us so relentlessly into the arms of his would-be murderess.

Warhol had indeed found his issue.

The Sexual
Politician

●●●

. . . the dandy's beauty consists above all in the cold appearance
which comes from the unshakable resolution not to be moved; one
might say the latent fire which makes itself felt, and which might, but
does not wish to, shine forth.

—Baudelaire

Exactly. The description of cool. But far more than latent fire is imma-
nent beneath the cold appearance of Baudelaire's dandy, and more
than latent fire lights Warhol's peculiarly disembodied image. Warhol
is the greatest living inheritor of that creature of style Baudelaire so
flawlessly described, but both are more than the Image to which they
wish to reduce themselves. The dandy refuses to be moved; he will not
respond. The passions are mute but immanent within him, and Baude-
laire's immemorial metaphor for those passions is fire—consuming, de-
structive, and feared. Baudelaire describes a man who lives only
through an image of himself. The dandy is an *envisioned* man; in the
ideal moment of his existence, he imagines himself, his life is coolly
transfigured by that repressed, unconsuming flame. He is one for whom
the fire of existence ignites only when he is able to see himself and
repress that fire. He imagines himself as a being with the properties
of another. So it is with Warhol. That image of the Self that Warhol
has so masterfully created looks isolated and luminous, an image on
the silver screen. But there is no image of the self that does not entail

—invisibly, perhaps, out of frame—the image of others. And the dandy's narcissistic isolation is haunted by the specter of others. It is against them that his "resolution not to be moved" acts with a power defined by mutism, passivity, visibility. Yet it is real power.

But it is almost never the kind of power he supposes it to be. As we shall see, his pathos derives from seeking a vision of the wholly autonomous self; his blindness consists in failing to understand that there *is* no self without others. Warhol's image has its purity, but its specific gravity impinges on us with the solemnity of an existential errand, an effort to define being. That image forces us into a consideration of the relations to others it embodies. To understand its power, we must understand—we must *hear*—its silences, hear to whom, and to what, those silences are directed. We must define the politics of Warhol's experience.

We are dealing here with the image, not the man. I will be speaking of the politics of masculine narcissism, of the metaphors locked within its flesh; referring to its dynamic structures of need and being as they alternate between coldness and adoration; between voluptuity and the refusal to give or be touched; between the slap of lust and a drifting revery of autonomousness. A warning: Though Warhol's world is decidedly homosexual, it is the strategies of narcissism and not homosexuality that have my attention here. Homosexuality is not an existential dilemma in the sense in which I understand the term: it is simply a way of conducting one's sexual life, happily or unhappily as the case may be. It can and does at times confront the dilemmas and impasses I will be discussing. But they are dilemmas that move in deeper regions than sexual behavior.

Nor do I mean by narcissism merely the adoration of the self, merely the rapture of the boy at the reflecting pool. I mean narcissism as a form of relating to others. I do not mean to define it clinically; I do not mean to enshrine it philosophically. I merely want to sketch the structure of an experience, in the hope of understanding what it has to say about love.

"Frigid people really make it."—A. W.

The face of the adolescent fills the mirror, and he suddenly feels flooded with a new rapture, he has made the beginnings of a discovery. The bliss of the narcissistic *frisson* is a life force, the first discovery to one's own *power*: I am tempted to think it the *sine qua non* of that discovery. The child in his dependence suddenly sees in the glass one to whom love's sustenance is not arbitrarily dispensed by others, one to whom a new kind of attention can be given: This being is not a child, not dependent. For the first time, he rapturously

feels that the person in that mirror is beautiful, capable of separateness and strength. Inscribed in that face, those features, those limbs, is whatever human power it is that makes one "Some One," makes one a being with something to say about the terms of self-esteem, a being no longer a childish suppliant, one capable of commanding attention and caring, one to whom love's sustenance is not arbitrarily dispensed by others; one capable of exercising that autonomous existence necessary to make oneself loved. Or feared. Or felt.

This discovery takes the form of a search; a deep attitude of scrutiny is its *tao*. But scrutiny is not enough. After the primary intuition that that "Some One" exists, one proceeds to discover its continuing existence by living. Suppose that "Some One" is never found. Suppose the narcissistic intuition becomes only the further pretext for division and weakness. Suppose the face in the distance of the mirror becomes the very image of the self divided. A vicious circle initiates itself. Eros is alive within one, demanding its gratification, hungry for others, insistent. Yet the self is not strong enough for the encounter; very often the Other means something very dire: the self feels too weak to confront the threat. To feel this weakness is in itself humiliating, and so desire awakens not the prospect of gratification, but the anguish of self-hatred, along with the threat of humiliation and degradation, all of them joining in a conspiracy of anxiety, which is in turn an agency of repression. Desire itself comes to be felt as a variety of pain. (That "pain" may be further disguised as "boredom," or "contempt," or "disgust.") Yet Eros will have his season. He turns his warmth on the one object he is capable of confronting: the isolated self. And anxiety and the threat of humiliation resolve themselves into serene rapture. For a while.

Fearing both others and the self, the ego returns compulsively to the narcissistic surge for confirmation, seeking to tap again that delicately overwhelming intuition of strength. But the face in the mirror is a stranger's. It reawakens not the sense of strength but self-hatred. And in the effort to rid onself of that hated self, one begins to love the attributes of the image that make it seem to be a stranger. The self can only be bearably envisioned as another. And in the throes of hatred for the self, one falls in love with that image of self as other. Now, this image of the self-as-other has one very noticeable attribute, its "personality" has something special about it. It is loved for itself alone. It does not relate to others.

Baudelaire's vision is born.

The narcissistic intuition of strength, of the power to live and relate, is replaced by a drifting, self-protective revery of self-sufficiency. The image in the mirror is eroticized but remote; beloved but unap-

proachable; needed but incapable of being possessed. And these attributes become the precise terms of the narcissist's existential description of himself. The nearness and farness, the presence and absence of the divided self are eroticized. For itself.

This turning inward is famous for its sweet pathos. We know that the boy hovering so breathlessly over the reflecting pool will never embrace himself. He wants himself—wants with a vast, sweet ache of yearning that cannot be assuaged. His dilemma is tender. But tenderness is not quite the whole story. He wants himself because he does not possess himself. His ache of yearning is also the ache of pain. Inevitably, his desire is imperious and all-consuming. He wants to live, but cannot; he correctly intuits that possession of himself is the One Thing Needful. Other people remain insignificant to him so long as the crucial, essential being eludes him. He is bereft, nothing matters but redemption. His pain is terrible. *He experiences himself as an absence.*

But his tenderness is cold. He is in deep complicity with the absence, and it is because of his complicity that fullness eludes him. For he wants only a self that wants only others. He wants precisely that self that the adolescent so rapturously perceived might have the power to live with others on his own terms. But that self does not want the narcissistic kiss—it humiliates and insults. He wants the joy of living, understood as relationship. But, through some injury or delusion, that joy seems unbearably threatening, and is mercilessly scorned.

So narcissism means dividing the self to obviate the threat of needing others. All its energy, all its eros, all its sweetness, all its rage, are directed toward this repressive end, which is almost never recognized as repression, because it is a repression that takes the form of desire. One thinks of desire and gratification as following a sequence. But narcissistic desire is simultaneously its own lush gratification and its own savage frustration. It is desire *as* frustration.

The narcissist yearns for wholeness because he feels himself to be divided, and his self-division finds its very image as he stands before the mirror. His divided autonomy is preferred to a wholeness of self. Yet that wholeness—obscurely intuited, loved as another is loved, mysteriously, elusively immanent in the mirror—is also his most dire image of self-obliteration. This is his dilemma: He desires only what he utterly refuses to possess. And so he is damned.

Those who have not known this damnation cannot understand how simultaneously seductive and terrible it is. R. D. Laing has said he is amazed only by the fact that more people are not raving mad; gibbering in the streets. To feel a desperate need for others that drives one inward rather than toward contact is to feel simply crazy. To feel oneself refusing everything one most deeply desires, to experience desire

as a form of refusal, is to suspect one's own sanity. Love is ferociously scorned. Self-esteem mercilessly despised. Meanwhile, eros saturates everything in a vast desert of disinterest. Yet these seemingly mad transactions occur with utter conviction and every appearance of complete necessity. It is indeed miraculous that its victims do not rave and scream, that they find themselves instead washing the dishes, showing up at work on time, and smiling to the cashier.

A word or two more about some characteristic ways of experiencing this conundrum. One such way, motivated by a refusal to permit the other his distinctness, habitually confounds the experience of desiring with the experience of being desired. One feels a baffling incapacity to sense the crucial distinction between the two, feels a peculiar blindness to the fact of their separate occurrence. Another modality requires that all emotion be self-reflective in order to be experienced at all. This self-reflective dimension may or may not be the grounds for a superior consciousness (though it often is); but, in its pathological form, it seeks to evade the immediacy of forbidden need by reducing it to the innocuousness of a spectacle in which one is both actor and audience. Outside the arena of this spectacle, emotion is simply not felt. It becomes impossible to desire in any simple way, impossible to tolerate being desired with that simplicity that calls for a frank return of feeling or rejection. Desire may wholly dominate the personality, but always as a means for assuring that actual gratification does not take place. One can adore—alone. For in one's adoration, one is "lovable." One can be adored—alone. For in one's indifference, one is invulnerable. But, in either case, abandoning an essential solitude means vulnerability to a love worse than death. And so one alternates inexplicably between abject adoration and a terrible *froideur*.

❋ ❋ ❋

But to return to Warhol.

I think a love affair can get too involved, anyway, and it's not really worth it. . . . You do it like you watch a movie made for television.
 —A. W.

Narcissism lives in the theater of itself; theater is its refuge. Warhol's early critics were fond of pointing out that his is a primarily theatrical as opposed to plastic gift. It is indeed a virtually metaphysical dimension of his identity. The narcissistic mind is likely to have a peculiarly deep commitment to the strategies of the unreal because the unreal gives permission for experience and emotions that are otherwise forbidden or unbearable. Condemned to passivity and repression, the im-

perious need to *act* still exerts itself. And so one *"acts,"* theatricalizing a role or identity not one's own. Forbidden emotion is given permission to emerge by virtue of the falsity of the role. Yet it is real emotion. That is *its* sweet pathos.

There is a breach between the need and the permission: the space between the real and the played, the distance of theater. It is also the space between the boy and the surface of the reflecting pool. Or, to subdue the discussion to Warhol, it is the distance of Warhol's stare, the distance between himself and the world he transposes beneath his aestheticizing gaze. But, in the voided, empty spaces of this distance, the Thing Denied is need. Need is humiliation; it is loss of self; it is death. Of course, denial does not make need go away. The obsessional transaction becomes this: a search for permission and repression at once—a search for permission *as* repression, repression *as* release. It is only in the narcissistic revery, only in Baudelaire's elsewhere, that these antimonies can be resolved. One enters the theater of that elsewhere in order to trigger a permission that will be as full as it is unreal. Now, Warhol *is* permission, he *is* theater; he creates around himself that aura of the unreal that is also the space within which he cannot be touched, not ever literally touched. There Warhol gives permission for the sexualization of his eros. That sexualization is something very different from the liberty of sexual desire as it craves others: that liberty can never be granted. It must always be taken, assumed in that very act of taking that is forbidden to the narcissistic mind.

The distinction I am invoking between sexuality and sexualization rather resembles the famous distinction between style and stylization, and is both as shadowy and as crucial as that concept. Self-reflectiveness is, of course, the key to both—just as stylization is so often named as the besetting vice of highly narcissistic art. But I am less interested in a normative definition than in a certain experience of emptiness, an eroticization that touches everything in one's experience except the wellsprings of gratification; a sexuality in which everything is permitted except *being.*

<p style="text-align:center">❋ ❋ ❋</p>

The central reality in this theater of the unreal is the body. What is the meaning of nakedness? Warhol is obsessed with it, he scrutinizes it endlessly, it is another of the mysteries he ponders over, staring. The flesh does indeed incarnate a mystery, but it is the mystery of desire itself, the mystery even of what desire is, and how it can be released. The body incarnates the mystery of the real. But for Warhol that mystery remains impenetrable. Nakedness is innocence, vulnerability, desirability. And so nakedness is scrutinized in search of all these things,

none of which the narcissistic mind can afford or tolerate. One's own flesh is adored at the distance of one's refusal to tolerate what it is, or what it represents. The endless scrutiny of the naked male body that constitutes the central erotic concern of Warhol's late work and all of Paul Morrissey's is a search for the wellsprings of feeling itself. The rapt, drenching attention given to those bodies is a search for release, an effort to discover the liberty to take and be—to take and be real—to have substance—that the flesh embodies. Nakedness is a search for permission. But its nakedness is covered, the search is false, the game rigged. In this theater of permission, permission *is* denied. The theater can only be entered because it is innocuous and unreal. It is an arena in which the flesh glows with the mystery of its absence, enhanced by an eros that denies substance to what it truly desires and that lives only in a theater that denies life to what it gives liberty.

These paradoxes are desired: What's craved is an unreal experience of liberty—understood to be free *by virtue* of the fact that it is unreal. This is an eros that sexualizes and theatricalizes need so completely that desire seems to drown in it. The result can be the familiar but still bizarre paradox: a completely sexualized personality unable to say anything at all about what it wants. In Warhol's world, this is the eros of the hustler, the transvestite, the superstar. Animated by adoration and indifference, desirability confused as desire, glamour confounded with self-hatred, this eros makes people shine in the peculiarly unreal way Warhol has made famous. It is also the eros that makes people jump out of seventeenth-story windows or swallow thirty Nembutals. Its pathos is the necrophilia and impotence of the star and sex idol, to which the Warhol ambience is so deeply addicted; the pathos of Valentino and Harlow and Monroe and James Dean. But it is also the pathos of the utterly dispossessed. And it is a dilemma to which Warhol, in another of the brilliant moves that make up the strategies of his own cool narcissism, has made himself the utterly absorbed and uncaring witness.

 ❂ ❂ ❂

Warhol's own solution to the narcissistic dilemma is so simple that it is positively breathtaking. It has been to absent himself as conspicuously as possible. He has joined the dandy's strategy with that of the voyeur, and elevated the conjunction to a principle of being. Predictably enough, as the ultimate voyeur, Warhol has surrounded himself with exhibitionists. His strategy is far more successful as a repressive tactic than theirs: In his voyeuristic compulsion to absent himself, in his refusal to be present within the circle of love, Warhol acquires a "capacity not to be moved" that is far more complete than the ex-

hibitionist's dream of having the world at his feet, adoring and enthralled. The exhibitionist dreams that, if only he were adored, he would at last feel substantial and autonomous, beyond risk, *real* within the glow of his fame and beauty. Haunted by invisibility and inexistence, his compulsion is to become visible, known. This compulsion insists upon incessant and extravagant renewal. Like the junkie, he must have his fix. He is wholly dependent on his dream of autonomy. He is going to shine, be untouchable, he is going to be a star. That is *his* pathos.

> That's the thing I'm always thinking about: Do you think the product is really more important than the star?—A. W.

By making himself the prime witness of this pathos-ridden and pathetic dream of autonomy, Warhol has achieved his own airtight image of autonomy. We're correct to speak of superstars, all right, but it is the merest flattery to give the name to Ingrid or Ondine or Viva. Warhol is the superstar. He has entered that pathological American dream and enacted it in reflective terms that provide him with a peculiar immunity to its dangers and disasters. Or at least so it seemed until Valerie Solanis appeared. As a master of passive power, Warhol *is* the self-esteem of his hangers-on; *He* is their fix. The results of this absolute dependency can be terrible: The annals of the Factory include not the rhetoric but the reality of madness and suicide that is like a heartbeat. As of this writing, the latest victim is Andrea Feldman, who, in the fall of 1972, leapt from a seventeenth-story window clutching a Bible. She had recently appeared in *Heat*. It is from this hysteria and dependency that Warhol seems so coolly immune. He can rest still within the hall of mirrors, unthreatened by the rising and shifting specters of the unreal, those prismatic flatterers that can become so cruel. Every suicide must be its own story. But surely those of the Factory must include some terrible conjunction between the incapacity to reach desire, the thirst for an authentic action, and the desire to *make it stop*. In his complete surrender to the demons of the divided self—withdrawal and passivity—Warhol discovered his autonomy, his power, and what once seemed his immunity. But, if he was able to make his peace with inauthenticity, others could not.

Warhol's avenging demon turns out to be not suicide, but murder.

Still, for a time the strategy seemed flawless. His conspicuous withdrawal allowed him both his image of autonomy and the gratification of being *seen* on a scale known to few artists in history. His psychological game of presence and absence is intimately related to the Duchampian logic he raided for his capacity to act as an artist, and film

gave him the means to hypostasize that condition with a fullness and variety previously unknown to him. Combing the psychological and aesthetic strategies, Warhol discovered the key to becoming the complete master of his narcissistic compulsions, and, by using both of them to diffract and dissociate those compulsions, he provided himself with a kind of horrible strength and liberty.

Finally, Warhol has brought the dissociation of sensibility to the most pathological elements of the American desperation—such as stardom—and subdued them to himself. Divide and conquer. As the word proclaims, stardom is a metaphor. He will shine. He will be remote, majestic, untouchable, simultaneously adored and self-contained. That's a contradiction: *the* narcissistic contradiction. Perhaps it is also a metaphor. As we know, Warhol's style is dissociative, which is what kept him out of Hollywood—and, as for metaphors, one of his principle artistic procedures is to untie the knot of metaphor. And he has untied the metaphor of the star to become one who is seen because he sees, one present because he is absent, a star who is in fact a stargazer. And, in this reflectiveness, he has discovered his fame and his life.

<p style="text-align:center">❀ ❀ ❀</p>

The homosexual hustler and the transvestite preside over most of Warhol's late films and all of Paul Morrissey's, linked for all their apparent difference by a common obsession with the mystery of how a man inhabits his flesh. They are at opposite poles of a common dilemma. The transvestite, on one hand, builds a life upon the denial of his anatomical reality; the hustler, on the other, proclaims himself to be "just a body." The one, claiming to be, as it were, pure psyche, asserts the complete power of the spirit over his (her) flesh: ("Jackie has decided to go back to being a boy for a while," one is told.) The hustler sees himself as flesh. At the same time, more paradoxes emerge within the game of sexual roles; by insisting upon a wholly feminine nature, the transvestite puts complete credence in the dominant efficacy of the so-called masculine property of will, while the hustler, identifying himself as the sexuality of his flesh and nothing more, proposes himself as a wholly passive and will-less being, subject exclusively to the will of others.

What binds the hustler to the transvestite in their inescapable collocation is a radical dissociation of will from flesh. Their dilemma is the same: Sexuality is the pivot of a conundrum about being and appearing. The transvestite absolutely links will and behavior, thereby deny-

ing the flesh; the hustler wholly dissociates will from behavior ("I'm not queer, see; I just do it for the bread"). In one case the body is made invisible. In the other case the will is made invisible. But whatever the choice, "they" *are* not their bodies.

But then drag queens have a way of making things not work for themselves. That's what happens to drag queens.—A. W.

Within these radicalized dilemmas, both transvestite and hustler confront the narcissistic confusion between desiring and being desired and, in that confusion, discover ultimate possibilities of repression as release. In the context of totally sexualized lives, their dissociation assures that the unbearable problem of "their" desires will simply never be referred to. The transvestite proclaims a sexuality he is anatomically incapable of gratifying: His entire life is built around a vaginal experience he will never have, the better to assure that the desires he *is* physically capable of consummating need never be expressed. And, to accomplish this fact, every detail of his life must be completely eroticized. The hustler, meantime, makes himself into a complete erotic object, just a body—the more perfectly to assure that his real desires will remain hidden by the opacity of flesh. He's fond of distinguishing between "business" and everything else in his life: "I just do it to pick up a few bucks." In point of fact, he subtly sexualizes every act: Sometimes Joe Dallesandro, who at least plays hustlers, helps out with the phones and daily work of the Factory. It's astonishing to watch the half-visible way in which he sexualizes the dreariest details of life in a business office, eroticizing every moment of human contact and virtually every object he touches.

But both men have wholly dissociated actual desire and their actual bodies. Sexual identity is in that sense forbidden. And the two major contributions of the Paul Morrissey films—his popularization of transvestite comedy and his unprecedented exploitation of the male sex object—are in both cases based in this prohibition. The comic core of the two transvestite comedies, *Trash* and *Women in Revolt,* is the problem of having or not having a vagina: Morrissey has created a new brand of middle-class humor that we might call vaginal parody. This is what makes the spectacle in *Trash* of Holly Woodlawn masturbating with a beer bottle one of the funniest scenes in recent film, and this is what sustains the comedy of her attempt in the final episode to convince a welfare worker she is pregnant. In *Women in Revolt* the "women's liberationist" Jackie Curtis, formerly frigid, at last discovers her True Being by screwing a former Mr. America who has

exploited his fame by going into business as a gigolo. In his bemuscled arms, Jackie's restless destiny is at last resolved. She bears her child, but Mr. America, never too keen on sex with women anyway, absconds, leaving her the prisoner of the squalling infant. But does the now truly liberated Jackie mind? Never. It was worth it all, worth the degradation, the disgust, the humiliation—even the baby, worth every precious minute. For in his arms Jackie discovered ecstasy. Whatever else may happen now, whatever further misfortunes this cruel world may bring, she knows she can bear it, she knows she has Truly Lived, Truly Known Joy. So it goes. Every grotesquerie of the transvestite fantasy is wrapped into a comic but pretty package and dumped before us, complete. At the outer limits of absurdity, flamboyancy rediscovers the banal.

Rather than deny his body by conceding complete supremacy to the fantastic, the hustler chooses instead to *confirm* his body. Central to his appeal is the appearance of inhabiting his flesh with complete ease and confidence, with a fullness and freedom from ambivalence rarely available to, say, his customers. Because he is "just a body," because he never under any circumstances allows himself to become involved in any apparent denial of that body—in the strategies of, say, effeminacy— he is taken to be intensely "virile." Because he is all body, he is taken as "all man."

Crucial to his transaction with his male customers is a mythology about being "really" heterosexual rather than homosexual. While enthusiastically participating in homosexual activity, the hustler denies as often as possible that he is queer; his customers console themselves with the superior insight that he is deluded, merely trying to deceive himself about his true "homosexual" nature, even though part of their excitement in him is very often what seems to be a "virility" they themselves do not feel they have. The terms of this obviously rigged transaction are in fact not applicable to the hustler's destiny, and for that matter probably not to his customer either. The real terms of the discussion should be Self and Other construed as existential self-possession. Both dispossessed, both men discover in mutual love-making a mutuality of revenge, defined by the narcissistic (rather than the homosexual or the heterosexual) terms of adoration and contempt.

To the customer, the hustler seems to literally embody the impenetrable mystery of how he has given his body permission to be itself. The hustler for his part refuses to acknowledge his divided experience, understanding himself to be a whole man engaged in the manly activity of making a good living. In fact, his wholeness, the confirmation of his own flesh, transforms the impulses of self-resolution

into a sexuality defined by an incessant, almost helpless act of giving, putting out. He seems to embody the mystery of self-possession, a mystery he then proceeds to violate. But there is no mystery. He has gained that permission by allowing the body to be itself so long as it is never allowed to be what Sartre would call *for itself*. His being, his body, is for others.

In revenge for this dispossession, the hustler arranges to be paid and secretly (or not so secretly) despises those who adore him. And what do his customers do? They perform on his body—so miraculously passive for all its "butchness"—an adoring act of revenge, revenge on that body that, by virtue of seeming to be for itself, is made for *them*, robbed in triumph of its "masculine will." The very act of adoration constitutes this revenge.

Part of this arrangement is involved in games of weakness and strength, conjoined with questions of class. Dear to the hearts of both the hustler and the customer is the image of the hustler as "strong": Physically strong, and psychically strong as well, insofar as he is imagined to be without ambivalence, wholly "in" his role. Likewise cherished by both is his "weakness," which consists of his passivity, as well as perhaps the "degradation" of his profession. This strength and weakness are linked to a class drama. The middle-class or upper-class customer feels his social superiority, knows *he's* the one with the money. And yet he is besieged by the "weakness" of a divided self-consciousness, that famous "ambivalence" so frequently seen as the besetting malaise of the upper-middle class, and supposedly unknown to the unself-conscious, blunt, earthy proletariat. It is precisely this apparent absence of self-consciousness that so attracts him to the hustler. And the same distinction is equally dear to the hustler, whose whole being is based upon denying the divided self that his behavior in fact manifests. So he plays dumb. Given the American mythology, stupidity enhances his supposed masculinity and offers the bonus of making him simultaneously weak and strong, just as the customer's class station makes *him* simultaneously weak and strong.

But this drama of weakness and strength serves the deeper purpose of once again providing release *as* repression. The hustler can *only* inhabit his masculinity as long as it is passive—preferably to the point of helplessness. The conjunction of will and flesh is wholly forbidden. The prime metaphors for this are potency and physical strength. And so in *Trash,* Joe Dallesandro opens the film incapable of being aroused by Gerri Miller, a go-go girl doing her best to help him get it up. Throughout the rest of the film, he is shown as a heroin addict, and, whenever naked, he is slumping, falling, crawling.

The kids nowadays learned how to really not care and do it with boys and girls.—A. W.

Flesh is probably Paul Morrissey's finest film thus far. It is not a major film; it is the work of an epigone; it entirely lacks the brilliance that sustains Warhol's most extraordinary work in film. But it also avoids everything that made Warhol's (late work) alone so atrociously bad. It is pretty; it is, in its way, elegantly made. The film is about flesh, about the dilemmas of the male body I have just been discussing. It carries to near-cartoon explicitness the obsessions that underwrite *My Hustler* and that institute this major theme in the Warholvian mystique. At the center of both films, the complete object of the camera's sexual attention, is a "beautiful" hustler—Paul America, Joe Dallesandro—whose task is to ripple his muscles, turn his groin, ruffle through his casual, butch crotch-scratching, so that the camera will look and never want to stop looking. There we have it: the male sex object. In careful naked array, the naked Joe sprawls on a bed. He is asleep. We are a long way from the film *Sleep* though we are instantly reminded of it. The opening shots show Joe being awakened by his wife, a sequence designed to awaken arousal in the audience, to initiate the fantasies that will be accommodated and dissipated in the plot that follows. The point is that men are weak but adoring, while women are strong but hateful. But in both cases the ostentatious adoration of that almost-always naked body is filled with a subtle, or not so subtle, rage. The film would have us know—but sweetly, sweetly—that, if the perfect male is going to be adored in his virility, he is also, by God, going to pay for the privilege.

We begin with a setup for sympathy. The camera's first task is to establish Joe as entirely desirable physically; to show his entirely sweet nature; to demonstrate how gently loving he is as the father of his child. He is filled with childlike delight and tenderness; he is cheerfully patient as he is exploited by his shrill, greedy, loveless, mocking, unsensuous (but fetishistic), small-minded wife.

Carping and mean-spirited, this woman forces Joe out of his beauty sleep and into the streets to hustle for money, claiming in a lie that she needs money to help a girlfriend get an abortion. And on those streets, Joe meets men—those sweet, weak adorers. There is an aged, rich, tremulous feebe, who, sloshing through his dentures, prattles enthusiastically about Beauty and the Greeks, while lavishly paying Joe to pose nude as Discobolis, Adonis, the Boy with a Thorn, and the like. Following this adventure, Joe pays a visit to a gently obsessed Korean War veteran who, in his guarded adoration, wistfully hopes he won't

have to pay for Joe's favors, though he eventually hands over the money as a sweet gesture of his wounded love. Back on the streets between tricks, Joe chats with his fellow professionals. They, too, are sweet, very good to each other, attentive, and helpful. But business is bad; Joe is forced to visit a coven of transvestites (thus providing Jackie Curtis and Candy Darling their first cameos in a Warhol production) where a real woman, the stupefied Gerri Miller, pays to give him a well-deserved blow-job. He could, of course, care less.

And so, when Joe goes to men, he graciously receives their money and their sweet, pitiable love. Women, on the other hand, have precisely nothing to offer. For after his hard day's work, Joe brings home the money his wife has demanded, only to discover the grasping creature in bed with her girlfriend. The two women proceed to mock and insult him. He has spent the day using his "homosexuality" nobly to provide for his wife, his child, and a stranger in trouble. The wife uses her homosexuality to mock and insult and demean this paragon. But, of course, the wife is no different from anyone else: She is totally absorbed in lust for Joe's body. Yet her lust is ungenerous and perverse; she must transform it into a nasty, wide-eyed, sexual gamesmanship and insult.

Such is the anthropology of this elegant little cartoon. And, after establishing the male's superb desirability, it is necessary to extract the revenge. After allowing Joe to be desired and adored by men filled with an entirely pathetic love, that humiliating and loathed "virility" of his must be punished and mocked. This is a task that the film-maker obviously prefers a woman to perform, and fortunately a hateful woman is on hand in the form of the wife, who performs the task with unfeigned relish. Well, the film seems to sigh in relief, thank God somebody is putting Joe through hell for having those balls. Serves him right, the butch bastard.

The misandry—man-hating—at the core of *Flesh* is the rage of alienation, an alienation from the flesh itself, an alienation the hustler's presence falsely seems to resolve. But on the unconscious level, the falsehood of that "resolution" is known and embraced: Everyone concerned knows he is not dealing with a "real man." But in the theater of the real man's unreality a certain thirst for the body's permission, otherwise forbidden, can be simultaneously permitted and repressed; at once exalted and humiliated; the conflict may release itself from the secret places where it is locked in the voyeur's, the john's, own self-hating flesh, to break out at the same instant it is theatrically resolved. Falsehood is necessary. A "real man" would not be allowed—he is the image of death.

The hustler's relation to his body is thus the imagined resolution of a central dilemma of alienated masculine consciousness in our time. As I have tried to indicate, though this dilemma may have many sources, its principle dynamic seems to me a terrorized unconscious denial of the permission to feel need. Now, the body represents the corporeality of those needs, the body is the soul's *form*, as Cocteau put it, locked within it is the praxis of all need, however ultimate—even the need to deny the body. And so the denial of need takes the form of subtle and pervasive denials, written in the ganglia and the muscles, of the logic and the life of the flesh itself. In men, this can take the form of refusing that dimension of the male body's psychological life that the analysts call (somewhat misleadingly, I think) phallic. One of the principle agents of this repression is the narcissistic revery, which drowns phallic energy in self-absorption.

In our time, Warhol is the most conspicuous image of this sexual strategy and its greatest living politician. It is a strategy that has had a central role in both the history of art and the history of masculinity: Its first and perhaps greatest genius was Baudelaire, and its tradition is that of decadence itself.

Dandyism is nothing if it is not a masochistic attack upon the experience of masculinity: It is centrally a vision of antivirility, an assault upon the life of the male body by means of, and in order not to surrender, its narcissistic gratifications. It is *the* great tradition of masculine misandry.

In America, that tradition has to varying degrees adopted and melded with the central line of American misandry as created by women. In the Catholic countries, the language of sexualized antimasculine resentment is largely involved, as was Baudelaire's, in the language of Satanism, images of impotence and degradation, of torture and damnation, the incapacity to act, visions of punishment for daring to feel need: Though the argument, of course, is that one discovers in this damnation the supposed *puissance* of Evil, a sadistic Satanism. In America, following its Protestant tradition, the recompense for the castrative torture is not Power but Goodness. Moral Elevation, if you will. The misandrous tradition of America's left Protestantism, founded by women, formulates its visions of male degradation in the language of Puritanism. It involves the male's degradation in the vile pleasures of sensual bestiality, as opposed to woman's spiritual disdain for the snares of the flesh. As a practicing Catholic from an immigrant background, Warhol to some degree participates in both these traditions, as *Vinyl*, for example, indicates. But, if Warhol can dabble in Satanism, he can also dabble in America's white-bread

versions of these matters: Could any film starring a blond named Paul America do otherwise? It is a kind of fresh-air revision, untainted by any nephitic *fin-de-siècle* incense. But the two games are very much the same.

Though the tradition of misandry in America was codified in the nineteenth century by left-Protestant women, it persists in this century quite conveniently without the assistance of God. The left Protestantism of the nineteenth century considered the male to be bestial and degraded because he was the *sexual* sex. He was filled with vile habits and desires: For example, he smoked and drank. This was filth. But there was no filth like the filth of feeling desire: Indeed, in a kind of mass proto-Freudian *aperçu,* the Women of America understood that the filthy habits of smoking and drinking were indeed connected to desire. But that was the male's sin: to need, to desire. It debased and degraded him. (It is true that women might become sexual—that is, they might fall—but only through the evil influence of men.) Because man is sexual (or at least much more sexual than woman), he is, as the doctrine was formulated by Mary Baker Eddy, "less spiritual," "less intellectual," than woman. He has no appreciation of the finer, higher things.

The mythology is dominated by images of animalism. Standard epithets (when the male is not a "child") include such random examples as "dumb ox," "big ape," "beast" (while "clod" declines to grant even sensate status). This tradition reaches its fulfillment when some members of the women's movement, in their search for a new humanism, see fit to describe half the human race as "pigs." Simian comparisons proceed from the large frame and masculine body hair: One hears about "brute strength." In its contemporary and secular versions, the tradition is very anxious to assert female sexuality as something real. Yet that sexuality is always understood to be ethically superior to that of men: It is "tender," and "loving," and "gentle," while that of the still debased, sensual, and animalistic male is "brutal" and "selfish," to the point where a major spokeswoman for the women's movement, Susan Brownmiller, thinks it correct to describe virtually all sexual contact between men and women as "rape."

This is not the place to explore all the variations of the American misandrous myth or the psychological damage it has done. I'd point out only that central to the myth is the view that the male is a far less elevated, less ethical, less conscious creature than the female. And, so it would seem, he acquires consciousness and ethical elevation to the degree that he renounces his maleness. It is precisely this aspect of the misandrous myth that the narcissistic mentality in America

seizes upon and makes its own. To embrace the narcissistic dilemma is to free oneself from the terrible degradation propounded by the myth: It is to become good. The failure to understand the narcissistic dilemma in men as being fundamentally misandrous makes the presence of Valerie Solanas in the Factory something of a mystery. But the moment one sees its actual outline, her role in the entourage becomes absolutely continuous and even predictable. The woman who wrote that in her ideal world the only men she would not send to death camps would be "faggots who, by their shimmering example, encourage men to de-man themselves and thereby make themselves relatively inoffensive," did not by accident find her home in a haven of male narcissism. But it is rarely pointed out that Solanas's diatribe is above all an antisexual tract: The reason that women are so much superior to men, why they are free and strong, while the male is basically a slave and disgustingly weak, is that women cannot and do not feel need *of any kind*, except when suffering from a kind of delusion imposed on them by the evil men. Solanis is a direct inheritor of the American misandrous tradition, departing from it only by recasting the language that the nineteenth century formulated as left Protestantism, and the twentieth as liberal sentimental humanism, into the language of hysteria, terror, and totalitarianism. Her belief that women are the unsexual sex (therefore the good, elevated, free, strong sex) is one that Mrs. Eddy would have instantly recognized and agreed with. (Only liberals within the tradition seem to have some difficulty with it: In her preface to the revised Olympia Press edition of the *S.C.U.M. Manifesto*, the feminist Vivian Gornick at no point lets on that she has understood Solanis's crucial insistence that women are the unsexual sex, and at one point rewrites a quoted section rather than let her readers know that Solanis considers Lesbianism male-oriented aberration, just as debased and disgusting as sex with men.)

The men who accept this experience of themselves may enter a decadence that is really a search for innocence. To renounce the phallic life is to gain a superior consciousness, to become sweet and good. But the flesh *will* have its way. This consciousness and this sweetness are achieved in an alienation that must be underwritten by rage. One hears rage spitting in the voice of Ed Hood; hears it shrieking in Ondine's diatribe; witnesses it in Dallesandro's stumbling body in *Trash*, sees it gleaming in the needles he is made to drive, Saint-Sebastianlike, into his body. There is even rage in Duchamp's dry laughter, the laughter of the *moqueur*. It is the rage of feeling that must renounce what it cannot achieve. It is the furious voice of need itself. That renunciation, the narcissistic repression, cannot survive on sweetness alone. It needs the help of hatred.

And, even surrounded by the protection of hatred, it always confronts the possibility of crack-up, of the Terror. Whatever obsessional accommodations may be made, in time, the body and need itself will have their way, in however much pain, as against however much denial. The difficulty, finally, with the theatrical Baudelairean Elsewhere, is that it is uninhabitable. For we inhabit flesh.

TRUMAN CAPOTE (after describing an apparently random series of people): *Now, Andy, you tell me what you think these people have in common.*
WARHOL: They committed suicide once?
CAPOTE: *Now use your mind.*

Warhol's image parses out the dilemmas of emptiness in that inhabitation. The surface of the reflecting pool is very still: Silver-haired, cool, the face hovers in its empty, ultimate space. It's an image of absence in our time: absence of will, absence of spirit, absence of flesh. It is empty as the space of the stare. Yet despite the placid serentity, an unexpected, dangerous presence lurks nearby, none other than Eros's old companion. John Keats—he thought his own name writ on water—confessed himself "half in love with easeful Death."

Half in love. Exactly.

Stillness

He is the silvery shadow cast by the 1960's, this quiet man and his films. I've been speaking of him as if he were a heuristic mystery, looking at the silence of his presence and trying to read it, attempting to discover, in its power and absence and passivity and fame, a Word. Part of the investigation has been an attempt to locate him in the final triumph and dissolution of that countercultural art born long before any of us were born, initiated in the reeking allure of mid-nineteenth-century decadence, in Baudelaire's repelled and salivating attention to a pustulating carcass, in a ditch near where his mistress stood hectoring him. And Warhol is indeed the improbable heir of that art, the last dandy. The subject is irresistible, exfoliating its implications: such as how that art has come to flourish in the late twentieth-century form in the Duchampian *avant-garde*, with its allure in the diseases of American decadence; the manner and meaning of its silent articulation in 1973. But there must be some kind of thematic energy that keeps the phenomenon alive, there must be a Word beneath the surface of the man who once told an interviewer, "If you want to know all about Andy

Warhol, just look at the surface of my paintings and films and me, and there I am. There's nothing behind it."

Nothing? It is true that this man, obsessed as he is with all the sly perversities of concealment, in the process of making himself into a public phenomenon, has rendered himself visible as a billboard, has indeed entrusted himself to surfaces in a very complete way. But meaning is not so easily eluded. Whatever Warhol's success in his lifelong seduction of silence, however full and content his gratifications in those surfaces he insists are all, it is implicit in the truth of language itself that the mere announcement of nothing proclaims something, that the flourishing self-effacement of "there's nothing there" points us toward some location, some silent nowhere that, with a little dogged effort, we may yet precisely name. The critic is lured by hints of secret places, compelled insistently to use the levers of words to finally get at It, the Real Story. "Every style reveals a metaphysic," said one such critic, quoted before. But Sartre, above all, knows every style also conceals a metaphysic, and not necessarily the same one as it reveals. And any profoundly convinced interpreter is likely to remain haunted by an intuition Sartre himself has fed with the lush fodder of book after book: That it's not merely any style—not merely Art—but any human move of any kind whatsoever that, if read attentively and persistently enough, will finally turn over the Real Story, that, if the flower is picked apart with sufficient pincing delicate care, the nub will at last exfoliate into some kind of Busby-Berkeleyan, show-stopping Truth.

Such is the allure of Warhol to the critical mind, the intuiticn that his silence is—or was—connected to something that a good critical work-over would make speak. I'm convinced that Warhol has a theme— indeed, one of the grand Themes—from which all his important work grows. And I think that by now we have descended through enough circles of perception to name it flat out, without orotund hysteria or further hermeneutical flower picking. The theme is death. Death. Saying it that way places it dramatically on the page, no doubt about that. But does the Word not quite stop the show? Perhaps not. For the death informing the Warholvian gaze is terribly metaphoric, of course. For one thing, it is webbed about with psychoanalytic metaphor, involving behavior like pathological withdrawal, which in its classic syndrome is surely an accommodation to an infantile fear of death. And that fear itself is one of the most polyvalent of all metaphors, knotted and mysterious, its sources as concrete as an absent mother's touch, as a father's strong embrace, as spilled pablum. And, of course, that metaphor is artistically engaged as well, on the most essential formal levels. The necrophilia embodied in the transformation of Marilyn Monroe's publicity still into a vision of Venus as a lame surface, the perverse morti-

fication of the camera's casual stare at Edie Sedgwick's sexual dis-
comfiture on a bed—that necrophilia is not necessarily explicitly gazing
out at us as the subject. More precisely, it resides in the stilled, disin-
terested gaze we must bring to these works in order to see them at all.

But the Ancient Enemy is more forthrightly present in Warhol's
world than are these mere Duchampian refinements. Death is there as
subject as well as means. There are the silk-screens of the disaster
series, one of a thousand suggestions Henry Geldzahler made in the
early 1960's to his then attentive friend, only to find a few days later
that the ghastly photographs had been found, and the process of mak-
ing them into art begun, ripped half-naked bodies hanging from the
shattered windows of once-proud Impalas. There are the silk-screens of
the electric chair, the photograph including the terrible sign that actu-
ally hangs above the steel chamber's riveted door: SILENCE. There
are six hours of death's counterfeit in *Sleep*. There are Warhol's re-
mote and perverse obsessions with the *body*, with that vision of carnal
presence that lives only through a complete involvement in paradox,
surely including the opposite term of life itself. And don't forget the
presence of death at the Factory itself, its unaccountable score. Freddy
Herko: 1965. Several others in the middle 1960's. Edie Sedgwick: 1971.
Tiger Morse: 1972. Andrea Feldman: 1972. Billy Linich—nearly—in the
very late 1960's. And, above all, our man himself—nearly—in 1968. And
—nearly—how many others along the way?

Ah no, our mock-naïf is no stranger to the Adversary. He's taken a
look or two, and in some deeply complex remote way liked what he's
seen. At least, it has held his attention as no other adversary could
possibly do. So there we have the thematic word: Death. Many tempta-
tions rise to mind before this admission, this insight. For example, there
is the immediate temptation to ransack the vocabulary of nineteenth-
century romanticism for precedents, and not only that rotting carcass
Baudelaire saw crawling with flies. It is also there in Keats's almost
homoerotic invocations—those vertiginous tongue-licking murmurs in
the Adversary's hairy ear—in the *Odes*; present, too, in Emily Dickin-
son's unspeakably conscious lusting after obliteration at the hands of
the Gent who so kindly stopped for her, whom she ends by addressing
more privately, ladylike decorum gone to hell, in the thirsting, almost
pornographic outburst, *"Say it again, Saxon!"* The familiar, obsessional
relation between desire and death may be figured in the whitened
shadow of the Warhol image; he recalls for us the willful persistent ab-
surdity of it, the sweaty bourgeois knot that the nineteenth century
tied and the twentieth century has been for seventy years trying to
untie, yanking at it, without final success, in socialism, in psychoanaly-
sis, in the assault on the *bourgeoisie*, in our century's multifarious

visions of the New Man and the New Woman. But the Adversary is shrewd, with a power to co-opt like no other. Where do such historical meditations carry us? To some vision of A. W. as nothing less than the final pallid endgame of the *Liebestod?* Come, come, one wants to laugh. Perhaps. Yet the idea is striking; it carries itself further, to the vision of A. W. as nothing less than the image of the Pale Rider himself, the sunglasses covering a gaze that too insistently suggests what Dickinson called the "distance on the look of death." Could that be it? We have perhaps been speaking all along about our own Pale Rider in *Vogue,* his Adversary presence saying something fearful about the co-option of all our optimistic means, about all that beautiful analysis and socialism and our *bourgeoisie* and its dreams of a new existence? Could he be indeed our image, our decadence? Is that perhaps why he has so very little to say? Perhaps life just doesn't happen to be his game.

The Adversary seems present even in Warhol's lusting, in a pornography intriguingly close to the central line of Western homoeroticism, the image of the Beautiful Male Body in its excruciated final anguish, from the Saint Sebastians to Michelangelo's Dying Slave to Gericault's shipwrecked men writhing on the rafts to Gustave Moreau's Cecil B. de Mille Babylon in catastrophe to—*Sleep, Vinyl.* These are painful reflections: it would seem we have come across something other than a genius for *décor,* something closer to the quiet rage of a profound mortification. Could this be Andy? Sweet, sweet *Andy?* Or perhaps the rage of our desperate twentieth-century sexuality itself? One can hardly help thinking of a sentence from the diatribe of the woman who—nearly—became A. W.'s own Pale Rider, point seven of the *S.C.U.M. Manifesto,* where Solanis speaks in hysteria of the Vile Male and perhaps herself, too: "7. The male likes death—it excites him sexually, and already dead inside, he wants to die."

Blink. Welcome to the twentieth century, Pale Rider. Useful nineteenth-century insight may carry us a while, but there is no way to keep Warhol at Baudelaire's side very long. The cold excruciation of right now will pry him loose, release him again to his modernity, his isolation, the elaborate thing he has done in life and art with feeling dead inside. A career as sophisticated in its mortified imagination of disaster as Valerie Solanis's act was hysterical, the spawn of pathological mortification. Yet these two people, so extraordinarily linked, perhaps share analogous roots in the contemporary insanity. Valerie lives in terror of dependence: That is what the *S.C.U.M. Manifesto* is about, an absolute terror before the experience of need. To her, dependence is sexual—is sexuality itself. Like Warhol, Solanis is obsessed with an image of autonomy, except that she is one of the losers afflicted with that delusion, she has played the obsession desperately, rather

than with Warhol's famous cool. Yet the pivot of sin and degradation
is desire. And the reward of sin and degradation, as the scriptures re-
mind us and as Valerie proposed, is death.

There it is, the Word again. Desire and the image of autonomy, fed
by rampaging narcissism, find themselves in the hands of the Adver-
sary, imagining that they have beat him, evaded him, but, in their
fascination, making choice after choice in his favor, in his service.
Grand statements and the wisdom of cliché remind us that the ac-
knowledgment of need is the beginning of freedom. The dear, opti-
mistic psychoanalytic wisdom speaks again; its still small voice, once
again requesting the emotionally real, reminds us that this is all delu-
sion, and after making that Helpful Suggestion falls into a patient,
attentive silence before the spectacle of the pinching, crazy furies. Sad
to say, the still small voice can murmur "reality, reality" until it is blue
in the face—nobody in this late century is listening. *Mens sana in
corpore sano*—hardly the direction of the American culture at this hour.
We do not seem to be a culture that can any longer afford such an
ideal.

To return to the camera. There is something about its stillness that
takes the mind up short in this discussion, something inevitable about
its indifference, its refusal to acknowledge the impulses of perception.
And yet, by virtue of that indifference, that stillness, that mechanistic
autonomy so drenched with the logic of disjunction and narcissism, a
strange freedom is born, a variety of freedom this country takes very
seriously indeed. It is the liberty of will-lessness, the autonomy of
dehumanization, the provision of a permission that need not be taken,
the establishment of a choice that need not ever be conscious that it
chooses. For in the Warholvian camera gaze resides the glamorous
metaphysic of the Adversary. Before that unmoving camera, you can
cry, you can rise to torrential Ondine-like heights, you can strip and
you can dance, you can sleep. In that camera's stillness is the liberty
of the machine's permission, that impersonal condition of choiceless
being that refuses to *become*. It is what the nineteenth century called
Eternity and what we call Immediacy.

There are, of course, other ways of speaking about that perverse
camera, the critical language of impersonality, for example, an under-
standing of it as a dimension of the modernist renunciation of the
rhetoric of sentiment and the pathetic fallacy. But it will not do to dis-
cover in that impersonal, rhetorical revision the image of either an
autonomous history of art sustaining it or a release from the personal
and the praxes of taste and desire. Single individuals never perform
impersonal acts. We are condemned to motive. That is a very different
matter from performing schizophrenic or dissociated acts, which to be

sure do seem to occur from time to time. One gladly concedes the impressive power of an aesthetic "impersonality" in Warhol's films; it is part of the poetry of a work like *Sleep*. With another artist, one might even be critically content to describe that power, content with a certain formalism. But Warhol is too much the personage for such a procedure; his art lives too fully outside the realm of art for it to be acceptable. A critic confronted with an artist of silence must decide if he is going to respect that silence. And, because I seem to be writing this book in a mood of admiring violation, no, A. W.'s secrets are not safe with me. His impersonality entails a schizophrenia, an emotional dissociation articulated through a brilliant revivification of the vocabulary of decadence, in an enterprise that derives its power from an unconscious, compulsive image of death. Death is there in the gaze; it cringes in the voyeur's withdrawal; it nags in the obsession with presence, twists the nerves of perversity, smiles in the programmatic mutism of the artist's inevitable but endlessly coy choices. It is in the passivity, in the brilliant false naïveté of that interminable act of witness that is the career of Andy Warhol. It is there in the silence. And death is, above all, in that *stillness*.

One returns to the mind content to stare for six hours in utter absorption at a breathing abdomen, enthralled at the spectacle of mere functioning life. Perhaps it holds the attention because it is so profoundly *other*, because mere life is indeed a mystery to this mortified gaze. Or perhaps that cool, still rapture is there because it loves, loves the one who breathes, so that the spectacle of the human body doing its small, superbly rhythmic thing brings forward the exaltation of loving joy. Right? Wrong. *Sleep* is a necrophilic act of love to the body, filled with tenderness at the spectacle of a silenced vitalism.

Seeking the last word, the critical mind (with its psychological and novelistic bent) cannot forbear one short speculation further. Somewhere in Warhol's long meditation on the plastic possibilities of his Stillness, reality intruded in the blunt form of Valerie with her gun; there were four loud shots. Typically enough for a man of few words, the silent *faux-naïf* victim came up with something to say, and it was profound: "Like I don't know whether I'm really alive or whether I died. I wasn't afraid before, and having been dead once, I shouldn't feel fear. But I am afraid, I don't understand why." Those four shots nearly reached the death inside Warhol, but not quite. But is it possible they awakened the necrophilic beast in some finally unmanageable way, that they put him at last face to face with the Adversary he'd made a great career courting and evading in his coy perversities? Before, Warhol had stared him down with a gaze that seemed to look and look away at once. He hadn't been afraid before, however extremely

he had been afflicted with those debilities that every day mow down a
few hundred more otherwise strong and gifted people. Just a touch of
despair. Just a touch of affectlessness. Just a touch of the incapacity to
believe, a smattering of withdrawal, a little smack of death, in short.
Infected with them all, Warhol had parlayed them into a great Pop
spectacle, and thereby saved his courage and his capacity to act and
be, in some corrupt and brilliant way. But when the day came with the
real wounds, when the real juices of life started spurting and drooling
into the crinkled, starchy Union Hospital linen inside a wailing ambu-
lance, maybe he had come face to face with the Adversary in some
inevadable way. Perhaps it was rather like the incident reported by the
friend who had tried to talk business with the evasive *maître* and com-
mitted the terrible violation of touching his shoulder to get his atten-
tion. Perhaps Valerie's murder attempt awakened the Adversary of
Warhol's necrophilia, so that the Ancient Enemy clapped his hand on
Warhol's shoulder and said irritably, *"Look at me when I talk to you!"*
And Warhol, the genius of evasion, cowered in terror; he looked and
saw what scared him as few people are ever scared, his imagination of
disaster began to clang with terror, the peaceful withdrawal looked
like it might recede into regions from which it could never return, the
passivity began to look like *the* stillness, and he saw the Adversary face
to face and was reduced to the silence, not of death, but of life and its
terror, and it stopped the master of the passive spectacle, stopped him
short.

Anyway, since the murder attempt, something central is gone. There
has been little work exclusively from Warhol's hand. The films have
become the work of Paul Morrissey. Warhol is no longer the man he
had made himself for the world until then. Stopped short. Or at least
possibly so. One can never tell what such a man might do in the fu-
ture: For the moment, his career has entered a phase in which it is of
interest to some chroniclers of faded chic, and little more. We are
left with nothing but the works and their Theme. Recoil from the spec-
tacle won't do, however strong the impulse of recoil might be. To call
it something other than it is won't do, no alternate moralism will re-
trieve it from this brilliant concatenation of narcissism and the coolness
of obsession and death and launch us into rhetoric about things "life-
affirming" and "joyous." Our long talking stare has indeed brought us to
the Word, and the Word sticks. It is death all right, so let it be death,
and I think we'd better take a good, long look.

Andy Warhol was born Andrew Warhola in Pittsburgh, Pennsylvania, August 6, 1928, the second son of Ondrej and Julia Warhola, both of whom had emigrated to the United States from Czechoslovakia during the previous decade. His parents were of peasant stock. Ondrej Warhola was a steelworker and coal miner who died from drinking poisoned water when young Warhola was fourteen years old. The artist's subsequent childhood and youth were spent in dire poverty.

Nonetheless, in 1949, Warhola was awarded his Bachelor of Arts degree in pictorial design by the Carnegie Institute of Technology in Pittsburgh, whereupon he immediately moved to New York and secured work as a commercial artist, illustrating magazine stories and articles, as well as designing shoes. His shoe designs

brought him a position in the art department of the
I. Miller shoe store. The young designer became
so swiftly successful as a commercial artist that,
within one year after his arrival in New York, he
was able to purchase the town house on upper
Lexington Avenue in which he still resides.

In 1952, at the Hugo Gallery in New York,
Warhola exhibited a series of drawings illustrat-
ing short stories by Truman Capote. It was his
first public exhibition. In 1956, he accompanied
one Charles Ligenby on a trip around the world.
Between 1956 and 1959, the Bodley Gallery in
New York was the scene of yearly one-man shows
of his prints and drawings.

By the middle 1950's, Warhola had simplified
his name to Andy Warhol. In 1957, Warhol was
awarded the Art Director's Club Medal, the cita-
tion noting particularly his shoe advertisements.
Warhol was, by this time, one of the most widely
admired and sought-after commercial artists in
the field. Between 1956 and 1959, a series of
books of his drawings, many of them hand-
colored, were published in strictly limited edi-
tions by Seymour Berlin. They are now very
scarce.

In 1962, exhibitions of Warhol's Campbell's
Soup can silk-screen were mounted in Los
Angeles and New York, and his work appeared
in four group shows, among them the contro-
versial *New Realists* exhibition at the Sidney
Janis Gallery. The events surrounding these ex-
hibitions made Warhol famous, and his reputation
increased with startling speed, so that, by the
middle 1960's, he was clearly the most widely
celebrated—if not the most widely admired—plas-
tic artist in the English-speaking world. His
works have been exhibited in virtually every
major city in the West. A simplified *catalogue
raisonné* of his work would include well over 650
paintings, sculptural objects, and graphic works,
many in multiple editions.

In 1963, Warhol began to make films. In its
present rudimentary stage, scholarship has been

unable to arrive at an accurate estimate of the number of films he has made: He has, at one time or another, publicly exhibited approximately one hundred. But various reports indicate that, in all probability, there exist many hundreds more, primarily portraits, made for the private amusement of Warhol and his friends.

In 1965, Warhol made the acquaintance of Paul Morrissey, who became an increasingly influential adviser, collaborator, and member of the large and reputedly somewhat *louche* entourage surrounding the artist. Most reliable evidence currently available indicates that, despite credits and public pronouncements to the contrary, the films attributed to Warhol since 1968—*Flesh, Trash, Women in Revolt, Heat,* and *Amour*—are properly attributed to Mr. Morrissey's exclusive, or all but exclusive, authorship.

On June 5, 1968, Valerie Solanis, a deranged member of Warhol's large personal following, entered Warhol's "Factory"—a combination studio, business office, and social salon—and attempted to murder him. Warhol very narrowly survived several critical gunshot wounds, and his slow recovery and impaired health have been accompanied by a marked diminution of productivity.

In 1973, Warhol founded *Interview*, a successful celebrity sheet, gossip magazine, and roster of the mondaine life. Until his death in 1987, the artist lived in New York, producing work in his classic manner and managing the rather substantial small industry that he'd created around it.

Until the end, he remained a widely sought-after figure in the social life of that city.

Filmography

●●

As of 1990, there is no complete filmography of Warhol's work. The basic filmographic research was performed by Jonas Mekas in *Andy Warhol*, by John Coplans, (New York Graphic Society, 1970), and it remains the basis of all subsequent filmographies. My own 1973 filmography was essentially a freshly annotated version of that effort. The revision included here is indebted for its further correction and annotation to the filmography in *Andy Warhol: Film Factory*, (British Film Institute, 1989) and '*Préambule à la Filmographie*,' by Miles McKane and Gatia Piccaboni, in *Andy Warhol, Cinema*, edited by Bernard Blistene and Jean-Michel Bouhours, (Editions Carre, 1990). The latter is likewise indebted to the research done under the supervision of Mr John Hanhardt in conjunction with the Whitney Museum's Retrospective of Warhol's films, mounted in 1988.

1963

Kiss. 16mm, 58 minutes. Silent, 16 fps. Filmed, November, December, 1963. Naomî Levine, Ed Sanders, Rufus Collins, Gerard Malanga, Baby Jane Holzer, John Palmer, Andrew Meyer, Freddy Herko, Johnny Dodd, Charlotte Gilbertson, Phillip van Renselet, Pierre Restaney, Marisol. (Originally run as a serial, *Andy Warhol Serial.*) Collection, Anthology Film Archives. Film-Makers' Co-Operative.

Sleep. 16mm, 6 hours. B/W, silent, 16 fps. Filmed July, 1963. John Giorno is the Sleeper.

Andy Warhol Films Jack Smith Filming "Normal Love." 16mm, 3 minutes. Color, silent, 16 fps. "A 'newsreel' film showing Jack Smith shooting *Normal Love*. The original was seized by the New York police in March, 1964, together with Jean Genet's film, *Un Chant d'Amour*. The fate of the original is unknown. No print exists." (J.M.)

Dance Movie. (Also known as *Roller Skates.*) 16mm, 45 minutes. B/W, silent, 16 fps. Filmed late September, 1963. Freddy Herko.

Haircut. 16mm, 33 minutes. B/W, 16 fps. Filmed November, 1963.

Eat. 16mm, 45 minutes. B/W, silent, 16 fps. Filmed November, 1963. Robert Indiana. Collection, Anthology Film Archives.

Blow-Job. 16mm, 30 minutes. B/W, silent, 16 fps.

Salome and Delilah. 16mm, 30 minutes. B/W, silent, 16 fps. Filmed late 1963. Mekas provides no description, and I have not been able to locate this film. Freddy Herko and Debby Lee. Mekas notes that it exists only in an original print.

1964

Tarzan and Jane Regained . . . Sort of. 16mm, 2 hours. Sound on tape by Taylor Mead. 16 fps. Taylor Mead, Naomi Levine, Dennis Hopper, Claes Oldenburg, Pat Oldenburg, Wally Berman.

Batman Dracula. 16mm, 2 hours. B/W, silent, 16 fps. Jack Smith as Dracula, Baby Jane Holzer, Beverly Grant, Ivy Nicholson. This is another film I have been unable to see or locate. Stills indicate that it was very much influenced by the style of Jack Smith.

Empire. 16mm, 8 hours. B/W, silent, 16 fps. "Filmed June 25, 1964, from the 44th floor of the Time-Life building. Arranged by Henry Romney. Co-director, John Palmer. Cameraman, Jonas Mekas (who happened to know something about the Auricon camera—this being Warhol's first Auricon movie.)." (J.M.) The listing of John Palmer is ambiguous—though it seems that the idea of this most conceptual of all films was originally suggested by Palmer.

Henry Geldzahler. 16mm, 100 minutes, B/W, silent, 16 fps. Filmed in the first week of July, 1964. Henry Geldzahler, a portrait film.

Couch. 16mm, 40 minutes, B/W, silent, 16 fps. Filmed in July, 1964. Gerard Malanga, Piero Helzicer, Naomi Levine, Gregory Corso, Allen Ginsberg, John Palmer, Baby Jane Holzer, Ivy Nicholson, Amy Taubin, Ondine, Peter Orlovski, Jack Kerouac, Taylor Mead, Kate Helzicer, Rufus Collins, Joseph LeSeuer, Bingingham Birdie, Mark Lancaster, Gloria Wood, Billy Linich. Those who have seen this film report that it is very long, and entirely pornographic, a series of the possible permutations of sexual adventure among the protagonists on the old red couch that was at the center of the 47th Street Factory.

Shoulder. 16mm, 4 minutes. B/W, silent, 16 fps. Filmed summer, 1964. Lucinda Childs' shoulder.

Mario Banana. 16mm, 4 minutes. B/W, silent, 16 fps. "Mario Montez eats a banana." (J.M.) Mekas mentions that "a few other versions" of *Mario Banana* exist. I have never seen any of them, and I was told by Paul Morrissey that the original film was at some point added to footage of another work. I have been unable to determine which.

Harlot. 16mm, 70 minutes. B/W, sound, 24 fps. Filmed December, 1964. Gerard Malanga, Philip Fagan, Carol Koshinskie, Mario Montez. Out-of-frame dialogue: Ronald Tavel, Harry Fainlight, Billy Linich.

The Thirteen Most Beautiful Women. 16mm, 40 minutes. B/W, silent, 16 fps. Baby Jane Holzer, Anne Buchanan, Sally Kirkland, Barbara Rose, Beverly Grant, Nancy Worthington Fish, Ivy Nicholson, Ethel Scull, Isabel Eberstadt, Jane Wilson, Imu, Marisol, Lucinda Childs, Olga Kluver.

Soap Opera. (Also known as *The Lester Persky Story.*) 16mm, 70 minutes. B/W, silent, 16 fps. Filmed, 1964. Jerry Benjamin, co-director. Baby Jane Holzer. "Exists in original only." (J.M.)

Taylor Mead's Ass. 16mm, 70 minutes. B/W, silent, 16 fps. September, 1964.

During this year, there were also a large but undetermined number of portrait films made on 100-foot rolls of film. Rainer Crone, in his unannotated filmography (*Andy Warhol*, Praeger, 1970) also lists the following films (which I have been unable to locate) as products of 1964: *The End of Dawn, Messy Lives, Apple, Pause, Lips.*

Another film, *Naomi and Rufus Kiss*, is variously listed as 1963 (Gidal) and 1964 (Crone), but by Mekas not at all. It seems very possible that it was made at the time of the sequence in *Kiss*. 16mm, B/W, silent, 16 fps. Naomi Levine and Rufus Collins.

1965

The Thirteen Most Beautiful Boys. 16mm, 40 minutes. B/W, silent, 16 fps. Filmed 1964–65. Freddy Herko, Gerard Malanga, Dennis Deegan, Kelly Eddy, Bruce Rudo, "Exists in original only." (J.M.)

Fifty Fantastics and Fifty Personalities. 16mm. B/W, silent, 16 fps. Filmed 1964–66. Allen Ginsberg, Ed Sanders, Jim Rosenquist, Zachary Scott, Peter Orlovski, Daniel Cassidy, Harry Fainlight, and others.

Ivy and John. 16mm, 35 minutes. B/W, sound, 24 fps. Filmed early January 1965.

Suicide. Also called *Screen Test #3.* 16mm, 70 minutes. Color, sound, 24 fps. Scenario and impromptu monologue by Ronald Tavel. Filmed early 1965.

Screen Test #1. 16mm, 70 minutes. B/W, sound, 24 fps. Filmed January, 1965. Scenario, Ronald Tavel. With Phillip Fagin.

Screen Test #2. 16mm, 70 minutes. B/W, sound, 24 fps. Filmed January, 1965. Scenario, Ronald Tavel. With Mario Montez. Out-of-frame dialogue, Ronald Tavel.

The Life of Juanita Castro. 16mm, 70 minutes. B/W, sound, 24 fps. Filmed January, 1965. Scenario, Ronald Tavel. Juanita: Marie Menken. Raoul: Elecktrah. Waldo Diaz Balart, Mercedes Ospina, Marina Ospina, Ronald Tavel.

Drunk. 16mm, 70 minutes. B/W, sound, 24 fps. Filmed, March, 1965. Scenario, Ronald Tavel, Larry Letreille, Gregory Battcock, Daniel Cassidy, Jr., Tosh Carillo.

Horse. 16mm, 105 minutes. B/W, sound, 24 fps. March, 1965. Scenario, Ronald Tavel. Larry Letreille, Gregory Battcock, Daniel Cassidy, Jr.

Poor Little Rich Girl. 16mm, 70 minutes. B/W, sound, 24 fps. March–April, 1965. Directorial assistance: Chuck Wein. With Edie Sedgwick.

Vinyl. 16mm, 70 minutes. B/W, sound, 24 fps. Filmed, March, 1965. Scenario, Ronald Tavel. With Gerard Malanga, Edie Sedgwick, Ondine, Tosh Carillo, Larry Letreille, Jacques Potin, John MacDermott and others. Cameraman: Bud Wirtschafter.

Bitch. 16mm, 70 minutes. B/W, sound, 24 fps. Filmed immediately after *Vinyl.* Marie Menken, Willard Maas, Edie Sedgwick, Gerard Malanga. "Exists in original only." (J.M.)

Restaurant. 16mm, 35 minutes. B/W, sound, 24 fps. May 1965. "Chuck Wein assisted with the shooting and scripting." (J.M.) With Edie Sedgwick and Ondine. This film should not be confused with *Nude Restaurant* or a second film called *Restaurant*, both of which were shot at the same time in October, 1967.

Kitchen. 16mm, 70 minutes. B/W, sound, 24 fps. May, 1965. Edie Sedgwick, Roger Trudeau, Donald Lyons, Elecktrah, David MacCabe, Rene Ricard.

Prison. 16mm, 70 minutes. B/W, sound, 24 fps. Sound on tape. Filmed July, 1965. Edie Sedgwick, Bibie Hansen, Marie Menken. "Exists in original only." (J.M.)

Face. 16mm, 70 minutes. B/W, sound, 24 fps. Filmed april, 1965. Edie Sedgwick.

Afternoon. 16mm, 105 minutes. B/W, sound, 24 fps. Filmed June, 1965. Edie Sedgwick, Ondine, Arthur Loeb, Donald Lyons, Dorothy Dean. "Reel One was originally shown as part of *The Chelsea Girls* during the screenings at the Film-Makers' Cinematheque, later taken out." (J.M.)

Beauty #2. 16mm, 70 minutes. B/W, sound, 24 fps. Filmed early July, 1965, just before *My Hustler*. Writer and assistant director, Chuck Wein. Edie Sedgwick, Gino Peschio, and, out of frame, Gerard Malanga and Chuck Wein.

Space. 16mm, 70 minutes. B/W, sound, 24 fps. Filmed summer, 1965. Edie Sedgwick, Eric Anderson.

Outer and Inner Space. 16mm, 70 minutes. B/W, sound, 24 fps. July, 1965. "Edie Sedgwick talks with her image on a television set. The dialogue is about space, mysticism and herself. During the Cinematheque screening Reel One and Reel Two were projected simultaneously, side by side." (J.M.)

My Hustler. 16mm, 70 minutes. B/W, sound, 24 fps. Filmed September 1965 on Fire Island. Director, Chuck Wein. Paul America, Ed Hood, John MacDermott, Genevieve Charbon, Joseph Campbell, Dorothy Dean. Collection. Anthology Film Archives.

Camp. 16mm, 70 minutes. B/W, sound, 24 fps. August or September, 1965. Paul Swan, Baby Jane Holzer, Mar-Mar Donyle, Jodie Babs, Tally Brown, Jack Smith, Fu-Fu Smith, Tosh Carillo, Mario Montez, Gerard Malanga.

Paul Swan. 16mm, 70 minutes. Color, sound, 24 fps. Fall, 1965. "Paul Swan in solo performance. Exists in original only." (J.M.)

Hedy. (Also known as *The Most Beautiful Woman in the World*, *The Shoplifter*, or *The Fourteen Year Old Girl*.) 16mm, 70 minutes. B/W, sound. Filmed November, 1965. Scenario, Ronald Tavel. Music by John Cale and Lou Reed. With Mario Montez, Mary Woronov, Harvey Tavel, Ingrid Superstar, Ronald Tavel, Gerard Malanga, Rick Lockwood, James Claire, Randy Borscheidt, David Meyers, Jack Smith, Arnold Rockwood.

More Milk Yvette. (Also known as *Lana Turner*.) 16mm, 70 minutes. B/W, sound, 24 fps. Scenario, Ronald Tavel, Mario Montez, Paul Caruso, and Richard Schmidt.

Lupe. 16mm, 70 minutes. Sound, 24 fps. Filmed December, 1965. Edie Sedgwick and Billy Linich. Scenario, Robert Heide.

1966

The Velvet Underground And Nico. 16mm, 70 minutes. B/W, sound, 24 fps. Filmed January, 1966. "And Warhol's rock and roll electronic

group presenting a 70 minute symphony of sound, broken up by the New York Police."—Gerard Malanga.

Bufferin. (also known as *Gerard Malanga Reads Poetry.*) 16 mm, 35 minutes. Sound, 24 fps. Gerard Malanga.

Eating Too Fast. (Also known as *Blow-Job #2.*) 16 mm, 70 minutes. B/W, sound, 24 fps. Gregory Battcock. "Exists in original only." (J.M.)

The Chelsea Girls. 16mm, 3 hours, 15 minutes. Color and B/W, sound, 24 fps. Filmed summer, 1966. Mekas supplies a list of the reels given titles and room numbers, which is not how the film was subsequently projected. Nonetheless I quote it here:

Includes *The Bed, The John, The Trip, The Duchess, Hanoi Hanna, The Pope Ondine Story, The Gerard Malanga Story, Their Town (Toby Short).*

The Gerard Malanga Story. With Marie Menken, Mary Woronov, Gerard Malanga.

Hanoi Hanna (Queen of China). Written by Ronald Tavel. With Mary Woronov, "International Velvet", Ingrid Superstar, Angelina "Pepper" Davis.

The Pope Ondine Story. With Bob "Ondine" Olivio, Angelina "Pepper" Davis, Ingrid Superstar, Albert Rene Ricard, Mary Woronov, "International Velvet," Ronna.

The John. With Ed Hood, Patrick Flemming, Mario Montez, Angelina "Pepper" Davis, "International Velvet," Mary Woronov, Gerard Malanga, Rene Ricard, Ingrid Superstar.

Their Town. With Eric Emerson. Strobe lighting by Billy Linich.

The program of September 15, 1966, lists: Room 732—*The Pope Ondine Story*; Room 422—*The Gerard Malanga Story*; Room 946—*George's Room*; Room 116—*Hanoi Hanna*; Room 202—*Afternoon*; Room 632—*The John*; Room 416—*The Trip*; Room 822—*The Closet.* After the management of the Chelsea Hotel threatened a lawsuit, all references to rooms were omitted in subsequent screenings.

Throughout late 1966 and a substantial part of 1967, Warhol was accumulating the reels that were to compose the film called **** or *The Twenty Four Hour Movie.* This was well over thirty reels of films. Once again, I quote Mekas's filmographic entry on this work, verbatim.

**** (Also known as *Four Stars.*) 16mm, 25 hours. Sound, color, 24 fps. Filmed August, 1966–September, 1967. Shown in full version only once, at the New Cinema Playhouse, 125 West 41st Street, New York, December 15 and 16, 1967. The two projectors' images were superimposed on a single screen. During 1968 and 1969, **** was gradually taken apart. No list was made of the reels and parts projected at the original show. Today it is impossible to reconstruct

the original film. From some of the markings on the film cans, and from conversations with Paul Morrissey, Gerard Malanga, and Andy Warhol, I managed to get together the following partial listing of the materials included in the original version of ****.

Group One. (Segment of ****.) 16mm, 30 minutes. color, sound, 24 fps.

Sunset Beach on Long Island (Segment of ****.) 16mm, 30 minutes. Color, sound, 24 fps.

High Ashbury. (Segment 76 of ****.) 16mm, 30 minutes. Color, sound, 24 fps. With Ultra Violet, Ondine, Nico.

Tiger Morse. (Segment of ****.) 16mm, 20 minutes. Color, sound, 24 fps. Filmed November, 1966.

Other reels that were part of **** (each reel 30 minutes): *Ondine and Ingrid,* Segment 68; *Ivy and Susan; Sunset in California; Ondine in Yellow Hair; Philadelphia Story; Katrina,* Segment 25; *Barbara and Ivy; Ondine and Edie; Susan and David,* Segment 82; *Orion,* Segment 42; *Emanuel,* Segment 35; *Rolando,* Segment 37; *East-hampton Beach,* Segment 43; *Swimming Pool; Nico-Katrina,* Segment 43; *Tally and Ondine; Ondine in Bathroom.*

International Velvet. (Segment of ****.) 16mm, 30 minutes. Color, sound. Filmed January, 1967. With Alan Midgette and Dickin.

Alan and Dickin. (Segment of ****.) 16mm, 2 hours. Color, sound, 24 fps. Filmed January, 1967. With Alan Midgette and Dickin.

Imitation of Christ. (Segment of ****.) 16mm, 8 hours. Color, sound, 24 fps. (There is a 100-minute version of this segment.)

Courtroom. (Segment of ****.) 16mm, 30 minutes. Color, sound, 24 fps. Filmed December, 1966.

Gerard Has His Hair Removed with Nair. (Segment of ****.) 16mm, 30 minutes. Color, sound, 24 fps. Filmed in July, 1967.

Katrina Dead. (Segment 23 of ****.) 16mm, 30 minutes. Color, sound, 24 fps.

Sausalito. (Segment of ****.) 16mm, 30 minutes. Color, sound, 24 fps.

Alan and Apple. (Segment of ****.) 16mm, 30 minutes. Color, sound, 24 fps. Filmed late January, 1967. With Alan Midgette.

1967

The Loves of Ondine. 16mm, 86 minutes. Sound, color, 24 fps. Filmed August–October, 1967. Ondine, Viva, Joe Dallesandro, Angelina Davis, Brigid Polk, Ivy Nicholson, and numerous unidentified men.

I, A Man. 16mm, 100 minutes. B/W, sound, 24 fps. Filmed late in July, 1967. Tom Baker, Ivy Nicholson, Ingrid Superstar, Valerie Solanis, Cynthia May, Betina Coffin, Ultra Violet, Nico.

Bike Boy. 16mm, 96 minutes. color, sound, 24 fps. August, 1967. Joe
Spencer, Viva, Ed Weiner, Brigid Polk, Ingrid Superstar.

Nude Restaurant. 16mm, 95 minutes. Color, sound, 24 fps. October,
1967. Viva, Taylor Mead, Louis Waldron, Alan Midgette, Ingrid
Superstar, Julian Burroughs, and others.

Lonesome Cowboys. 16mm, 110 minutes. Color, sound, 24 fps. Filmed
December, 1967–January, 1968, in Arizona. Taylor Mead, Viva,
Louis Waldron, Eric Emerson, Joe Dallesandro, Julian Burroughs,
Alan Midgette, Tom Hompertz, Frances Francine. The last film
completed before Warhol was shot on June 5, 1968, *Lonesome
Cowboys* was not released until May 5, 1969. The Film-Makers'
Cooperative.

The Films of Paul Morrissey
1968

Blue Movie. (Also known as *Fuck*.) 16mm, 90 minutes. Color, sound.
Viva and Louis Waldron.

Flesh.

1970

Trash.

1972

Women in Revolt.

Heat.

1973

l'Amour.

Other Films

There are in addition to the "released" films of Warhol and Morrissey, a
large number of films made at various times that have never had public
screenings. In 1973 Warhol and Morrissey also collaborated upon two
Italian-produced 3D horror movies *Flesh for Frankenstein* and *Blood for
Dracula* which were made back to back but released separately. In 1976
Andy Warhol's *Bad* was released. Warhol did not direct *Bad* but acted
as its producer and animating spirit. The director was his friend Jed
Johnson. The script was by Pat Hackett. The film stars Carroll Baker,
and features Susan Tyrell, Geraldine Smith, Maria Smith, Clydia Foxe,
Susan Blond and Brigid Polk. It opened in April 1977, running time 109
minutes. Rightly named, *Bad* was a complete failure financially. It
marks the definitive end of Warhol's involvement in film-making.

Index